THE SPIRIT *OF* THE GARDEN

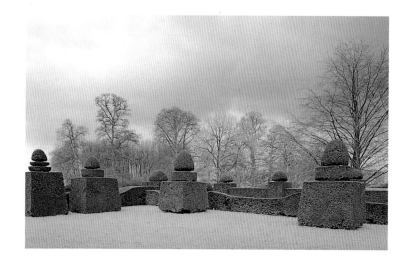

THE SPIRIT *OF* *THE* GARDEN

JOHN HEDGECOE

WITH PATRICK TAYLOR

COLLINS & BROWN

Page one: *Topiary ornaments the buttresses of a clipped yew hedge at Huis Bingerden in Gelderland, eastern Netherlands, defining the boundary between the formal garden and parkland beyond.*

Opposite: *The shores and islands of Lake Maggiore in Italy, with its beautiful natural scenery, provide a benign microclimate in which exotic trees and shrubs flourish.*

First published in Great Britain in 1997
by Collins & Brown Limited
London House
Great Eastern Wharf
Parkgate Road
London SW11 4NQ

1 3 5 7 9 8 6 4 2

British Library Cataloguing-in-Publication Data:
A catalogue record for this book
is available from the British Library.

ISBN 1 85585 292 6 (hardback edition)

ISBN 1 85585 403 1 (paperback edition)

Conceived, edited and designed by Collins & Brown Limited

Editor: Katherine Lambert

Designer: David Fordham

Photography: John Hedgecoe

Reproduction by Classic Scan, Singapore

Typeset by M.A.T.S.
Printed and bound in Italy by L.E.G.O.

CONTENTS

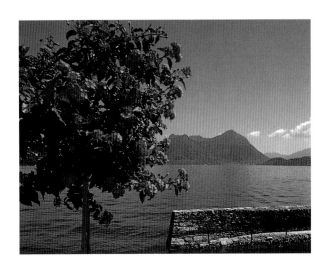

FOREWORD

BY JOHN HEDGECOE

A VISION OR A DREAM? The garden bursts forth from its slothful state into a melody of colour and light. The grass is green. Is perfection realised in all its splendour in the summer sun, or will it wait until the autumnal light floods its orange rays upon the cold crisp days? Then the skeletal forms, the bleaker to be seen, allow the winter light to penetrate a sequestered place. You look, the lawns are white.

He who plants a garden, plants happiness, it is said. Gardeners are by their very nature optimists: they look towards tomorrow while working for today. The beauty of a garden – the colour, the form, the composition, the sense of smell, the surprises, the shape and design – lies as much within a person as without. The gardener tries to tame nature; however, it is the light that makes the garden live, it is the rain that makes the garden smell.

The effect a garden has on the mind and body is of peace and tranquillity. It is a place where one can sit and contemplate or meander through, whether it be a series of rooms that interlink, an open space that preserves a specimen tree, a palace garden or your own vegetable plot. In Japan it was considered an honour to work for a year in the Emperor's Garden; prominent individuals would vie with each other for the opportunity to perform menial tasks there in peace and contemplation, revitalising both mind and body. A garden has the ability to be evocative both visually and spiritually. The joy it can give is immeasurable, the spirit it contains is strong. This is what I set out to capture in my photographs – the pleasure felt through the head, heart and hand, touching all the senses.

When you are young, everything seems to grow so slowly; when older, everything seems to grow too quickly. I have had the pleasure, the enjoyment, the opportunity and the hard work of making two gardens. But still the beauty of a single flower I have grown myself from a seed or an avenue of limes I purchased from a nursery enriches the tapestry of the garden, giving new sensations and pleasures. I like surprises, I dislike rules, I like water both turbulent and tranquil, all plants and all colours if placed in happy surroundings. I like focal points, be it a rose bush or a fountain. I love the care and attention people give to their garden so they can share it with others. Once Henry Moore's wife, Irina, was walking round my first garden in Essex when she said, 'John, I don't really like sculptures in gardens – I prefer just flowers'. I said, 'but Irina, your garden is a sculpture garden'. 'That's for Henry', she replied.

Naturalistic planting is becoming a feature of many late 20th-century gardens. In John Hedgecoe's own garden in Norfolk (opposite), a sweep of scarlet poppies takes the garden into the countryside.

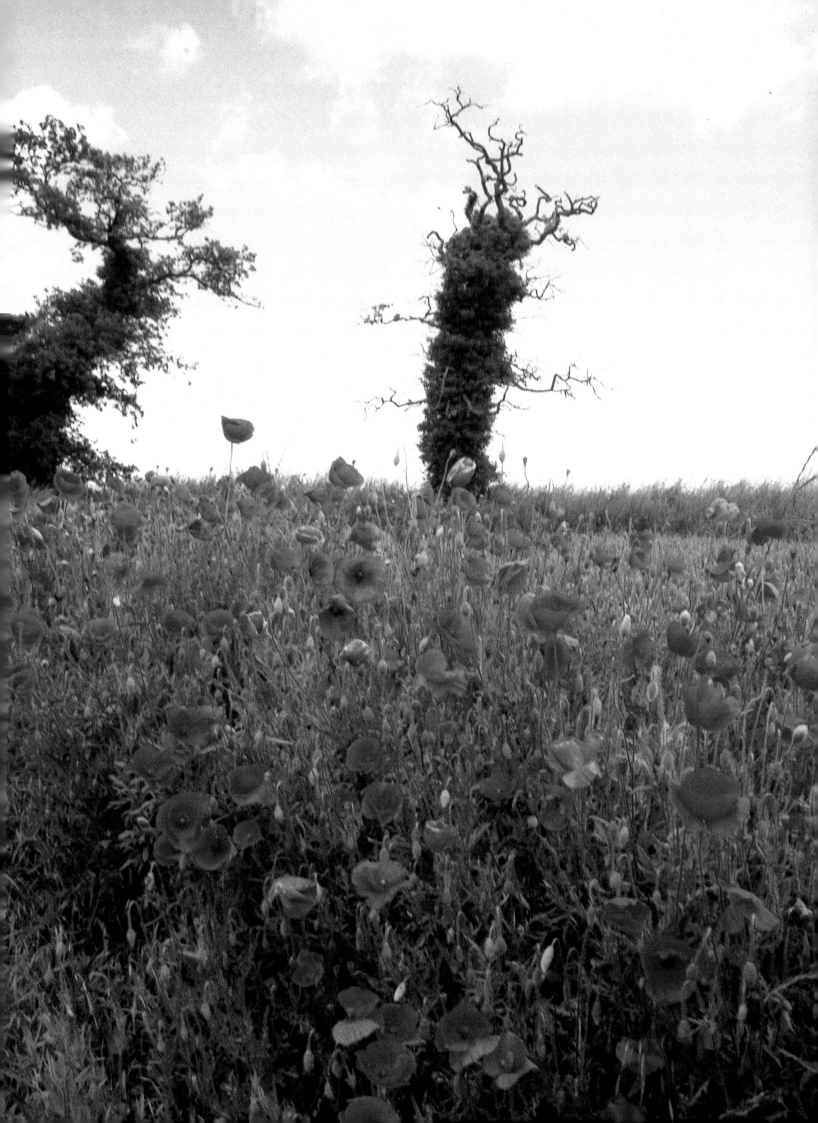

INTRODUCTION

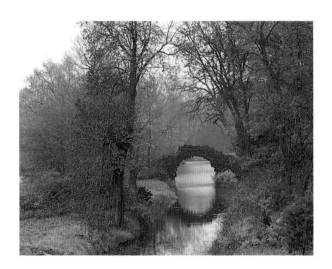

W HAT IS A GARDEN? That is a question which is simultaneously very easy, and very hard, to answer. Versailles is certainly a garden, but then so is your, and my, backyard. Louis XIV used Versailles to impress his friends and intimidate his enemies. We use our gardens to grow plants, read in the shade, play games with our children and eat summer picnics. But beyond these more or less mundane activities the garden is, most potently, the place of refuge from an unpleasant world, or a poetic image that appeals deeply to the imagination. Few books have a more evocative title than *The Spirit of The Garden*. There is always the hope that in our gardens we may be ourselves more completely than in any other setting.

Best of all, for some rare spirits, the garden is a medium of artistic creativity of unique power and expressiveness — gardens, surely, are among the most complex of all visual works of art. If it were possible to preserve a great garden in the same way as a 15th-century Florentine painting — and to make it portable and saleable — gardens would occupy as treasured a place in the world of culture as any masterpiece of painting.

Painting and sculpture are, by their nature, unchanging, except in acquiring the gentle patina of age. Among the most irresistible charms of gardens is their impermanence — they change all the time and delight us with their variety. In the long term even the longest-lived plants must die, and from month to month their appearance is affected by the changing seasons.

The weather itself has a crucial effect on the atmosphere of a garden. Who has not been in a garden on a rainy day when the looming clouds suddenly open, the sun bathes the scene in light, and colours glow with freshly-lacquered sparkle? Gardens present so many different aspects — any observant visitor will never see exactly the same thing twice.

Water and architecture are inseparable in grander gardens, past or present. A rustic bridge of picturesque design is typical of the later features of the immense 18th-century landscape park of Wörlitz in Germany.

Unlike other works of visual art, the garden is made to be entered physically, and explored. Visitors wander freely and follow a route determined completely by whim. Because of that, each visit will be a unique experience, with plants, ornaments, views and garden buildings appearing in a sequence that can never exactly be repeated – even if the more evanescent ingredients, such as plants and light, were to remain precisely the same. A great garden thus has powers of perpetual renewal.

One further quality, possessed by no other works of visual art, is the intensely evocative dimension of scent. I do not mean merely the scent of flowers, although that is vivid enough. I mean the sparkling whiff on a damp and muggy day of the perfume of the sweetbriar's leaf, as fresh as a crisp apple. In early February or March my garden is invaded by the foxy odour of crown imperials, to some nostrils unpleasant, but to mine a lovely reminder that spring is on the way and a burst of blossom about to break. One of the essential dimensions of an English or Dutch formal garden is the curiously pungent but evanescent scent of box foliage. The perfume of many culinary and medicinal herbs – rosemary, sage, sweet bay, thyme and lavender – brushed against in passing, or welling up unexpectedly on a hot evening, is surely one of the most intense experiences a garden has to offer.

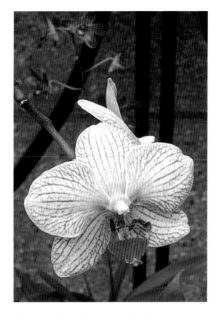

The orchid family is one of the largest botanical groups of all, with over 17,000 species. Almost all of the spectacular exotics, largely from the jungles of tropical America, require very specific cultivation in climate-controlled orchid houses.

Yet the level and complexity of artistry of many of these gardens, and the range and subtlety of emotions evoked, easily rival the great works of art in other media. On countless occasions I have been all alone in some wonderful landscape and marvelled at this privilege given to me, and yet it is a privilege available to everyone.

John Hedgecoe takes us on his own personal gardening odyssey. His photographs evoke every kind of experience in all kinds of gardens, vividly showing the astonishing range of expressive possibilities they offer. The contrasts are extraordinary. On the one hand we have the introspective character of the Japanese garden; on the other, the exuberant, flower-filled cottage plot of the English countryside. On a rocky wind-lashed Cornish promontory a garden is fashioned, clinging to the cliffside; on the roof of a Manhattan skyscraper a similar challenge is mounted in a very different setting. Here is the great Californian collector's garden, bristling with rarities from the desolate drylands; there is Versailles, a garden planned to dominate the landscape and display the crushing power of the king. Louis XIV wrote a book describing the exact procedure for visiting the gardens at Versailles, laying down precisely what should be admired at each point – 'You leave the château by the hall in the marble courtyard. You go out onto a terrace on the uppermost step of which you must pause to admire the disposition of the parterres' – and so, relentlessly, on. This is not Hedgecoe's way. He seduces rather than dictates, darting about, camera in hand, winkling out the revealing detail, the unexpected view – trying always to seize the spirit of the place.

To almost all of us the most precious place of all is the neglected patch behind our own house. It is here, in our private domain, with its powers of solace and potential as a field of creativity that we learn to love gardens. Later, on, as we explore the creations of the masters, we begin to understand the astonishing expressive possibilities of the gardener's art. But a golden thread links them all, for they are places 'where a soul's at ease'.

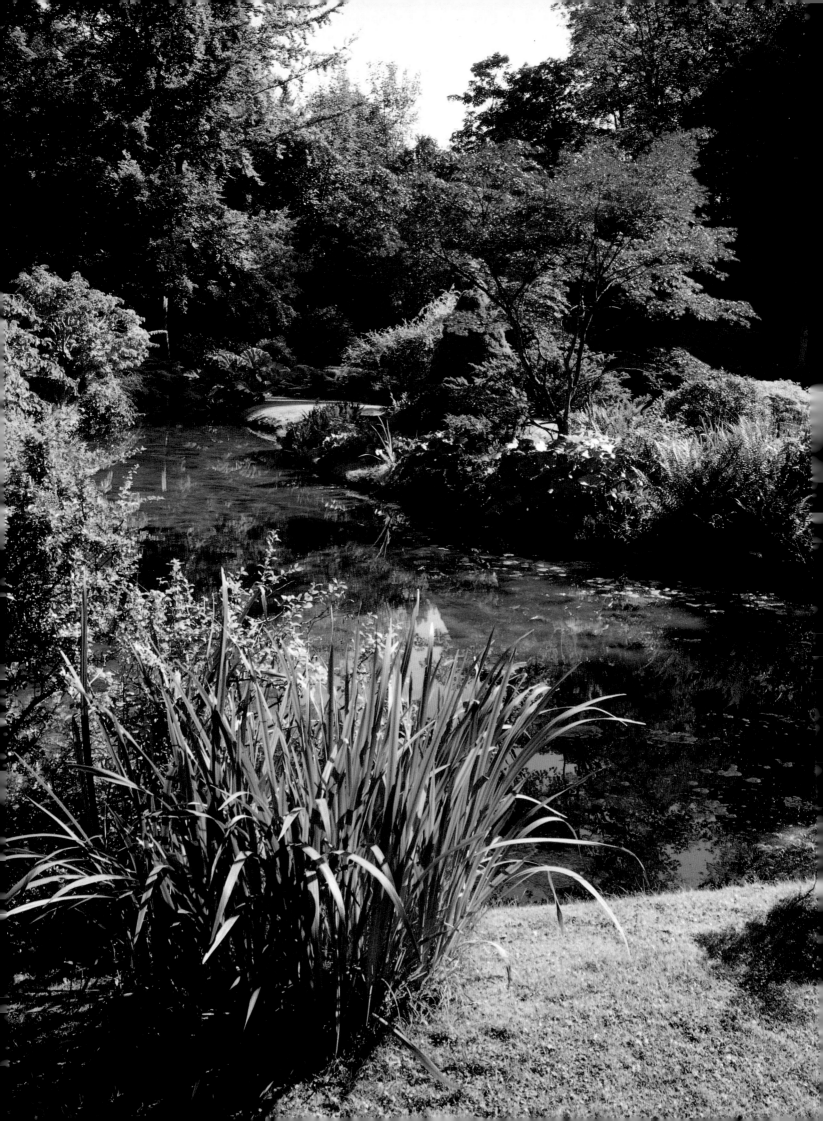

I
IMPRESSIONS
OF
WATER

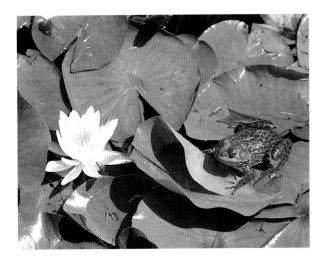

As THE ESSENTIAL MEDIUM for growing certain
plants, water has inspired gardens of very different
kinds. In this Santa Barbara garden *(opposite)*, the sacred
lotus, *Nelumbo nucifera*, scatters its soft leaves over the
surface of a lake, with vivid pink flowers rising above.
In the more intimate setting of the artist Robert Dash's
garden on Long Island *(above)*, it provides a home for
water lilies *(Nymphaea* species) – and a frog.

Water IS THE most precious of all garden
ingredients – no plant can live without water. In the
first garden of all, in Eden, it was a key element –
'And a river went out of Eden to water the garden;
and from thence it was parted, and became into four heads.' Those
four rivers are also revered in Islam and described in the Qu'ran. To
this day the Moorish gardens of southern Spain celebrate that
quadripartite division in the ubiquitous device of four rills flowing
from a central pool.

No aspect of the use of water in the garden was left unexplored
in the gardens of Islam. It was relished as a flowing force and given
movement by running over undulating or stepped channels to give
a rippling surface – the *chadar* – still found in many near-Eastern
gardens. Fountains were often of the most exquisite subtlety, with
water gently bubbling from a spout into a lotus-shaped basin or
simple pool. Huge expanses of water, in exactly the same form as

the French *miroirs d'eau* of the 17th century, were used in Andalusian palaces. To provide shade these ornate buildings had deeply overhanging eaves, and flat pools of water were carefully designed to reflect cool light into the shady interior. Such pools may still be seen in the excavated remains of the great city-palace of Medinah Al-Azahara near Córdoba, where little rafts bearing candles were floated at night to provide drifting sparks of light. The Moors were skilful hydraulic engineers; the 14th-century cisterns and pipes still supply water for the astonishing phalanx of arched fountains at the Generalife in Granada. In the heyday of the Islamic gardens in Spain, where underground irrigation systems fed water to the plants, the sunken beds were planted so that the flowers were flush with the surounding paving, creating the impression of an Eastern rug.

Ancient Roman gardens, such as at Hadrian's Villa, gave water a central place, and they were the inspiration for the gardens of the Italian Renaissance, from which most of our ideas about the use of water in gardens are derived. The explosion of inventiveness in garden design in 16th-century Italy exploited the full decorative potential of water as never before. The Villa d'Esta at Tivoli took advantage of all the latest developments in hydraulic science to power an astonishing array of fountains, cascades, water-driven organs and *giocchi d'acqua*. Renaissance gardens paid special attention to watery deities, with nymphs dwelling in grottoes, Neptune rising among sporting dolphins and Venus borne upon a cockle-shell amidst the waves.

Many of the ideas of French baroque gardens in the 17th century were derived from Renaissance Italy but carried out on a gigantic scale. Vast expanses of water were used to reflect and multiply the images of elaborate statues and urns. Fountains were built on a scale previously unknown and the problem of providing sufficient pressure perpetually taxed the engineers. At Versailles there was never enough water to supply the grandiose fountains that were one of its great features. A vast pump, the *machine de Marly*, was built by the banks of the Seine in 1680 but even that proved inadequate and when distinguished visitors toured the gardens a team of boys was recruited to turn stop-cocks on and off at critical moments to maintain the flow.

The English landscape garden in the 18th century had water as an essential ingredient. At Stourhead, the little River Stour was dammed to create the exquisite serpentine pool that lies at the heart of the garden. The placid surface of the water reflects the trees that crowd the surrounding slopes and, above all, the stately temples on its banks. The importance of water at Stourhead — and many other 18th-century gardens — is celebrated in the iconography of garden ornaments. There, a river god reclining in a moist grotto is a symbol of the source of the Stour; nearby a shivering nymph reclines on the top of a cascade. Such falls of water, more or less naturalistic, were a common feature in the 18th century and in some gardens, such as Bowood in Wiltshire or the Hermitage in Perthshire, they were given particular prominence.

The movement towards naturalistic gardening in the 19th century created a completely novel way of using water. The margins of a lake or stream provided the perfect environment for moisture-loving plants, many of them exotics newly introduced to the West. The exquisite Himalayan primulas, giant foliage of *Gunnera manicata*, and trees like the American swamp cypress, *Taxodium distichum*, require special watery conditions in which to flourish and so waterside arrangements of such plants were found in many collectors' woodland gardens in the 19th century.

Annual flowers embellish a stone urn at the Château de Courances in France — an affirmation of transitory colour in an essentially green garden of serene formality, dominated by vistas, woodland and water.

In Japanese gardens, only revealed to the West in the 20th century, water is treated with exquisite subtlety. Its ripples are symbolised by a sea of raked gravel, interrupted from time to time by a rugged rock about whose crags it swirls. The sound of water dropping gently into a pool was important to the Japanese garden aesthetic, and cunning devices of swinging bamboo pipes were made to create the random sounds of falling water. Such effects are closer to the spirit of 20th-century water features in gardens. In public places in New York City, veils of spray descend to form a cooling backdrop in public gardens, and contemporary artists like William Pye and Ian Hamilton Finlay have used water as an essential and expressive ingredient of garden monuments.

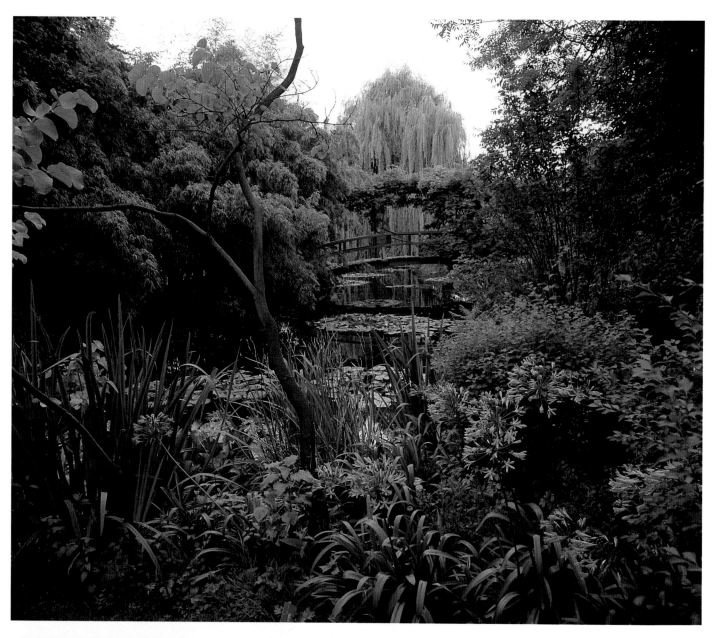

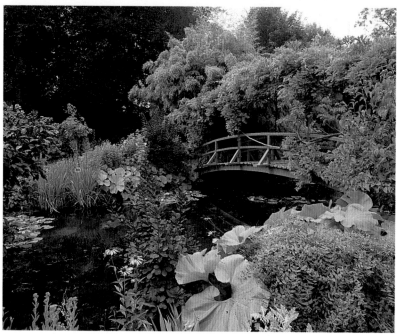

THE LILY POND at Giverny in southern Normandy *(left and above)* is the most famous feature of the mesmerising garden created by the Impressionist painter, Claude Monet, with a specific agenda – to provide himself with the ingredients and inspiration for his paintings. The pond was the setting for the great series of canvases on which he was still working when he died. An arched bridge, painted a subtle shade of green-blue and swathed with wisteria, spans the pool and provides a vantage point. The planting about its banks is richly varied, from the bold rounded shapes of *Petasites japonicus* foliage and the blade-like leaves of irises, to the sparkling blue flowers of agapanthus and the sombre purple of *Cotinus coggygria*.

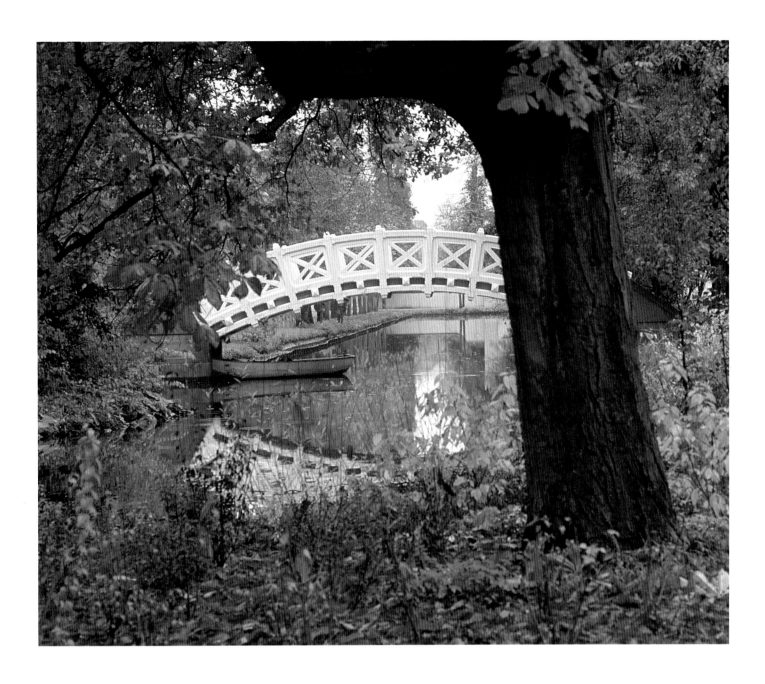

TREES, WATER and garden buildings are deployed with virtuoso skill in the princely gardens of the castle at Schwetzingen near Mannheim in Germany *(above)*. From 1776 onwards, a landscape garden in the English style was created by the designer, Frederick Ludwig von Sckell. Here, an arched bridge of Chinese inspiration glows amid the autumn foliage.

ON A MISTY winter's day at Oxnead Hall in Norfolk *(following pages)* a bridge seems to defy gravity and float in the water. This apparently ancient granite bridge was in fact built quite recently by the new owner of this historic estate. In 18th-century landscape gardens the bridge was seized upon as an essential decorative building, susceptible to great elaboration and able to hold its own with the trees and temples that also formed part of the landscape.

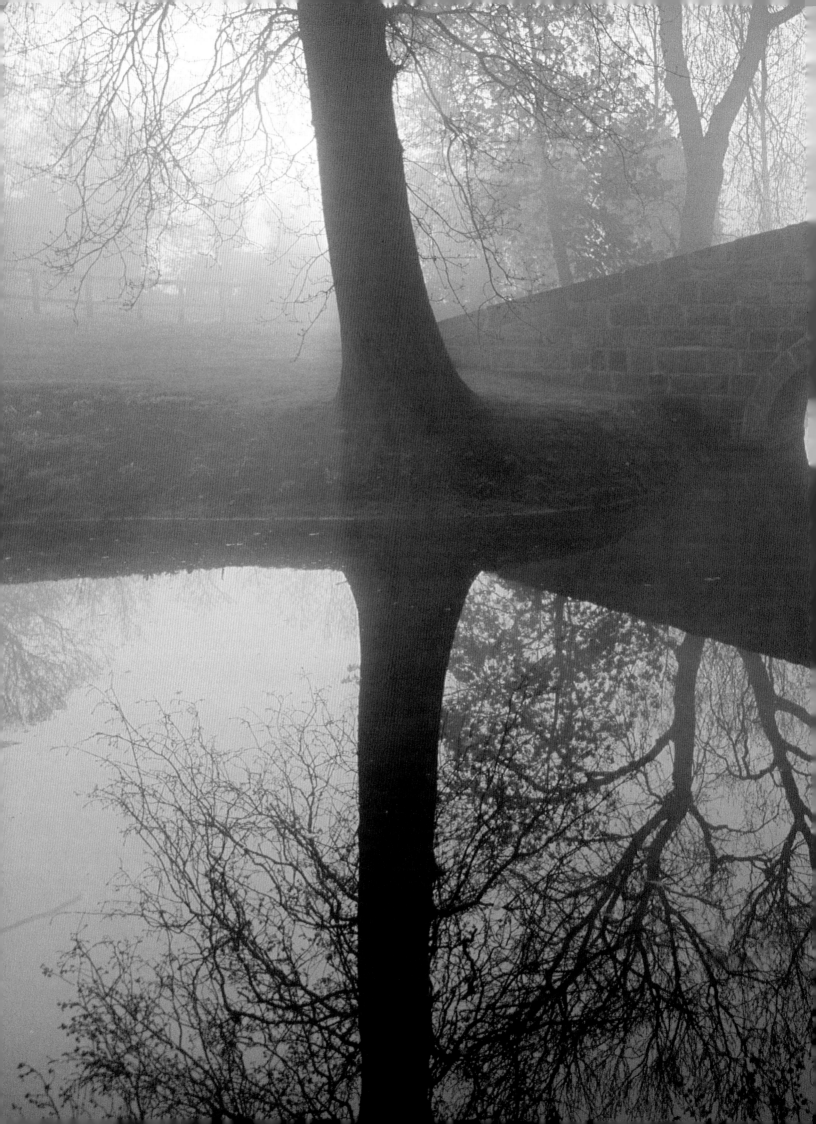

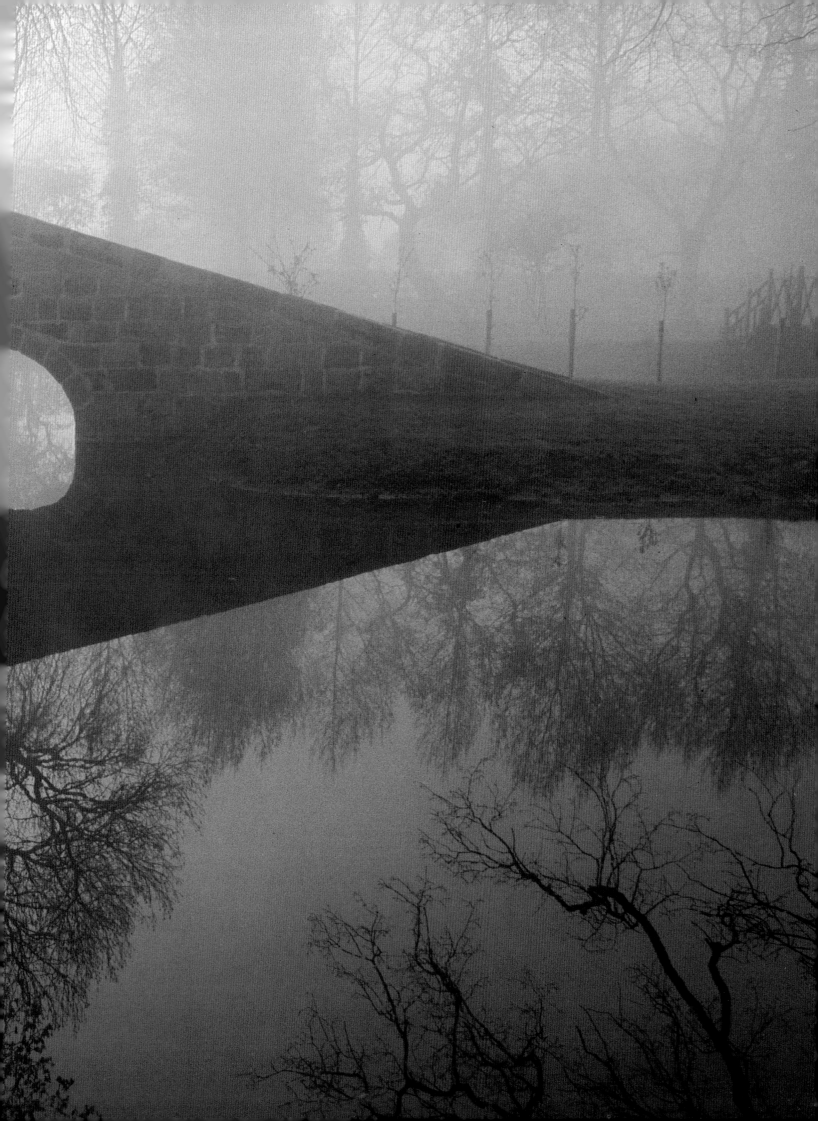

The ROMANTIC ASPECT of the former moat at Haseley Court in Oxfordshire (*above*), blurred by woodland, helps to disguise the fact that this was originally a fortified manor house (indeed, part of the fortifications remain in the moat). As in many old English gardens, features from the past endure but are given new atmosphere. Today its appearance suggests that the house dates almost entirely from the 18th century.

Water permeates the garden at the Château de Courances, south of Paris (*opposite and following pages*), and is used in every imaginable way – as formal cascades, stately canals, gushing springs and placid moats. All these are subjugated to a subtle plan with the great house at its centre; house and garden both date from the 17th century. The most memorable effects are achieved with magnificently grown trees, brilliant green turf and the sombre, reflective surface of water. There are no great rarities here and the landscape sings the praises of great deciduous trees – limes, ash, horse chestnuts, poplars, beech and oak – planted in avenues to emphasise a canal or vista. The decorative building seen here was formerly a *foulerie*, or fulling-mill.

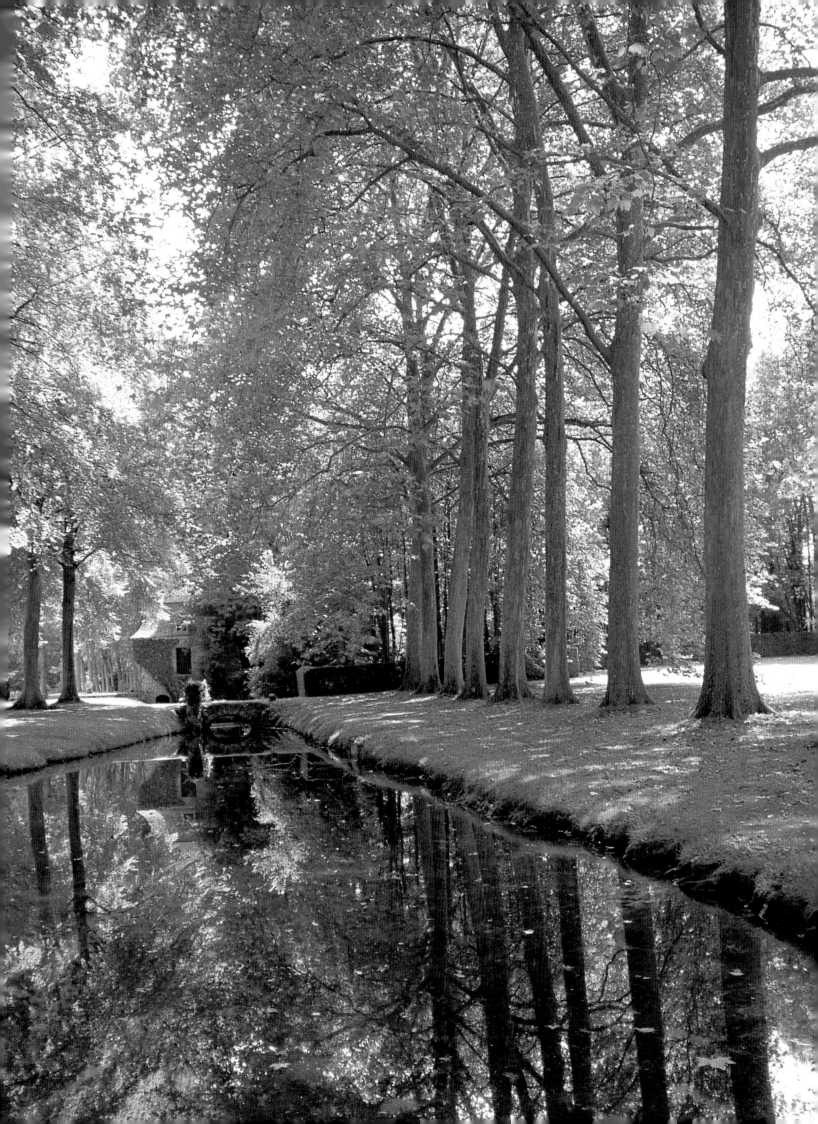

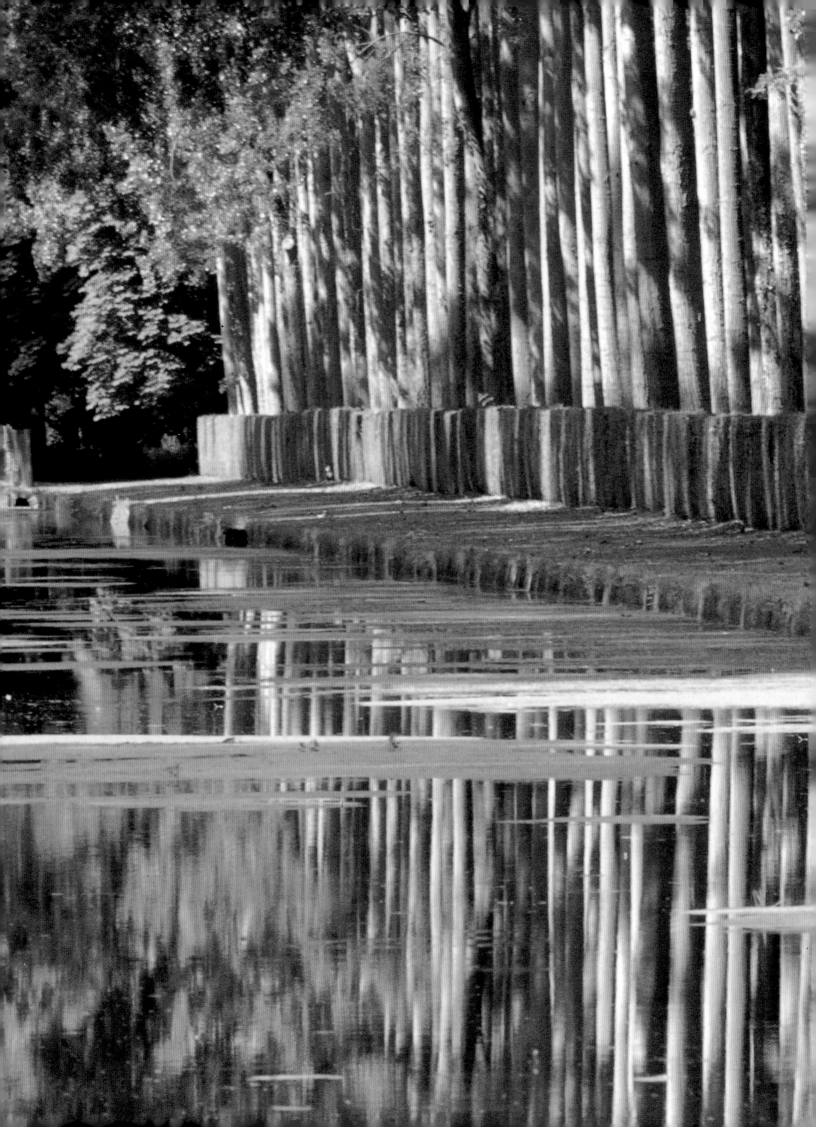

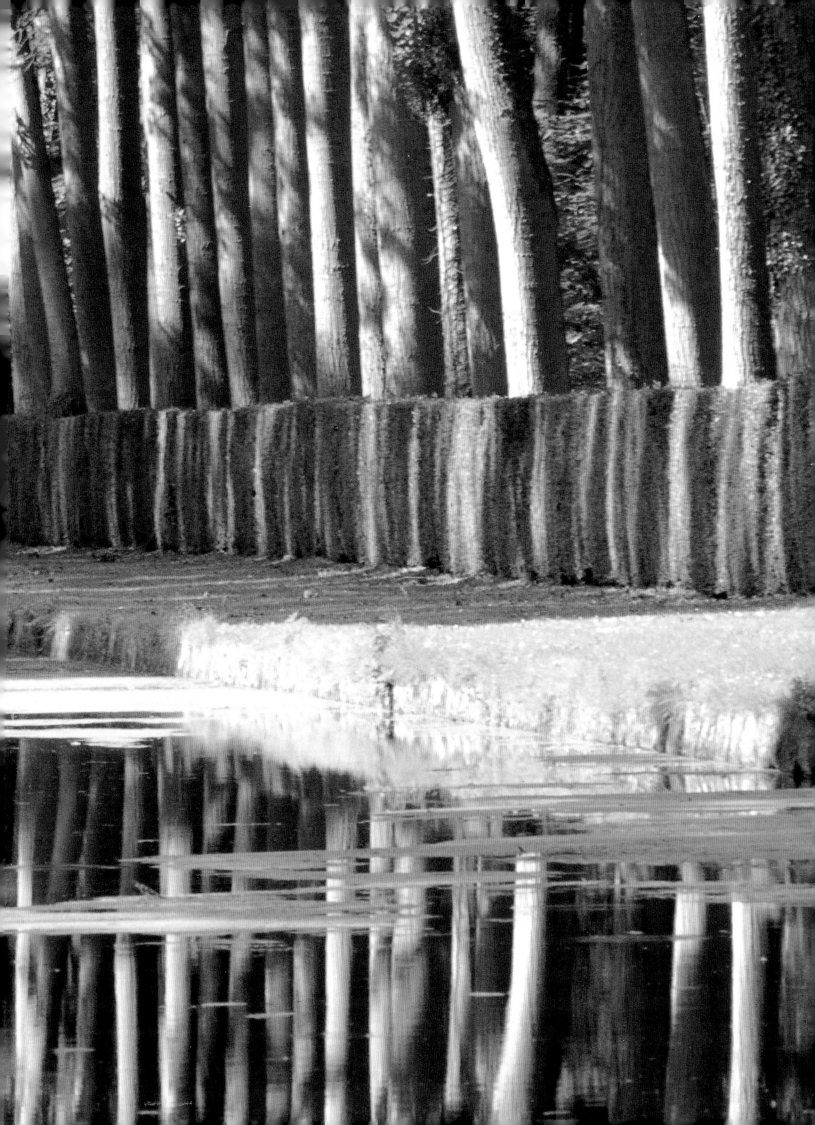

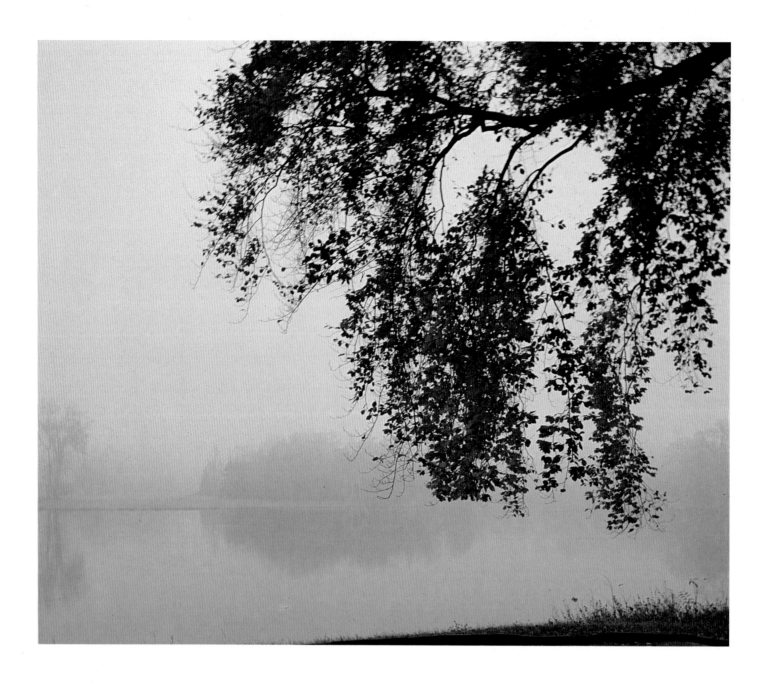

AUTUMN BRINGS the most romantic atmosphere to the immense 18th-century park at Wörlitz (above), where the russet leaves of a beech tree, *Fagus sylvatica*, sweep down to the waters of a lake. Wörlitz was the earliest landscape garden in Germany and remains one of the great adventures in garden design of its time. Started in 1765 but continuing well into the 19th century, it was created as the centrepiece of a giant landscape embracing fifteen miles of the banks of the River Elbe, with canals and lakes fed by its waters. Over 100 acres survive and other parts of the original, larger scheme are still to be seen at the Park Georgium and Park Luisium. Since the unification of Germany these treasures of the landscape movement are more accessible to garden lovers.

GARDENS OF FORMAL spirit show their essential character to great advantage in winter, stripped of the superficial ornaments of flowers and deciduous foliage. In the 16th century, Oxnead Hall in Norfolk (opposite, above) had a great terraced garden taking full advantage of its setting on the banks of the River Bure. Stourhead (opposite, below) in Wiltshire is often thought of as the most perfect 18th-century garden. It was begun in the 1740s by a banker, Henry Hoare II, one of those gentlemen-landscapers who have made such a vital contribution to the art of gardening. At its heart is a lake, created by damming a stream, about whose sinuous banks are distributed exquisite temples. Here, the domed Pantheon is glimpsed through the autumn foliage.

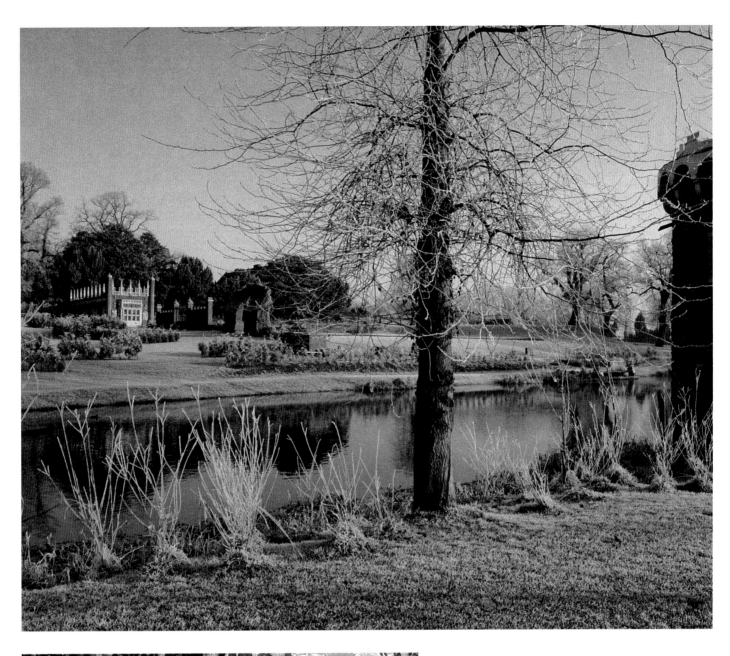

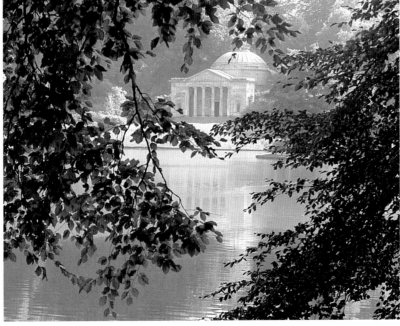

WATER, ACCORDING TO the great
20th-century gardener Russell Page, has three
functions: sound, movement and reflection. Here
(*following pages*) a weathered, lichened statue
contemplates the symmetrical outlines of pyramidal
trees mirrored in the still waters of a lake.

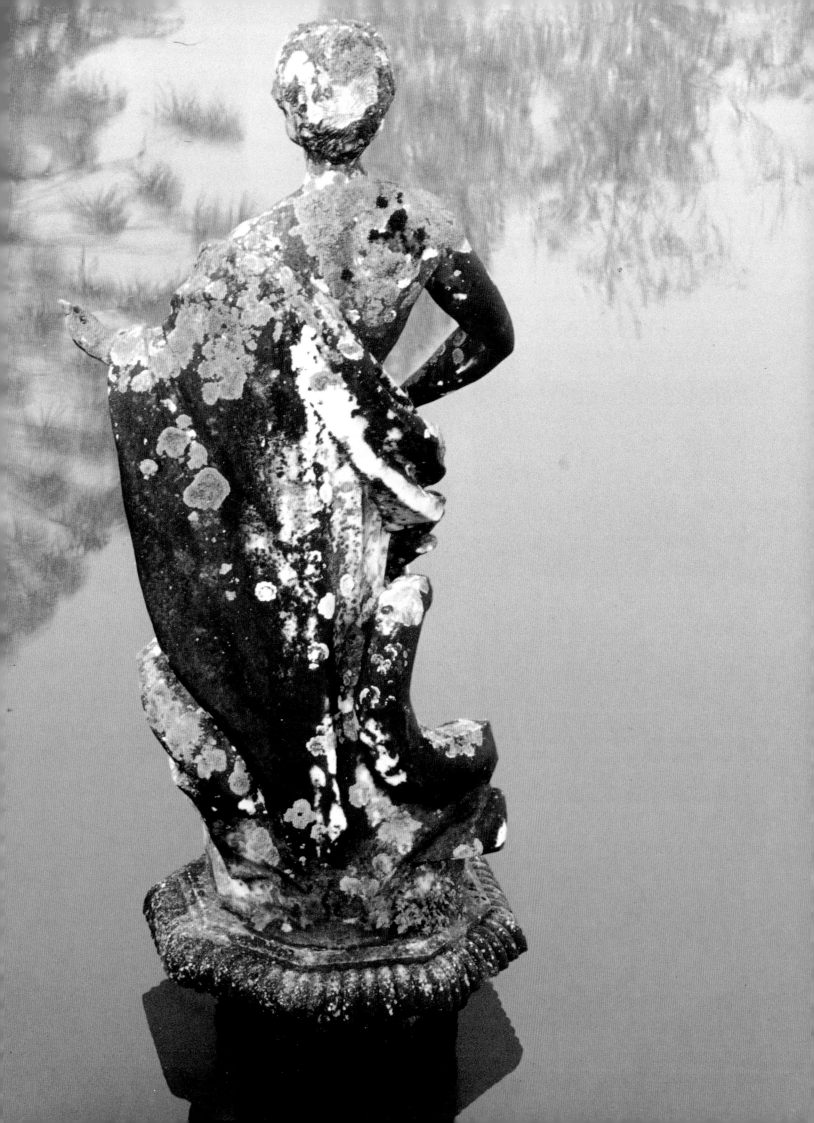

LILY PADS FLOATING on the surface of still water *(below)* always convey a sense of repose. The true water lily, species of *Nymphaea*, is found all over the world. In the second picture the foliage on the right is that of the tender sacred lotus, *Nelumbo nucifera*, whose flowers, rising well above the leaves, are deliciously scented.

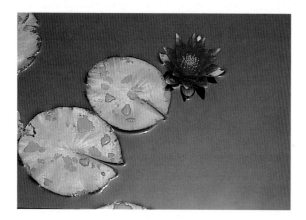

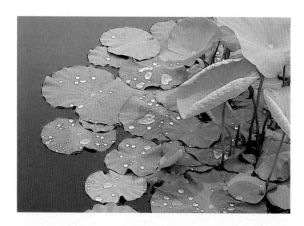

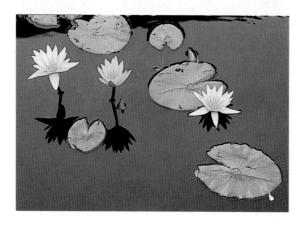

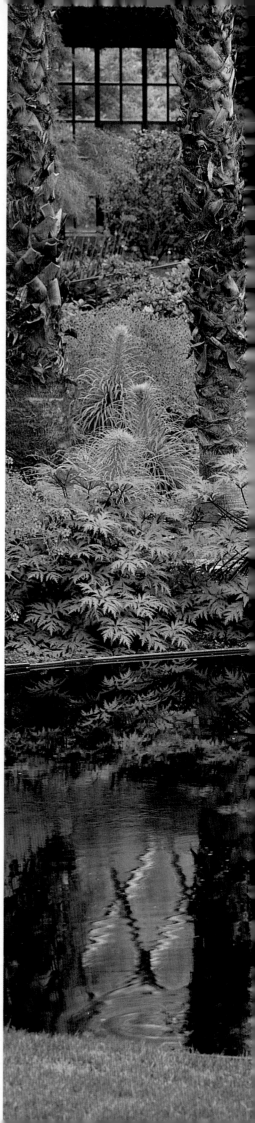

THE ELABORATE water gardens at Longwood in Pennsylvania show the eclectic North American tradition at its liveliest *(opposite)*. One of the great showplaces of US horticulture, founded in 1906 by the Du Pont family, the gardens now embrace over 1,000 acres. Bronze cranes (a symbol of longevity) are often found in traditional Japanese gardens, usually placed in the shallow waters at the edge of pools. Bedding pelargoniums fringe the edge of the water and are also hung in baskets on the trelliswork. Under the gnarled trunks of date palms are the purple flowers and architectural foliage of the Madeira cranesbill (*Geranium maderense*). Beyond it on the right is an underplanting of the Chusan palm, *Trachycarpus fortunei*, whose fan-shaped leaves are strikingly ornamental.

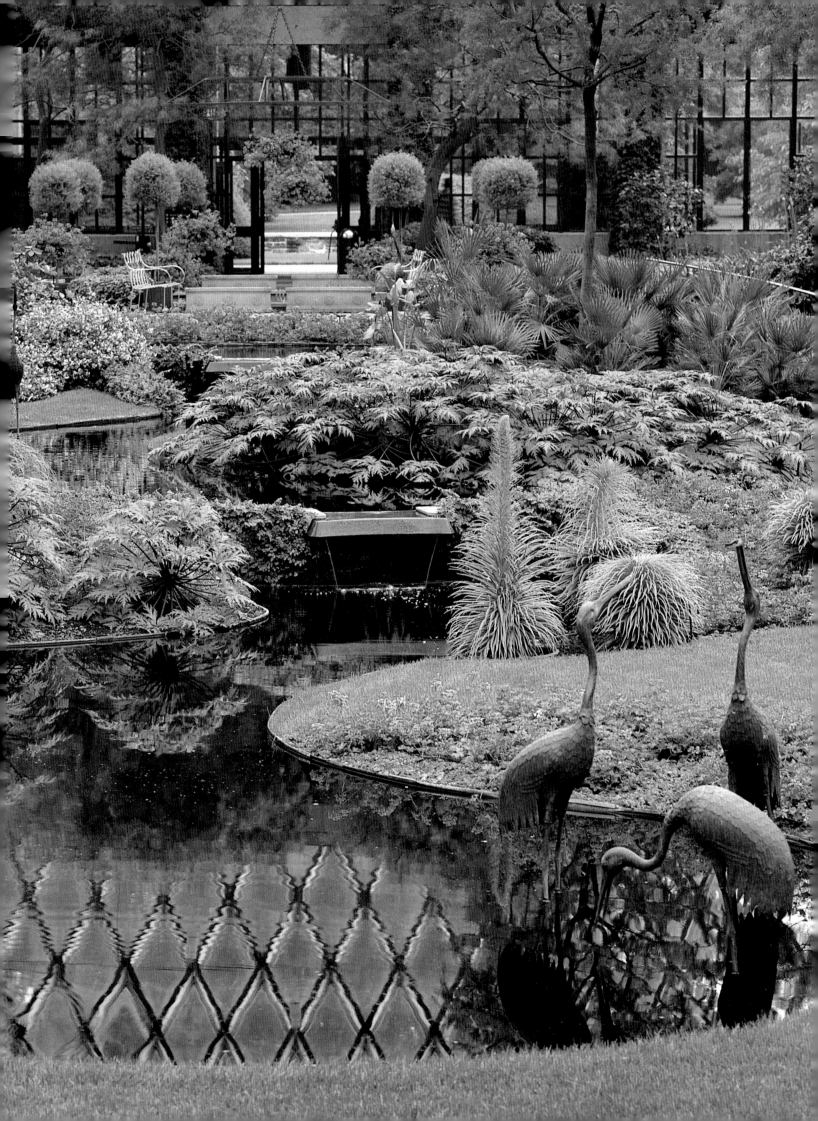

THIS CIRCULAR POOL of classical simplicity at Longwood would not look out of place in a French garden of the 17th century, with its plain *jet d'eau* ruffling the surface of the water. But it is lined with modern pavers and edged with sharp white marble, and the planting is in the tradition of 19th-century municipal parks. Mop-headed, grafted *Buddleja alternifolia* rise out of regimented ranks of pink busy-lizzies (*Impatiens* cultivars). This swashbuckling way of gardening has liveliness and colour in the context of a public park — but would it work in a small private garden?

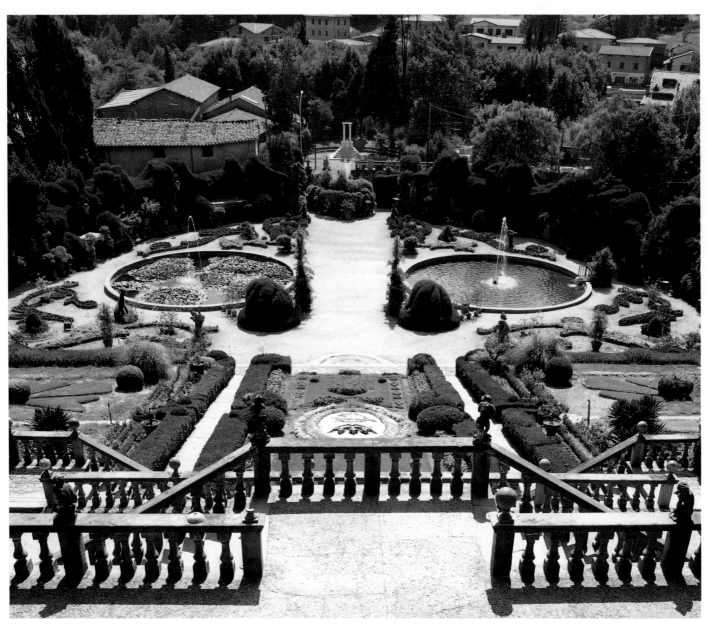

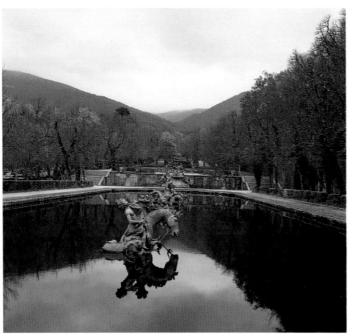

THE FORMAL USE of water lends itself to
strikingly varied treatment in different traditions.
The garden at Villa Garzoni in Tuscany *(above)*,
dating chiefly from the 17th and 18th centuries,
bristles with ornament, amongst which two circular
pools provide a calm contrast. The royal gardens of
La Granja in Spain *(left)* were built by King
Philip V, inspired by memories of Versailles where
he spent his childhood. An immense sheet of water,
forming a mirror-like surface and decorated with
exuberant baroque statues, is the culmination of a
series of flights of steps. A similar effect is achieved
at Old Westbury Gardens, Long Island *(opposite)* but
here the formality is softened by abundantly planted
borders. Built at the turn of the century by the
Phipps family, Old Westbury was a conscious
evocation of a 17th-century English estate.

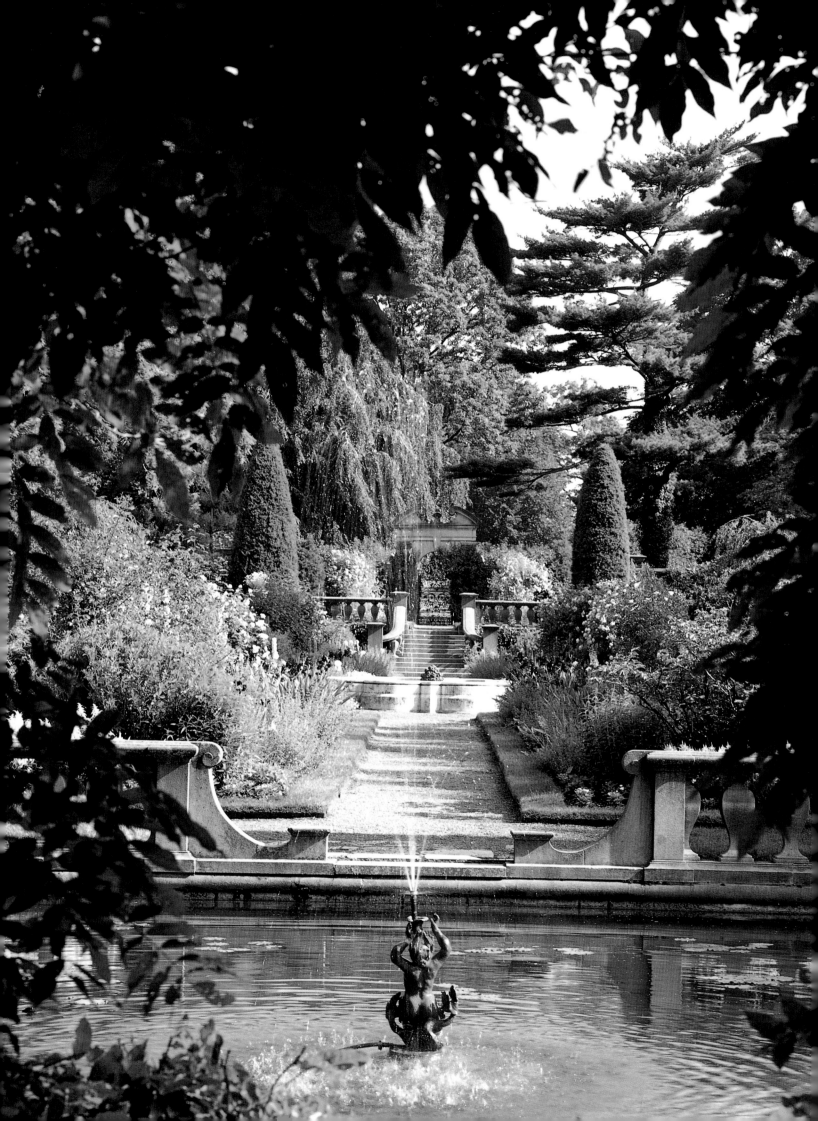

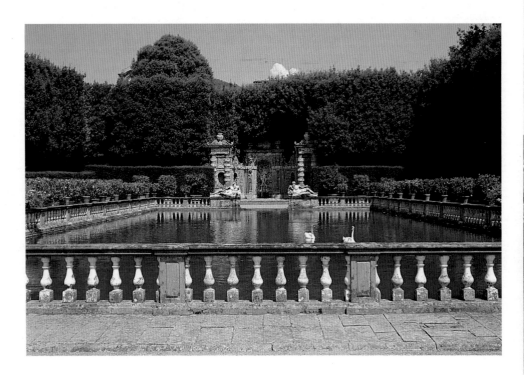

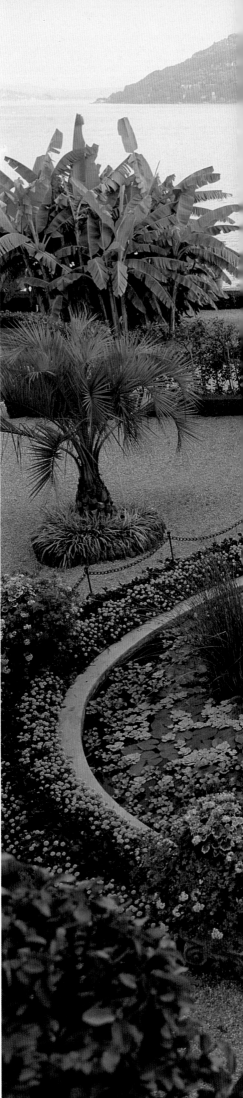

A BALUSTRADED FISHPOND at the Villa Reale near Lucca in Tuscany *(above)* is edged with lemon trees, and two figures of river gods, symbolising the rivers Arno and Serchio, recline at its edge. The elaborate screen behind them, with intricate rustication, has as its centrepiece a figure of Leda and the Swan set in a grotto-like niche; real swans guard the pool to this day. This splendid garden has had a chequered life, changing owners many times. It has always had its admirers, ranging from the 16th-century writer Montaigne to the 19th-century artist John Singer Sargent, who painted atmospheric watercolours of the garden. He was especially attracted by the enclosure shown here.

A DREAM-LIKE ISLAND GARDEN was contrived by the Borromeo family on the precipitous slopes of Isola Madre in Lake Maggiore in northern Italy *(opposite)*, in which naturalistic groves of exotic trees run down to formal arrangements by the shore. Here the surface of a circular pool is almost obliterated by water lilies. The Borromeo were great patrons of architects and gardeners, and from the 17th century embellished their islands with stately villas and gardens. Isola Madre is one of a group known as the Borromean Islands off the north-western shore of the lake. An English priest, Bishop Burnet, visited them in the 17th century and recorded that they 'are certainly the loveliest spots of ground in the world'.

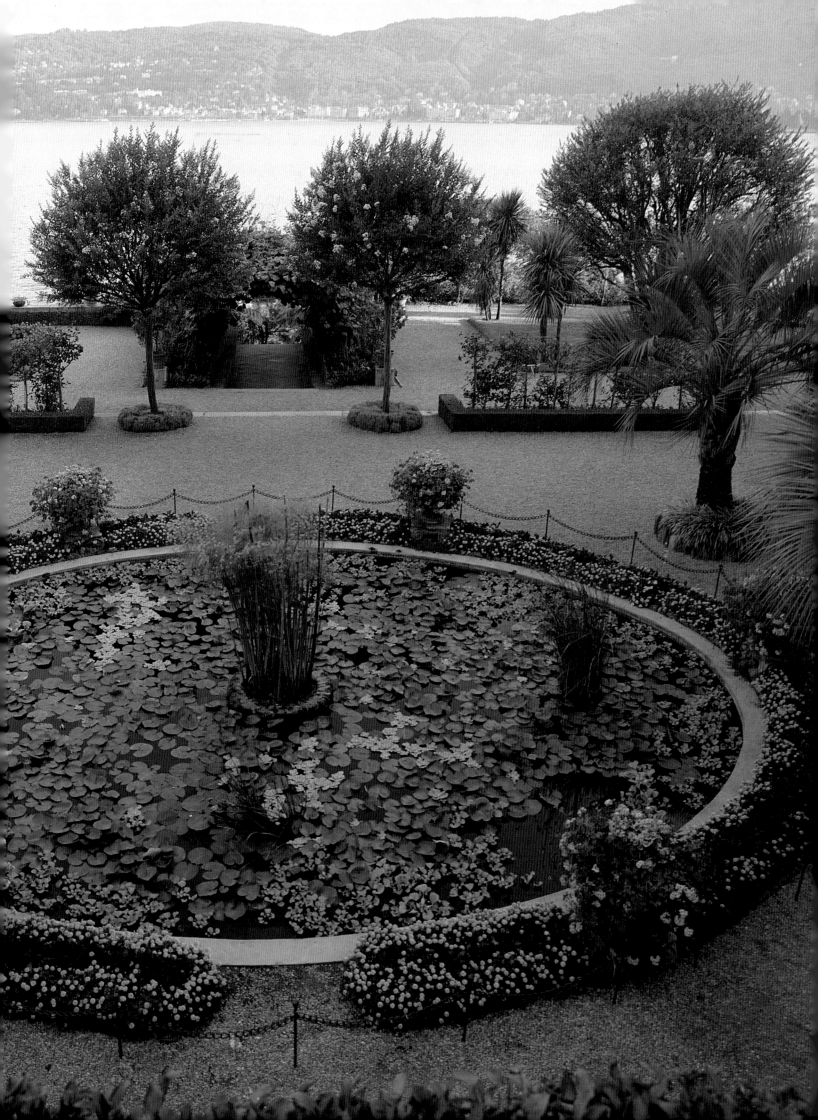

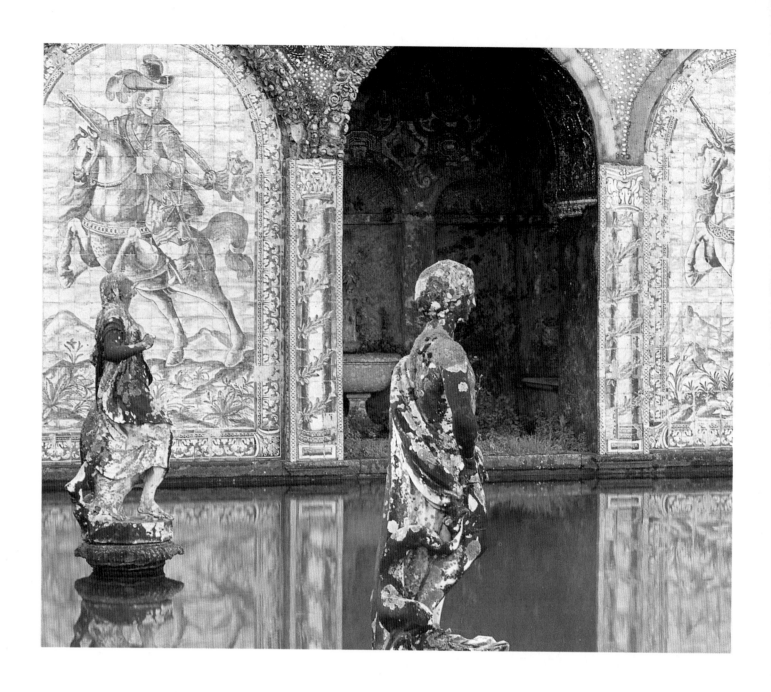

In THE ARCADES of the lake house at the Palácio da Fronteira in Lisbon *(above)*, ceramic tiles, at which the Portuguese excel, are used to marvellous decorative effect. The gardens, laid out in the 1660s by the Marquês de Fronteira, were deeply influenced by the gardens of the Italian Renaissance but interpreted in a distinctively Portuguese fashion. They have a lively character, like a backdrop for one of Mozart's more light-hearted operas. The gardens also show the strong influence of the Islamic tradition. At the garden of the Villa San Remigio on the banks of Lake Maggiore *(opposite)*, the highest terrace is full of watery imagery. Venus (born from the sea) rises from cockle shells and dolphins frolic in the niches behind her. The house was built in the mid-19th century in the style of a Swiss chalet by an English diplomat, Peter Browne. In the early 20th century his grand-daughter, who had married a Neapolitan aristocrat, Silvio della Valle di Casanova, built a new villa in the traditional style and had the garden remade in the Renaissance fashion.

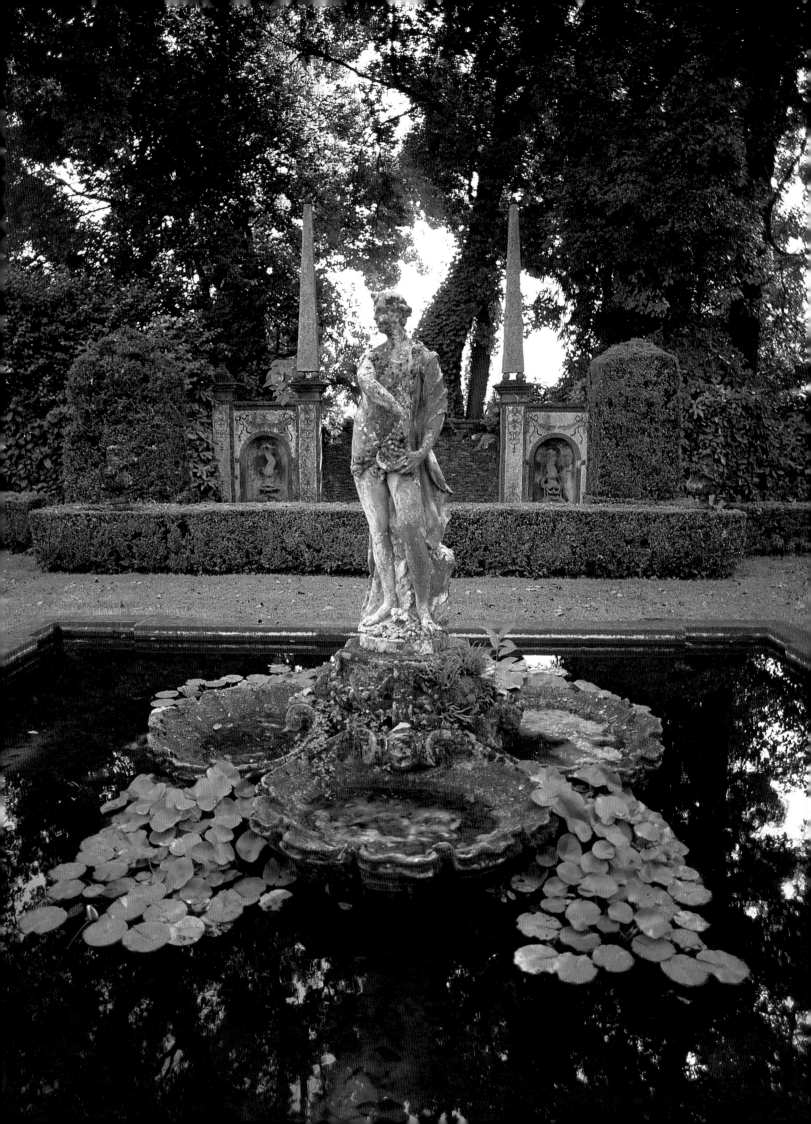

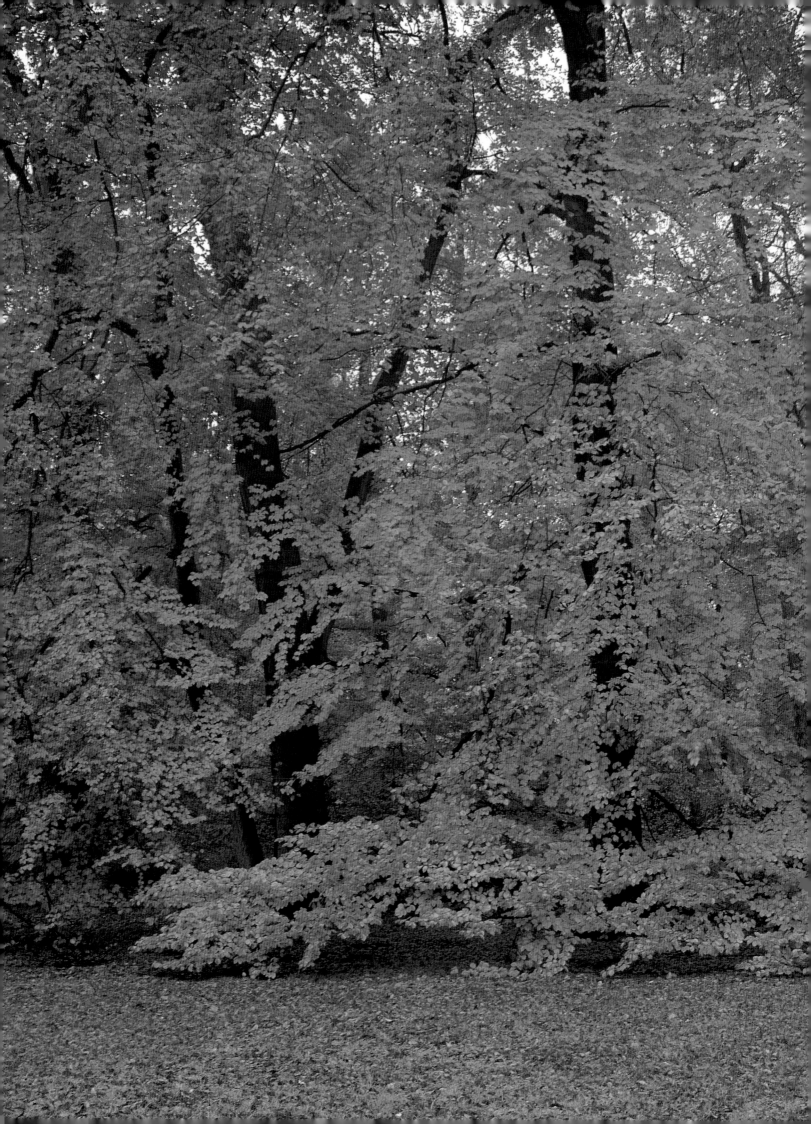

II
TREES
AND
WOODLAND

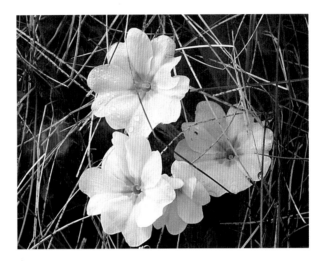

A LOVELY FLOWER of hedgerows and woodland, the wild European primrose, *Primula vulgaris (above)*, has a subtle scent and beautiful pale creamy-yellow petals. In Somerset, primroses are known as 'darlings of April'. Then, when the flower garden has produced its last delights, woodland trees *(opposite)* clothe themselves in the gold and russet colours of autumn.

TREES ARE FUNDAMENTAL to any garden – woodland is a key element in gardens on the grand scale. Used either formally or informally, or as the appropriate context of naturalistic plantings of shrubs, bulbs and perennials, it is only completely convincing in a large area. Woodland was also the setting for a more contrived style of gardening. The wood as the abode of nymphs and deities occupies a central place in Western mythology. In the Italian Renaissance, with its rediscovery of the non-Christian tradition, the *bosco*, with its mythological undertones, was an important feature of many gardens. Although the main garden was geometrical, crisply linked by an axis to the house, there was often an informal garden of groves alongside it where symmetry was banned and winding walks led through a shady wood. In some rare cases, such as the extraordinary 16th-century Sacro Bosco of Bomarzo, it was the mysterious woodland itself that was the chief focus of the garden.

In the 17th century the gigantic layouts of French baroque gardens, such as those at Versailles or Fontainebleau, used formal groups of trees, or *bosquets*, as an essential part of the garden vocabulary. This style of woodland gardening was still practised in the later baroque gardens, like that at Schloss Schwetzingen made in Germany in the 18th century. But by that time one of the greatest revolutions in the history of garden taste was knocking at the door. The English landscape movement used woodland, with water and turf, to recreate an idealised naturalistic landscape, with distant temples rising on promontories and statues of nymphs and Diana, the goddess of hunting, lurking among the trees. Although a distinctive English style, the roots of this movement were in Italy. For it was the romanticised 17th-century paintings of the Roman *campagna* by Poussin and others which inspired the revolution. These paintings were eagerly collected by aristocratic Englishmen on the Grand Tour and the landscape itself was visited and studied.

The English landscape style in the 18th century was, after the French baroque style of the previous century, the second fashion in gardening to take the world by storm. Even in France it inspired a host of imitations, although *le jardin anglais* often seems as little English as the *Englischer Garten* in Germany, where it was equally popular. Many of the most beautiful woodlands and finest specimens of trees found in European gardens are relics of this universal style. Landscapes such as Aschaffenburg or Sanssouci in Germany owe much of their beauty to these lovely old survivals.

The interest in woodland itself, either as a convincing way of displaying a collection of trees or as the context for other naturalistic planting, is a much more recent development. That extraordinary polymath Thomas Jefferson counted gardening among his chief passions. As American minister to France in 1786, he used any spare time to visit gardens, admiring especially the new informal style in England – 'The gardening in that country is the article in which it surpasses all the earth. I mean their pleasure gardening. This, indeed, went far beyond my ideas.' When he returned to Monticello he knew better than to ape English styles; instead he laid out an informal woodland grove more appropriate to the climate of Virginia and to his own taste. Here he gathered together native and exotic trees, among them hickories, maples, ash, chestnuts and oaks. Under this tall canopy he grew clumps of shrubs including broom, calycanthus, magnolias and the native north-east coast fringe tree, *Chionanthus virginicus*. In this way, using a variety of woody plants as his artistic medium, he painted a landscape picture. In the early 19th century it became a much admired feature of the garden at Monticello.

The flow of new trees and shrubs into Europe in the 19th century gave impetus to a style of woodland gardening in which these new treasures could be given a suitable setting. Conifers from the Pacific north-west and flowering shrubs from the Himalayas were two groups of plants that transformed European garden taste in this period. The botanical collector, who desired specimens of every species, joined hands with the gardening aesthete whose chief desire was to use these new plants as the ingredients of a harmonious landscape with spectular results.

In England in the early 19th century the dominant garden theorist was John Claudius Loudon, whose *Encyclopaedia of Gardening* (1822) was among the most-used reference books of the day. His response to the influx of new plants was to develop the theory of the 'gardenesque', among the tenets of which was the

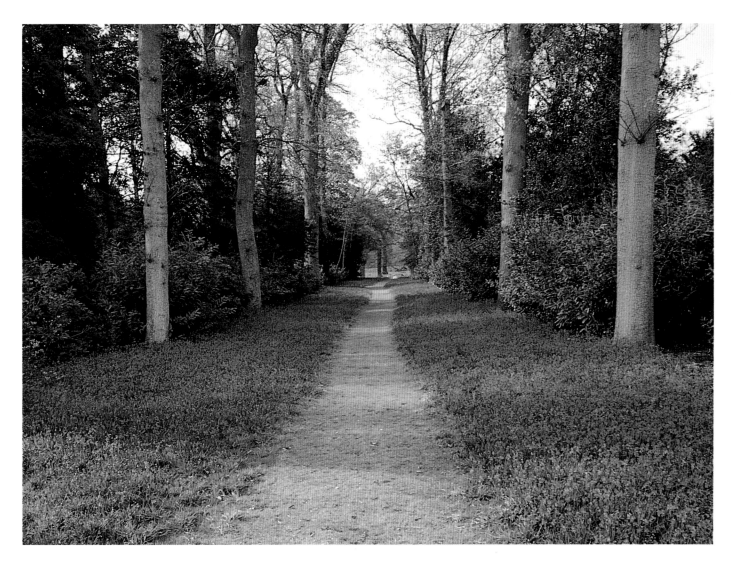

Spring is the greatest season for woodland flowers, and European bluebells never fail to stir the heart. At Blickling Hall in Norfolk, they carpet the ground under trees along a grassy pathway.

display of trees and shrubs as single specimens in lawns so that their special qualities could be admired in lonely splendour. He recommended winding walks and sweeping beds as an appropriate setting for these specimen plants. The Irish gardener and writer, William Robinson, set down the principles behind a more natural approach to gardening. *The Wild Garden* (1870) was one of the best-selling gardening books of the day, urging gardeners to use hardy plants only and to dispose them in a naturalistic way. His associate, Gertrude Jekyll, in her book *Wall, Water and Woodland Gardens* (1902), included a chapter entitled 'When to Leave Well Alone', recommending that, if you are lucky to possess a piece of natural woodland, you should do almost nothing to it all.

In more recent times, all these tendencies have had their effect on garden design. The passions of aesthete and collector have rarely been so closely intertwined as they were in the person of Lionel de Rothschild. Between the wars he embarked on a simple plan at Exbury House in the south of England – to build up a complete collection of every tree and shrub hardy in the British Isles. He recruited 150 men to prepare the ground and employed 70 full-time gardeners. This, and many other great private gardens, never recovered from World War II. Woodland gardening on this scale moved from private to public patronage. Today, it is for the most part the great public and botanical gardens which foster the study of trees and shrubs, and maintain ornamental woodland for our pleasure and enlightenment.

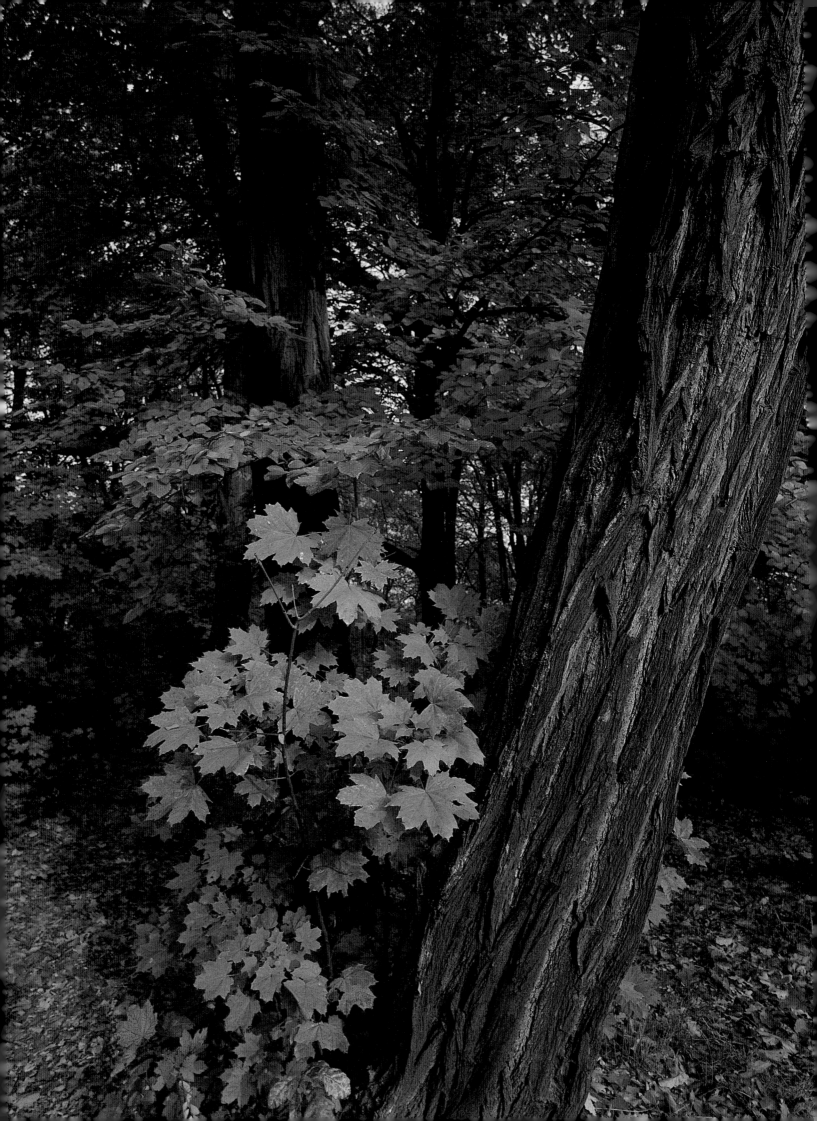

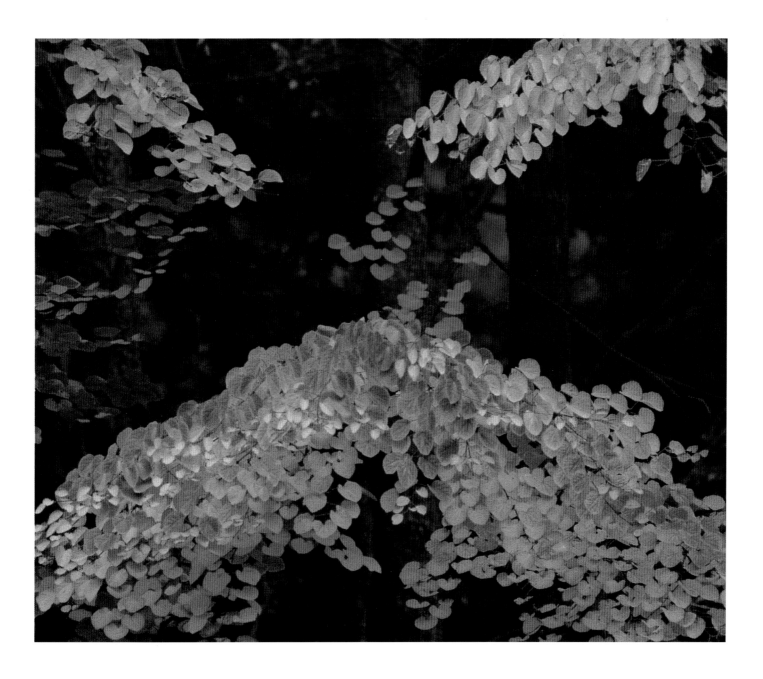

THE FISSURED TRUNK of a European hornbeam, *Carpinus betulus (opposite)*, is one of its most striking characteristics. In autumn, the toothed leaves turn a warm golden yellow, making a brilliant ornament. At the foot of its trunk is a seedling sycamore, *Acer pseudoplatanus*, one of only three native European maples. The wood of the hornbeam – 'the hardest, heaviest and toughest of our native woods', as the tree connoisseur, Henry Elwes, called it – is used for many purposes, among them, the moving parts of a piano's hammers and the boss of carriage wheels. The katsura tree, *Cercidiphyllum japonicum (above)*, a broad bushy tree of great character, was introduced to Europe from Japan in the 19th century. In autumn the graceful, downward-sweeping branches with veils of shapely leaves typically take on rich butter-yellow colours. However, the distinguished gardener, Mark Fenwick, aptly observed of them, 'One never knows... what colour they will assume. Here, they are seldom all red or all yellow, but generally assume shades of red, orange, pale yellow, pale pink and green.'

A GREAT HORNBEAM, *Carpinus betulus*, flaunts its russet foliage in autumn in the Charlottenhof Park at Potsdam near Berlin *(above)*. This immense landscape garden in the English style was added by Peter Josef Lenné in the early 19th century to the 18th-century Park Sanssouci. 'Sanssouci' means 'carefree', which gives some idea of the spirit in which the Emperor Frederick I of Prussia embarked on his great enterprise in 1715. The garden was in the baroque style of the day, but as it developed it followed the changing fashions of its time. Charlottenhof is decorated with fine garden features in the classical taste – a Roman bath and a poet's grove – but its greatest charm for the visitor today is the magnificent mature woodland.

THE ROMANTIC landscape garden at Aschaffenburg in central Germany *(opposite)* was laid out on the banks of the River Main by the Elector and Archbishop of Mainz, Friedrich Karl von Erthal, from 1785. It was designed jointly by Wilhelm von Sickingen and an architect, Josef Emanuel d'Herigoyen. A little later, the landscape architect F. L. von Sckell added many features. The park is rich in ornamental buildings, and a chief vista takes in as a spectacular eye-catcher the Johannisberg, the old archbishop's palace, perched on a distant height on the far side of the river. One of the great attractions of historic gardens in Germany is the varied styles to be found in the huge numbers of formerly independent principalities, each with its own distinctive atmosphere.

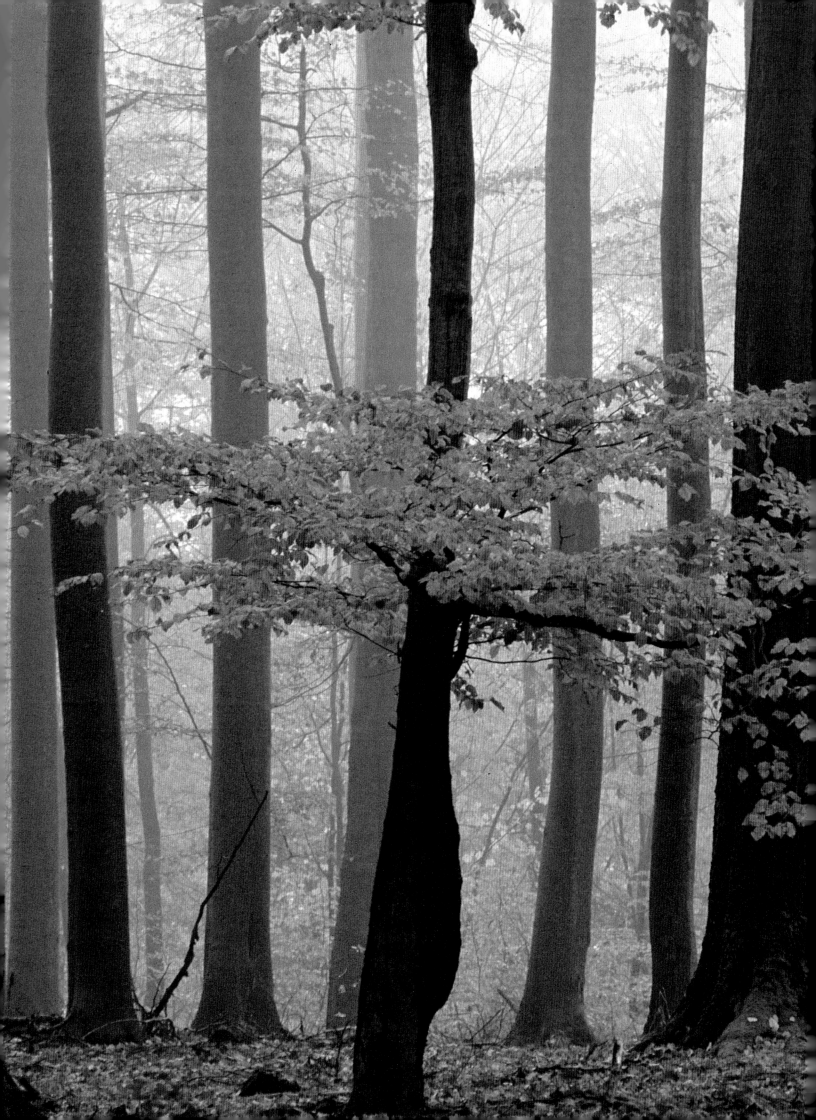

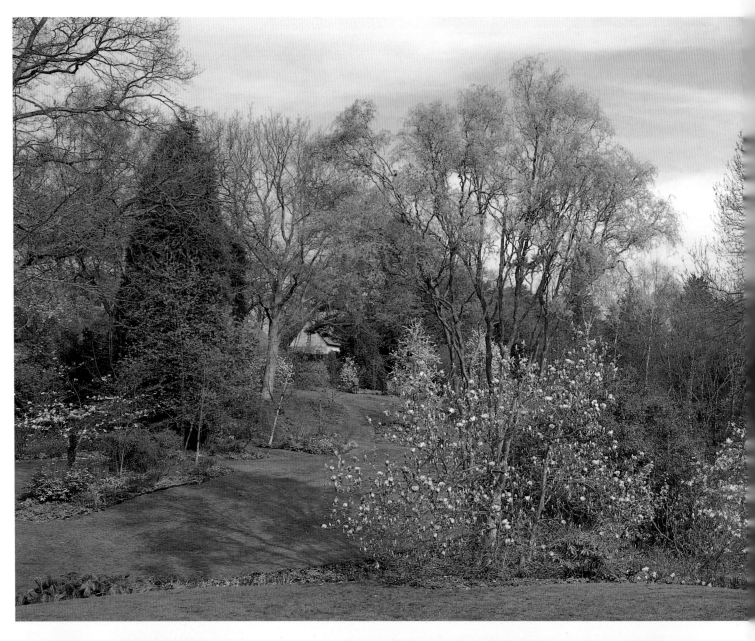

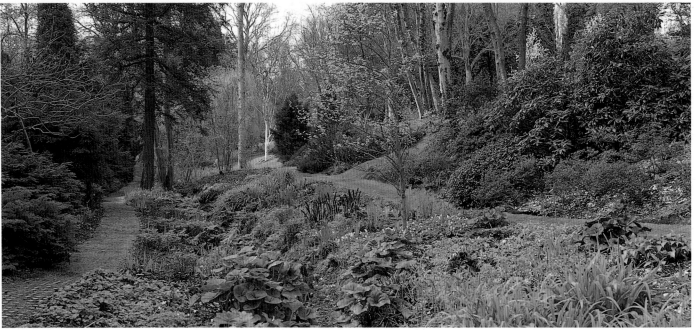

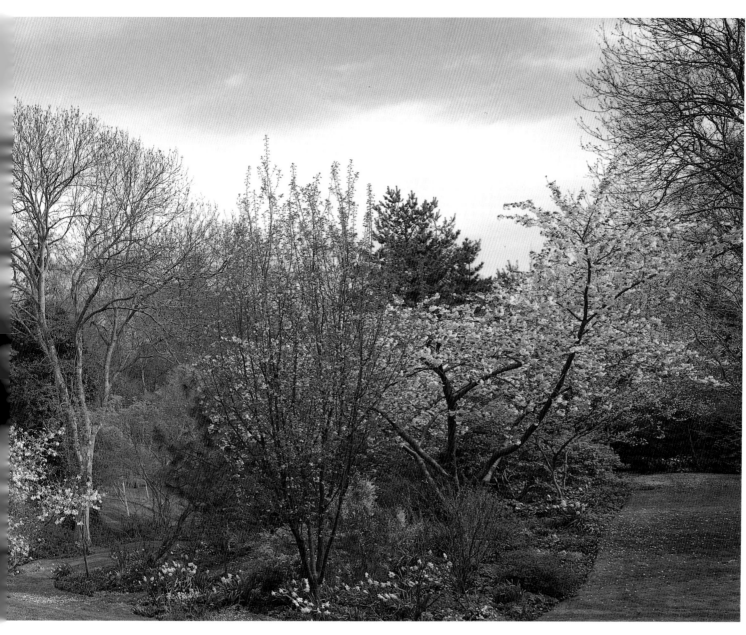

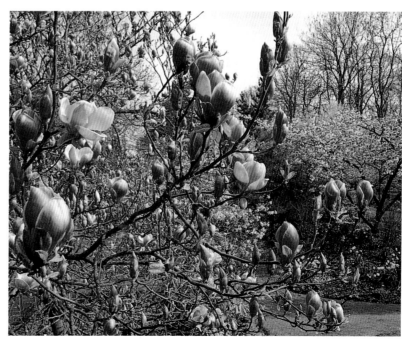

AN IMMENSE COLLECTION of woody and herbaceous plants has been disposed in an idealised naturalistic landscape of great charm by the Princess Sturdza at Le Vasterival, quite near the coast in Normandy. Magnolias *(above and right)* make a dazzling display early in the year when the foliage of other trees is just beginning to break. Grassy plants wind along the contours of the land, threading their way between groups of plants. At a glance, much of the planting seems made by the hand of nature, but *(left)* among the fresh new leaves of spring, a rhododendron's vivid dab of purple shows the gardener at work.

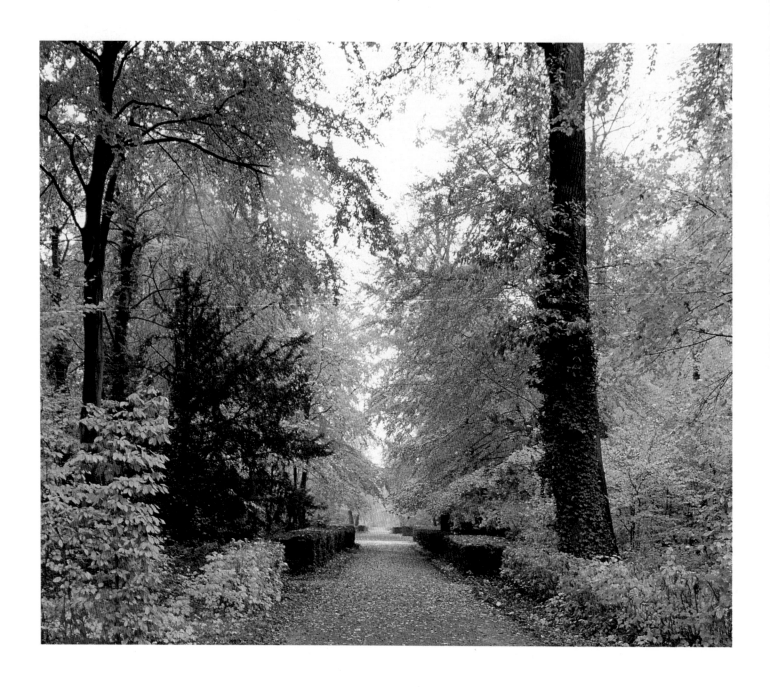

T HE AVENUE OF TREES, or *allée* cut through woodland, remains one of the most
powerfully atmospheric expressions of the gardener's vocabulary. At Schloss Schwetzingen
near Mannheim *(above)*, passages pierce formal woodland to provide exhilarating vistas.
Built as the summer palace of the Electors of the Rheinpfalz, the garden was embellished
with an English-style landscaped park designed by F. L. von Sckell in the late 18th
century. At Marsh Lane in Essex *(opposite)*, an idiosyncratic and powerfully expressive
garden capitalising on the bold architectural shapes of fine trees was created by the English
architect Sir Frederick Gibberd, a fanatical amateur gardener on the grand scale. He
enlivened the woodland with statues and architectural fragments.

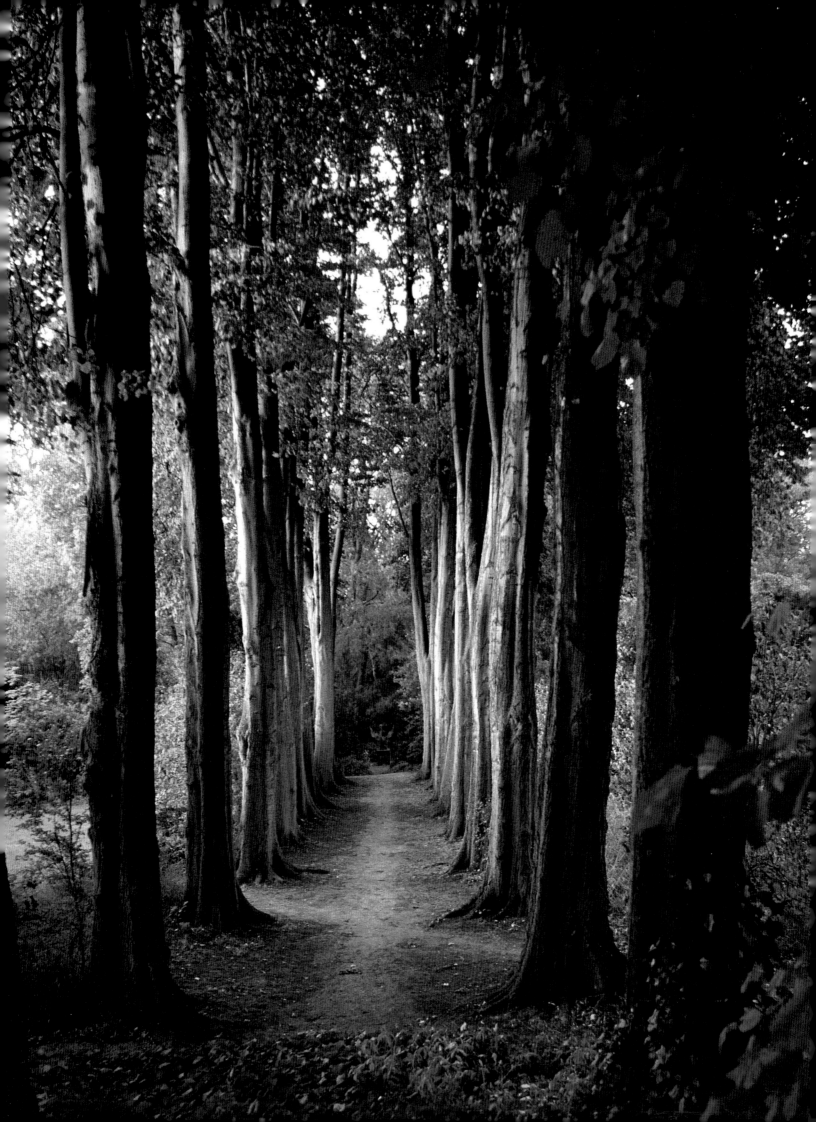

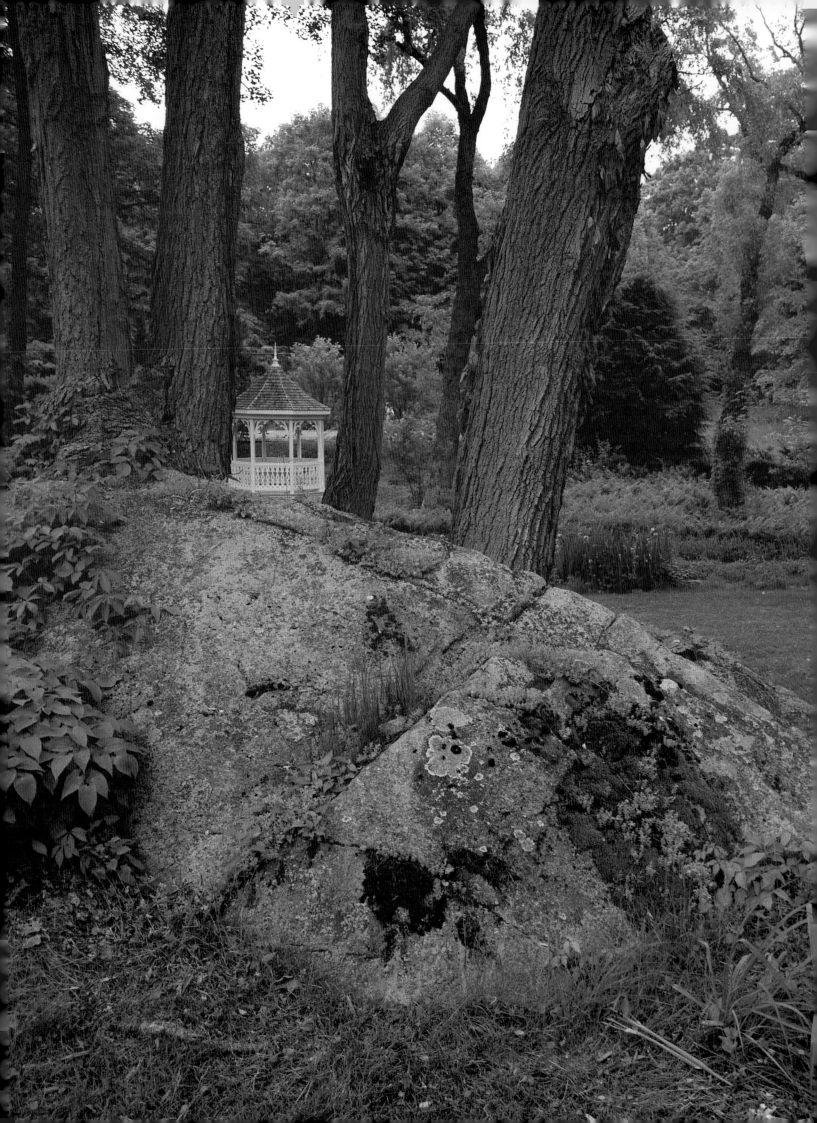

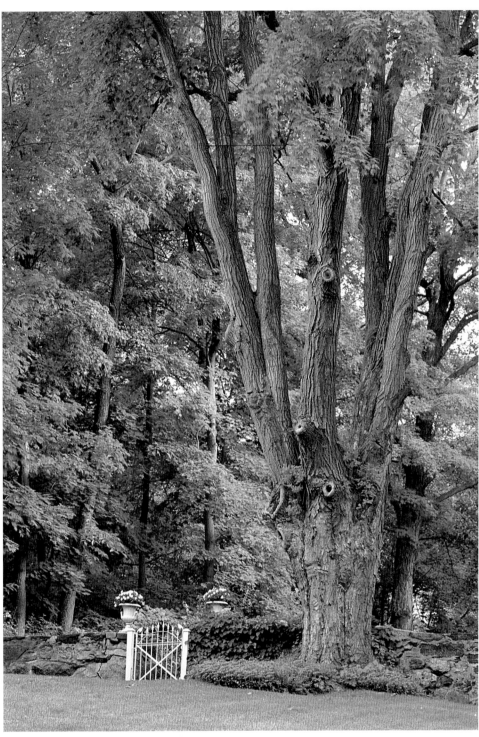

THE USE OF native trees in American gardens has an ancient and honourable history.
At White House, Connecticut *(above and opposite)*, much of the flavour of the place comes
from American native plants. An immense sugar maple, *Acer saccharum (above)*, which has
been pollarded at some time in its life, has an unforgettable presence. In autumn, its
foliage, turning shades of orange, gold, crimson and scarlet, is one of the great ornaments
of New England. The beautiful white Virginian fringe tree, *Chionanthus virginicus* on the
right of the picture *(opposite)*, flaunts its white flowers in spring. Thomas Jefferson loved it
and called it 'the snowdrop tree'. At his own garden at Monticello, he not only collected
plants native to Virginia but also experimented with plants from different climates.

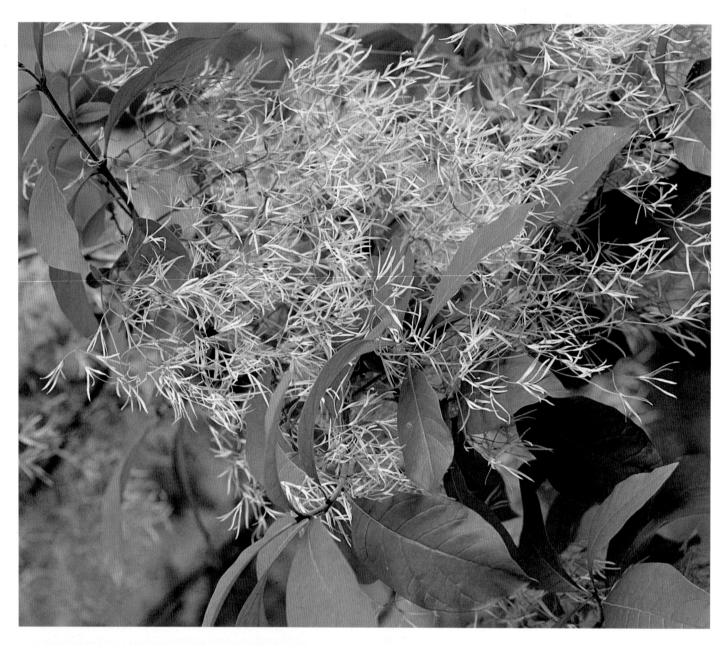

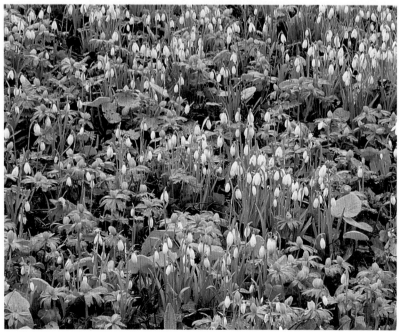

CHIONANTHUS VIRGINICUS (*above*) is a decorative North American shrub or small tree, a member of the olive family, which produces graceful fringes of white flowers in the spring. Although hardy in many climates, it requires hot weather to ripen the flower-bearing wood. An archetypal and always beautiful winter mixture in English gardens (*left*), appearing in January or February, is the native snowdrop, *Galanthus nivalis*, with the cheerful yellow winter aconite, *Eranthis hyemalis*, its ruff of leaves like a Tudor dandy's. Both plants flourish in rich, moist soil. A common small tree of suburban gardens, the weeping birch, *Betula pendula* 'Youngii' (*opposite*), casts out a veil of tumbling branches of twiggy growth descending to the ground.

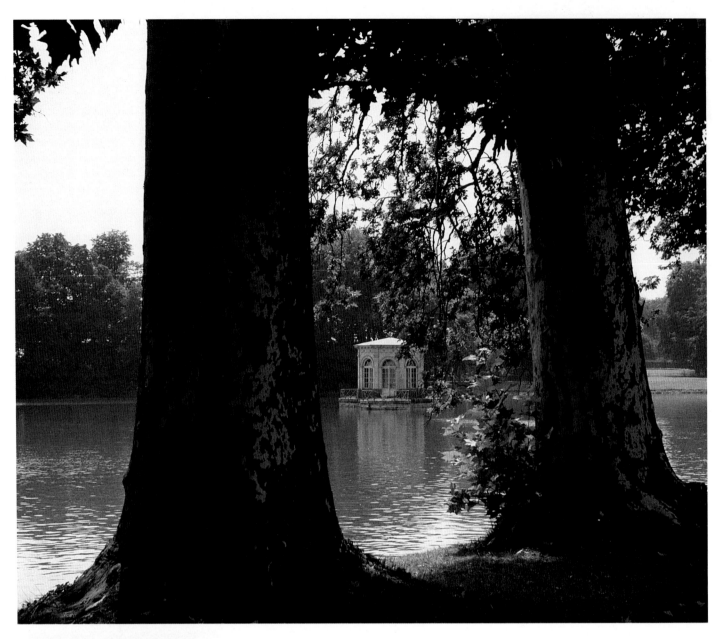

MAJESTIC TREES lock buildings into the landscape. An old carp-pool at the Château de Fontainebleau *(above)* is overlooked by an Italianate pavilion dating from the earliest days of the garden in the 16th century. The garden was redesigned by André Le Nôtre in the 1640s and finally landscaped for Napoleon by Maximilien-Joseph Hurtault in the early 19th century. The 18th-century hunting lodge at Wörlitz in eastern Germany *(left)* forms an eye-catcher in woodland. The elaborate landscaping of the park produced some of the most atmospheric garden scenes of their time. The melancholy, poplar-girdled Rousseau Park *(opposite)* was built at Wörlitz in 1782 in homage to the famous Île des Peupliers at Ermenonville near Paris where Jean-Jacques Rousseau was entombed in 1778.

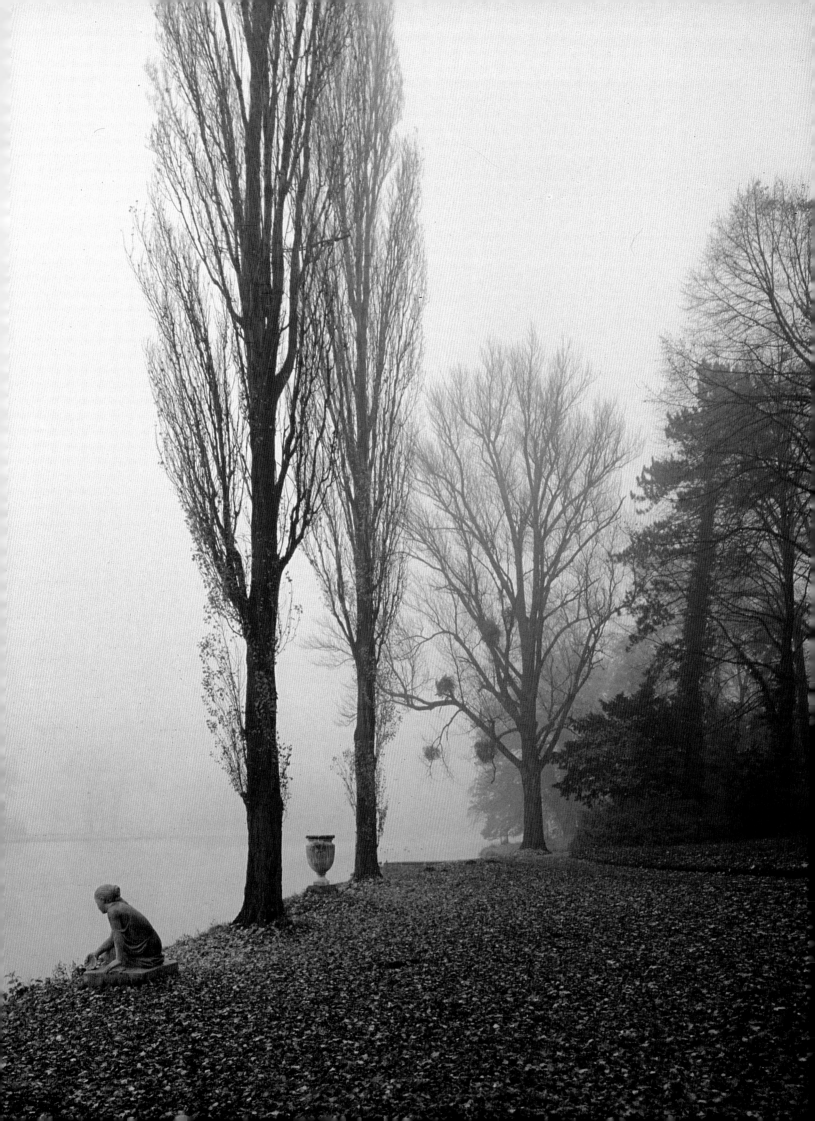

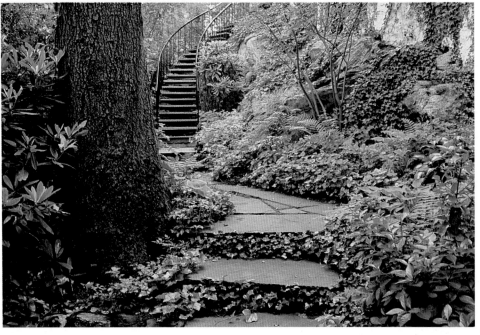

STEPS, OR A FORMAL staircase, often have the powerful effect of luring the visitor on to explore the woodland beyond. At Sanssouci (*left, above*) an immense flight of stairs, dating from the 18th century, has an almost intimidating grandeur entirely in keeping with the scale of the surrounding landscape. Don Walsh's subtle design for the garden at Larchmount House, New York State (*left*), is beautifully detailed. Stone slabs wind their way through ivy, changing course to climb the rocky outcrop. An intimate, romantic atmosphere prevails at the Villa San Remigio on Lake Maggiore (*opposite*), where a softly curving staircase scales the slope of a woodland terrace.

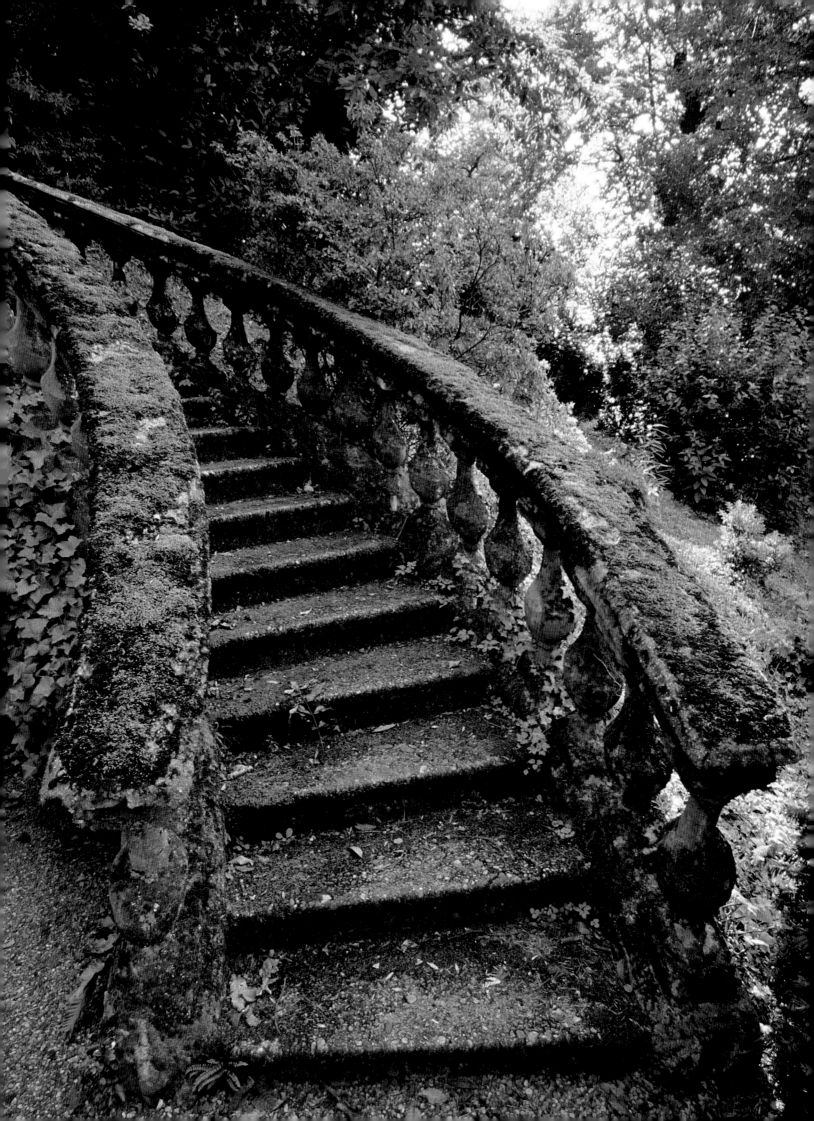

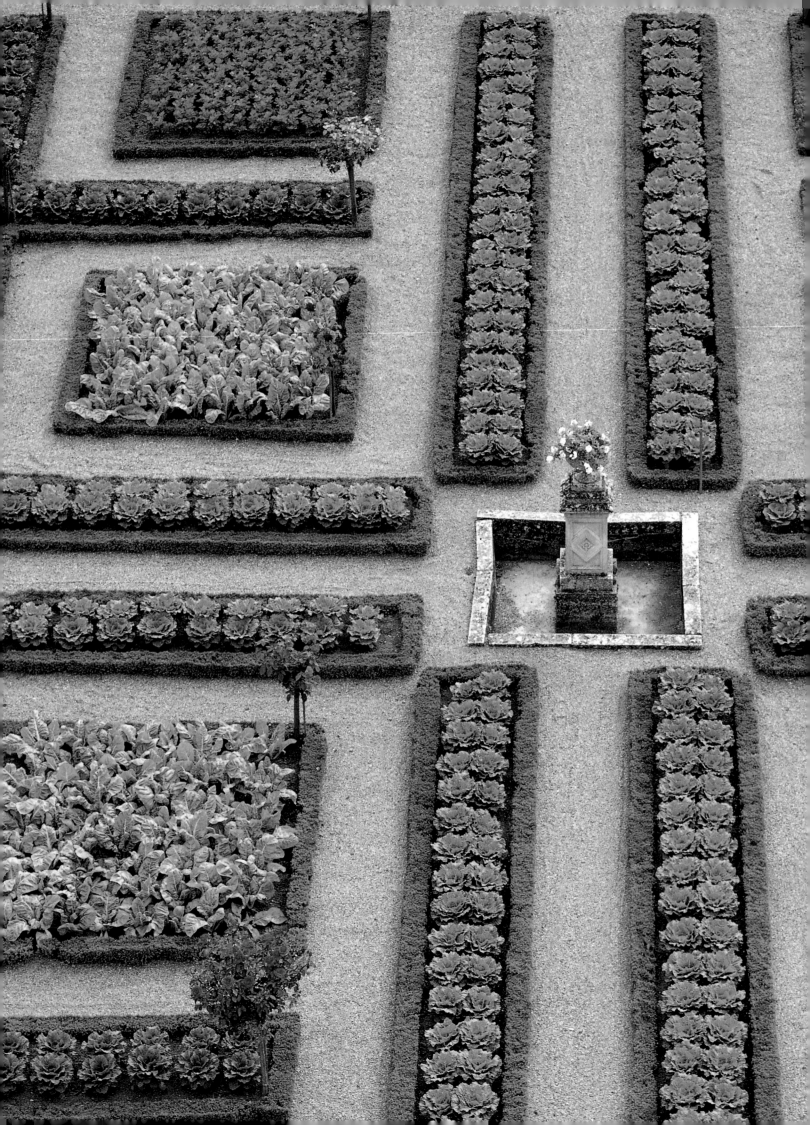

STRUCTURED SYMMETRY

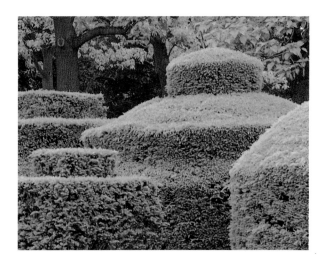

GEOMETRY AND SYMMETRY are fundamental elements of the formal garden. At Longwood Gardens, Pennsylvania *(above)*, the crisp geometry of clipped yew, *Taxus baccata*, creates a lively formality. The intricate, patterned beds at Villandry in France *(opposite)*, bedded-out with seasonable vegetables, raise the kitchen garden to the status of high art. Here, much attention is paid to the colour of foliage – blue-green cabbages contrast with the fresher colour of spinach.

THE PATTERNED GARDEN of symmetrical arrangement and geometric shapes has, in one form or another, the longest history of any garden style. The gardens of Islam or of the classical Roman age codified the principles of this manner of gardening. The essence of the formal garden is straight lines, balance and ornament in the form of fountains and pools, and statues and vases. The planting is relegated to a subsidiary role except in the case of topiary – the clipping of usually evergreen bushes into ornamental shapes. Pliny the Elder called ornamental gardening *opus topiarium* and the gardener in charge of it had the title *topiarius*. Topiary, especially of the fine-leafed evergreen box was standard Roman practice. At the J. Paul Getty Museum in Malibu, California, a villa of Pliny's time has been recreated with a garden full of lively ornament. Some of the planting is of uncertain authenticity but the effect is nevertheless convincingly decorative.

The Islamic gardens which survive in southern Spain have never been excelled for exquisite beauty. The Patio de los Leones at the Alhambra is the epitome of the formal garden, in which no planting interrupts the purity of the conception. It is enclosed by cloisters with intricately carved decoration. At its centre, a single jet of water rises in a stone basin supported on twelve carved stone lions whose mouths spout water into the circular pool surrounding them. From the pool water runs in four rills, quartering the space and channelling the water into the arcaded rooms that form the patio. The motif of a central fountain or ornament and a quadripartite division is a common one and recurs repeatedly in formal styles.

The sense of harmony that inspired the gardens of Islam is also to be found in those of the Italian Renaissance. Here too was symmetry based on refined architecture and exquisite craftsmanship, but Italian gardens had a far more worldly character – created as outdoor rooms in which the villa owner and his cultivated friends could relax, walk and discuss the topics of the day. The Islamic garden seems to be more inward looking, as though to provide a setting for solitary meditation rather than for social life. A new idea of the Italian Renaissance was the emphasis on the relationship between house and garden – they shared a common axis, forging a visual link between the two. This principle has remained, right up to gardens of the present day, one of the most enduring legacies of the Renaissance garden design.

The greatest architect of Renaissance Italy, Leon Battista Alberti, included in the description of his ideal garden in *De Re Aedificatoria* (1452) topiary clipped into extraordinary shapes. This passion for topiary spread to all countries in which Renaissance garden ideas had an influence. The statues and urns which formed such an important part of the decorative scheme of formal Italian gardens of this period were often based on classical originals. These motifs spread throughout Europe, so that such themes as the Discus-thrower (*discoboulos*) or the Belvedere Apollo virtually came to be mass produced. Italian Renaissance garden designers, learned in the significance of mythological imagery, carried out elaborate programmes of symbolism. In 17th-century France such ideas, along with much else from the Italian Renaissance, were borrowed in royal gardens like Versailles. Louis XIV saw himself as the Sun King, the centre of life on earth. The statues and garden buildings make many references to the Greek god of the sun, Apollo, and his attendant deities. At Versailles, the palace itself faces east and west and the king's private rooms were placed at the centre of the building so that they were on the axis of the rising sun and the setting sun. William of Orange's garden at Het Loo in the Low Countries showed a similar concern for garden symbolism. King William, a deadly rival of the Sun King, saw the creation of gardens as an aspect of their enmity. William associated himself with Hercules and, in particular, the golden apples (i.e. oranges) of the Hesperides. The great formal gardens of Het Loo, now marvellously restored, are rich in Herculean imagery.

Although the formal garden became unfashionable in the 18th century, as the English landscape style swept all before, it never disappeared completely. Its essential ideas lurked in the background, to re-emerge triumphantly in the 19th century when all sorts of historical styles of gardening were rediscovered. In one area of the garden, however, formality never went out of fashion – the kitchen garden. This was often divided in a four-part arrangement, with a cruciform pattern of paths, sometimes with a dipping-pool at the centre.

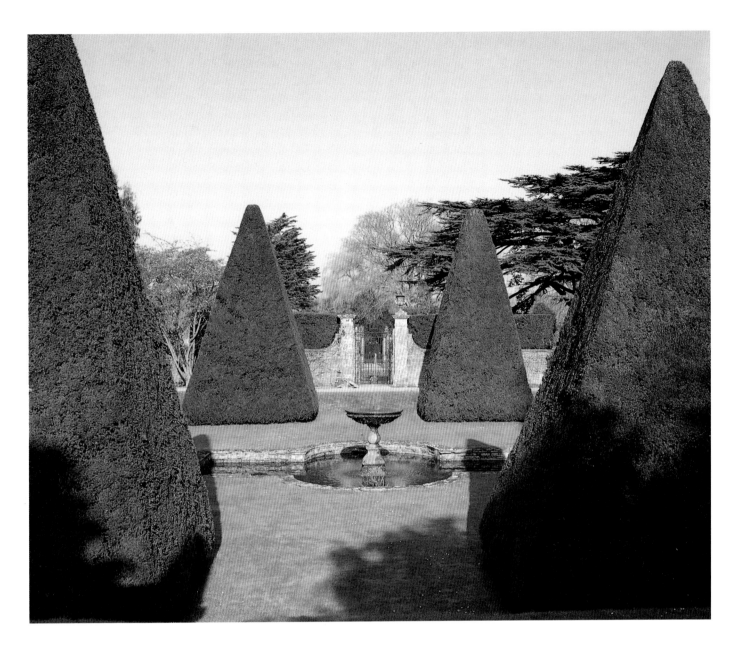

The ingredients of a formal garden — vista, focal point, fountain, topiary, lawn, enclosure — have exercised their fascination on garden designers from the Renaissance to the present day. The formal garden at Athelhampton Manor in Dorset, created by F. Inigo Thomas as a frame for the 15th-century house, date surprisingly from the late 19th century.

Many gardens created in the first part of the 19th century were dominated by a newborn formality, as the Victorians fell in love with the historic styles of earlier periods. Although supposedly authentic, their recreations always have a strong flavour of their own time. In the second half of the century, as a naturalistic garden philosophy became influential, there raged a fierce war between the proponents of the formal, or architectural, garden and the wild garden promoted by William Robinson. A happy marriage between the two tendencies produced the remarkable gardens of Sir Edwin Lutyens and Gertrude Jekyll, in which the strong architectural bones of the design were fleshed out with exquisitely judged planting.

In 20th-century gardens a lively eclecticism has prevailed, with gardeners feeling free to draw on the past. Although ecological gardening has had some impact, the dominant garden style is formal in spirit. Clipped box hedges, yew topiary, urns and statues bring a heady whiff of the Renaissance to many a suburban plot. A 20th-century garden like the extraordinary *potager* at Villandry yokes together two horticultural traditions. It is a celestial kitchen garden in which fruit and vegetables are disposed with all the *brio* of the Renaissance.

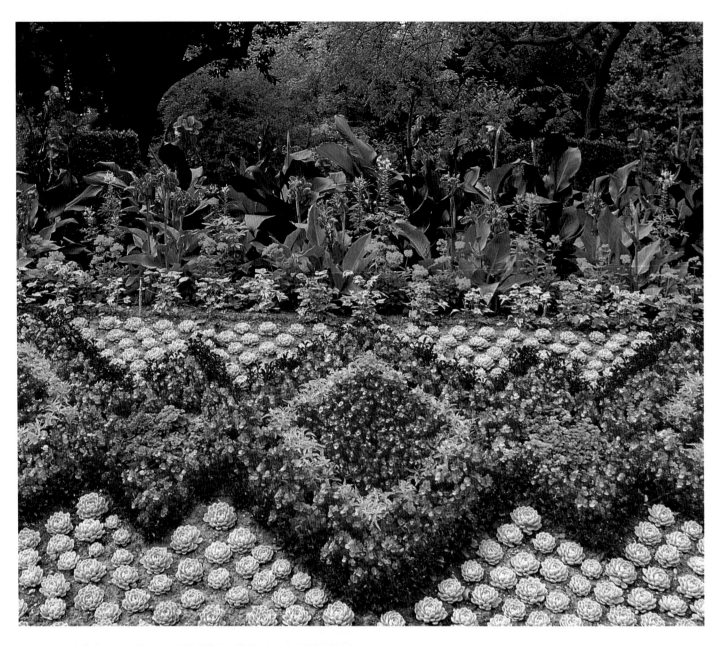

Elaborate summer bedding schemes have been a speciality of the French since the 19th century, particularly in the meticulously detailed arrangements of carpet bedding. This technique of pattern making with flowers is well displayed in these flawlessly regimented rows of tender plants at Versailles *(above, left and opposite)*. The gardens were originally created for an entirely different purpose – to show the absolute power of absolute monarchy. Today, open from dawn to dusk for the great public to wander in at will, they have been refashioned to suit the tastes of a more democratic age; an overlay of municipal jollity veils André Le Nôtre's grandiose schemes. Purists may shudder at this historical *gaffe* but *mosaïculture* has become an essential feature of French public gardens.

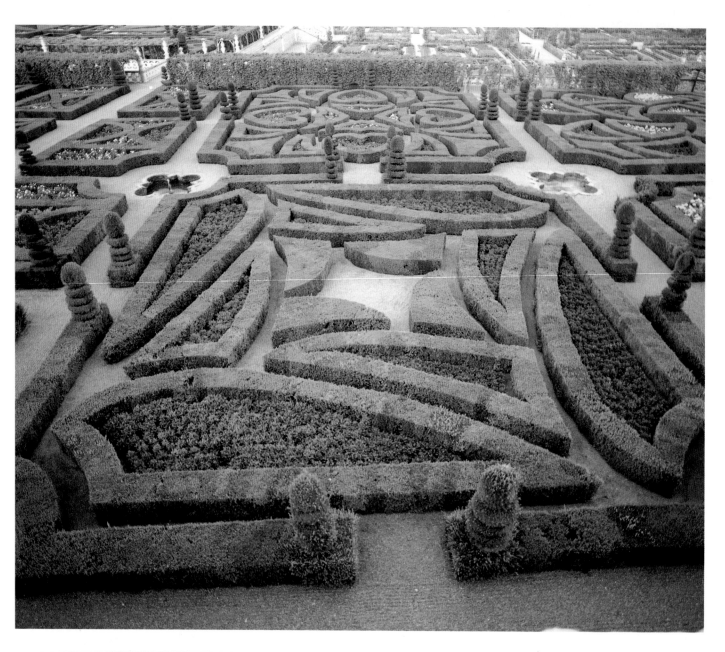

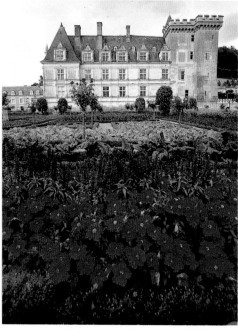

ONE OF THE MOST extraordinary formal gardens of the 20th century was created at Villandry on the banks of the River Loire by a Spanish doctor, Joachim Carvallo. He bought the exquisite Renaissance château, built from the pale limestone of the region, in a derelict state in 1906, restored the house and laid out the garden. Inspired by 16th-century French designs, he interpreted these in a boldly original way. Part of the garden, seen in the lower part of the picture opposite, were laid out as an ornamental *potager*. The *jardins d'amour* (*above*) are a freestyle evocation of traditional parterres but filled with modern bedding plants which are used throughout the garden to provide splashes of intense colour (*left*).

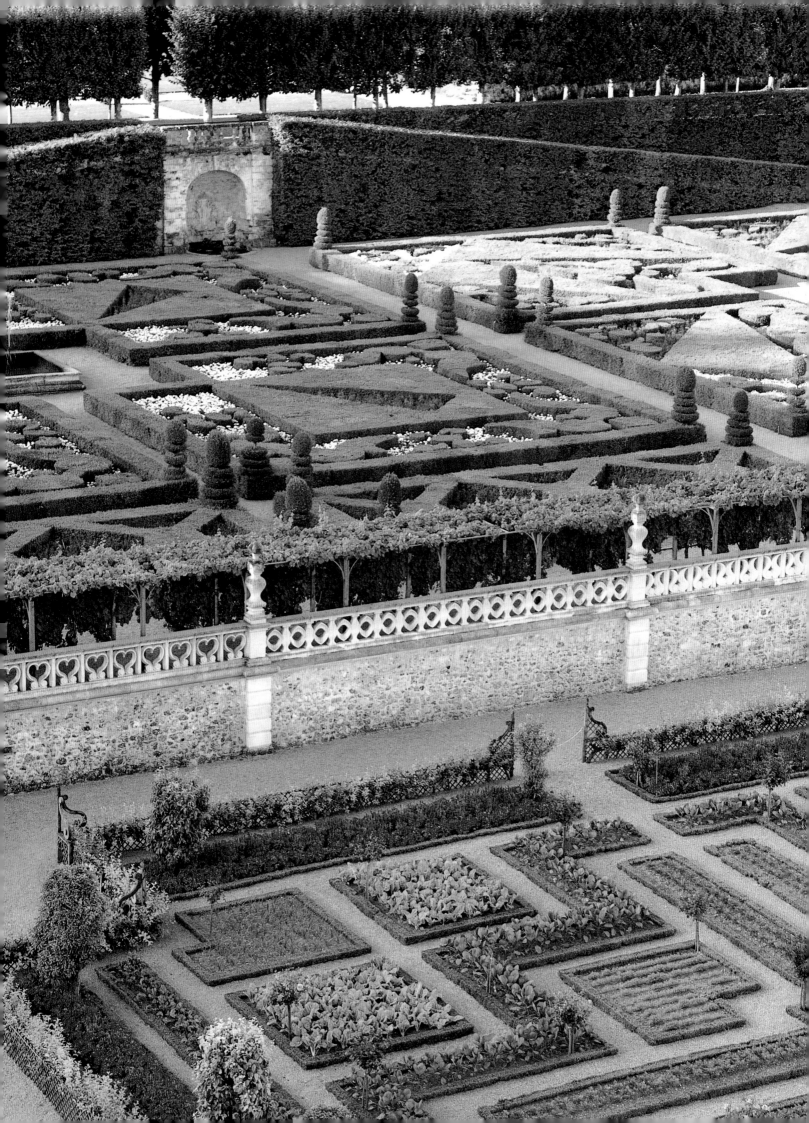

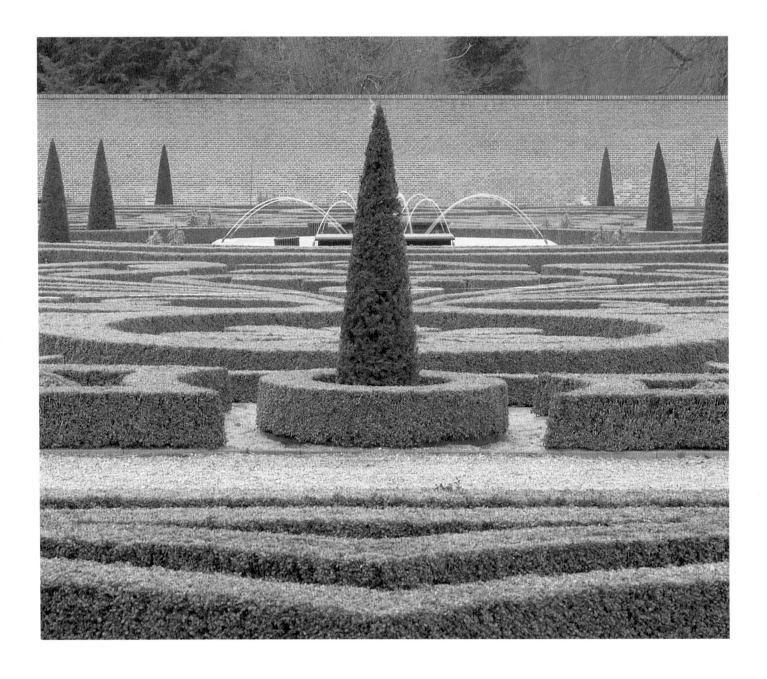

T OPIARY – 'VEGETABLE SCULPTURES' as the 18th-century poet Alexander Pope called it – has been an important ingredient of formal gardens since the Romans. At Het Loo in the Netherlands (*above*), it forms an essential part of the elaborate patterns of the box parterres. At Kasteel Twickel (*left*), a romantic, moated castle in the eastern Netherlands, the neo-classical garden uses topiary in a more playful way, with intricate, clipped shapes poised on swollen yew plinths. At the Palácio da Fronteira in Lisbon (*opposite*), intricately worked geometric shapes of box are clipped with razor-edge precision, contrasting with rounded mounds and cones. Portuguese gardens display a taste for particularly elaborate topiary patterns.

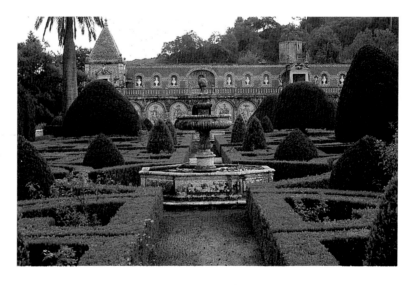

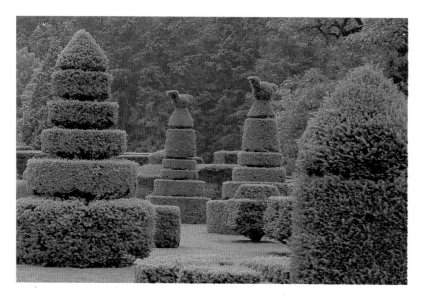

Topiary can display great expressiveness, ranging from the solemn and monumental to the cheerfully exuberant. At Longwood Gardens (*left*), elongated shapes, clipped as birds or geometric tiers, make a fine contrast to the natural backdrop of mature trees. Gigantic rounded shapes of yew and box at Oxnead Hall in Norfolk (*above*) lure the visitor round a corner. The magnificent array of topiary shapes and figures at Haseley Court in Oxfordshire (*opposite*), despite its venerable air, dates only from the 1850s – in 19th-century England there was a craze for recreating historic garden schemes. The garden was neglected for many years but a man in the village took it upon himself to clip the topiary every year while the rest of the garden went to seed.

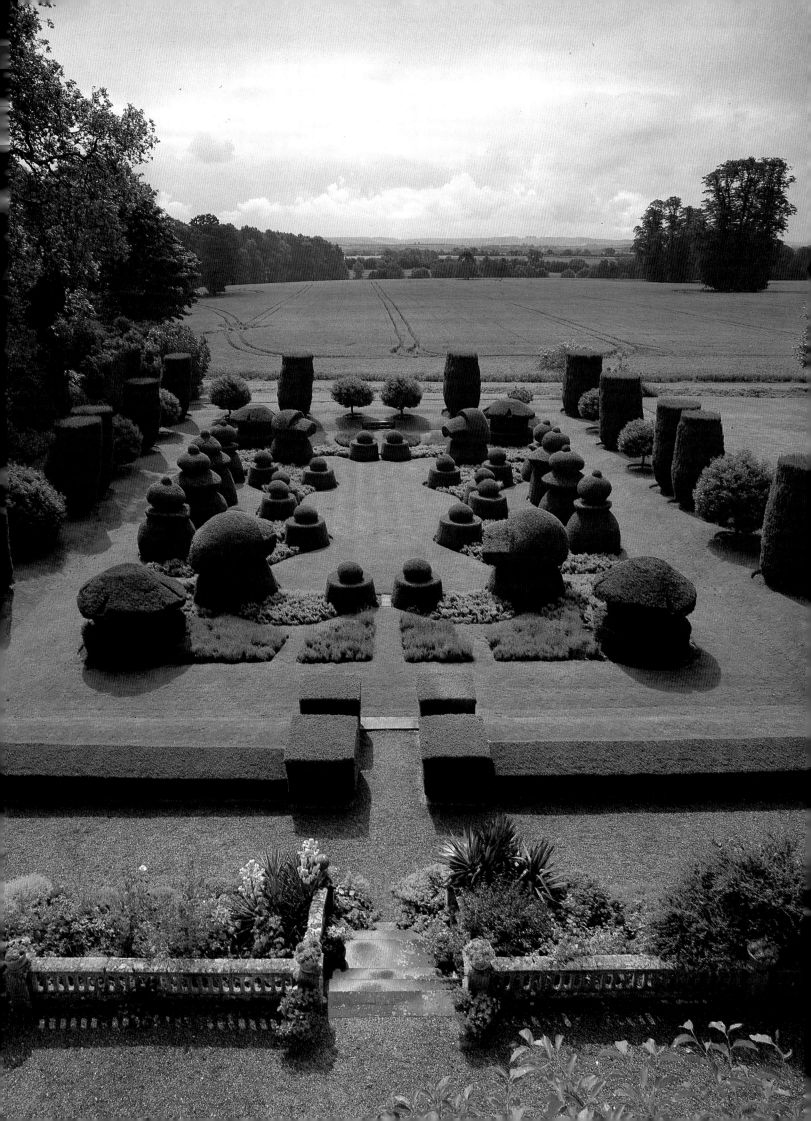

A LIVELY ROMANTICISM often blurs the geometry of formal gardens in England. Haseley Court in Oxfordshire *(above and opposite)* is a medieval house largely rebuilt in the early 18th century. The topiary garden was planted *ca* 1850, but the garden had already been famous for its topiary as early as 1542, when the historian John Leland described it as 'a right fair mansion place and marvellous fair walkes, *topiarii operis* (i.e 'works of topiary') and orchards and ponds'. The estate was bought in the 1950s by the American interior decorator and gardener Nancy Lancaster, who restored the old garden and added much of her own, including an elegant little box knot garden in front of an outhouse *(opposite)*.

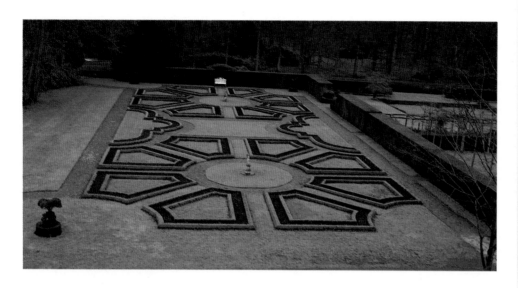

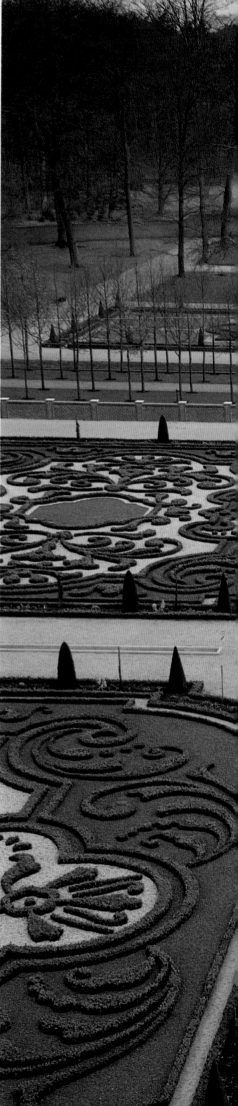

THE BOX-EDGED parterre at the garden of De
Wiersse in the eastern Netherlands (above) was laid
out in the early 20th century by the 17-year-old
daughter of the house, Alice de Stuers, mother of
the present owner. This part of the garden had been
in the 18th century entirely formal in character;
Alice reinstated two handsome statues which
survived from the 18th-century scheme and made
them the centrepieces of her new design. The
narrow beds are filled in summer with Hybrid Tea
and Floribunda bedding roses massed in blocks of a
single colour. Today, most of the garden is a
romantic woodland layout, spread around a moated
manor house in the rural landscape of Gelderland.

THE RICH FORMAL DESIGN at the royal palace
of Het Loo in the Netherlands (opposite) spreads out
like an oriental rug below the southern façade of the
palace. Arabesques of clipped box form the tracery
patterns within the beds, and contrasting
background colour is provided by fine chippings of
stone or brick. In order to provide sufficient
pressure to power the King's Fountain in this
famously flat part of the world, water had to be
piped six miles from high ground. For the
restoration, 17th-century horticultural manuals were
studied and only plants of the period used. The
narrow beds edging the parterres, decorated with
topiary cones, were filled with particularly rare
plants displayed individually like precious jewels.

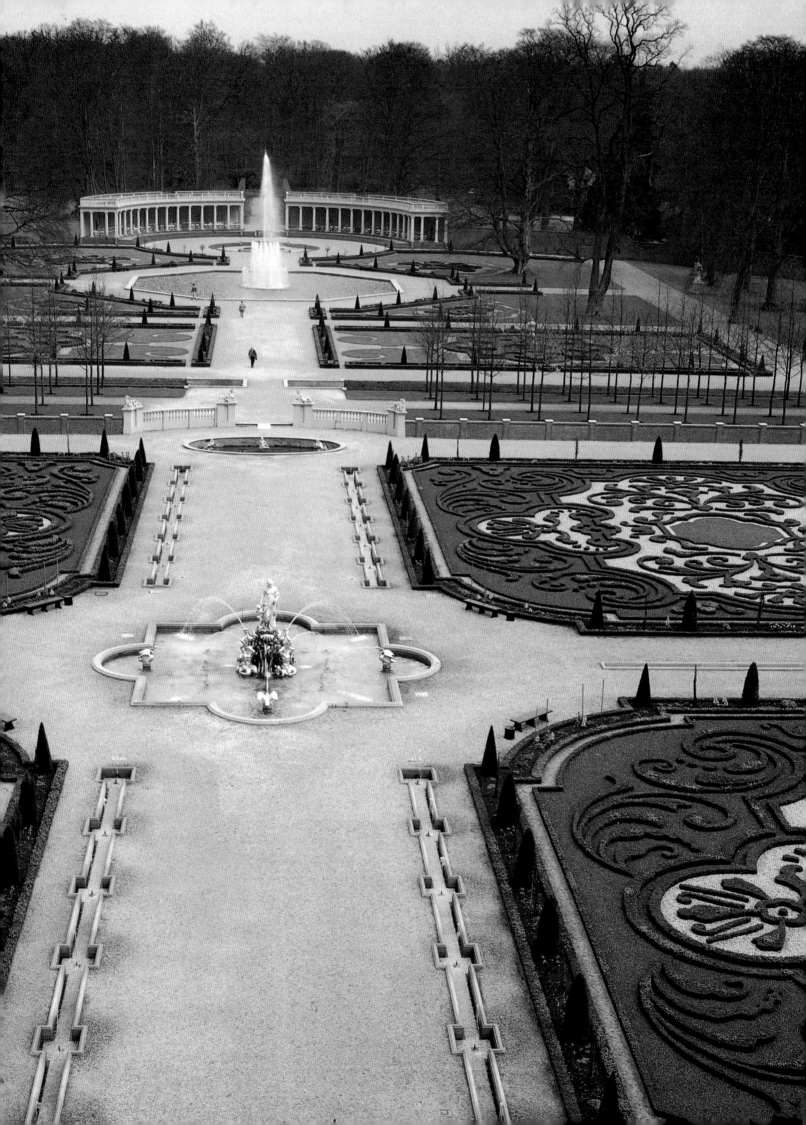

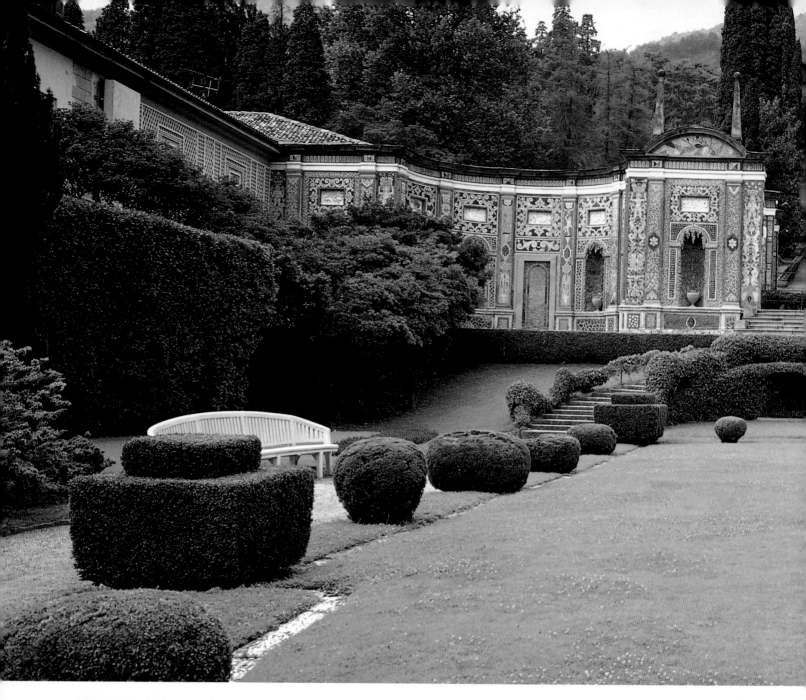

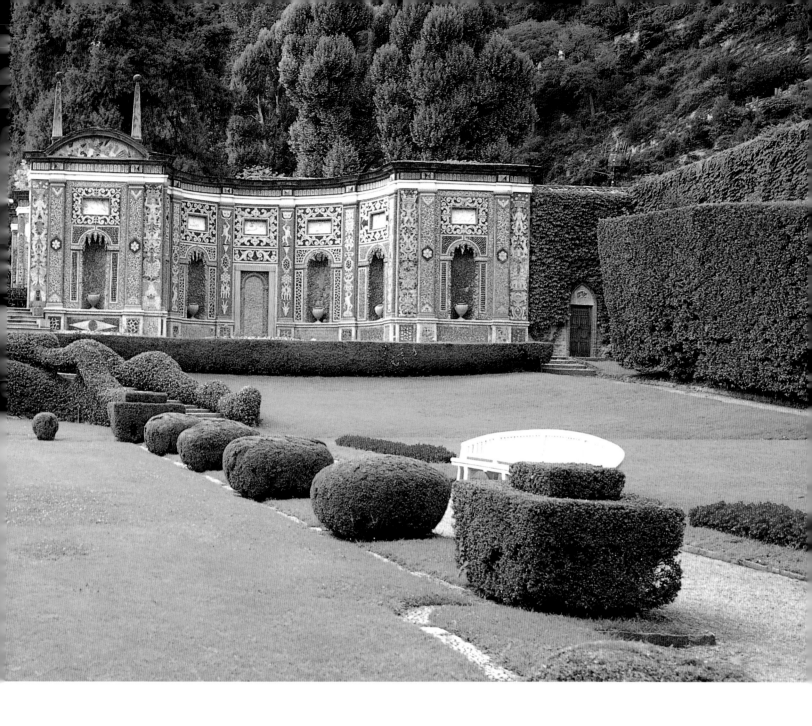

Two different interpretations of the formal garden style. The French love of symmetry and discipline is exemplified in this arrangement at the Château de Courances *(opposite)*. The dapper architecture of the little pavilion is echoed in the restrained geometry of lawns and topiary. Cones of yew contrast with mounds of box and the lawns are sharply edged with strips of wood. Restraint is not a word that comes to mind when visiting the Villa d'Este on Lake Como in northern Italy *(above)*. Built for Cardinal Gallio at the end of the 16th century to the designs of the architect Pellegrino Pellegrini, it occupies a spectacular position on the western shores of the lake. Since the end of the 19th century, the villa has been a magnificent hotel, the Grand Hôtel Villa d'Este. Only parts of the original garden survive, but they are wonderfully romantic. The features shown here belong to the Renaissance layout. The pavilions which flank the opening of the avenue leading up the hill are inlaid with pebbles and coloured stucco; beyond them, a grassy walk runs between stepped water-courses, and Italian cypresses soar upwards. At the very top of the hill, a more recent neo-classical pavilion contains a heroic statue of Ariosto, court poet in the Renaissance to the d'Este family at Ferrara.

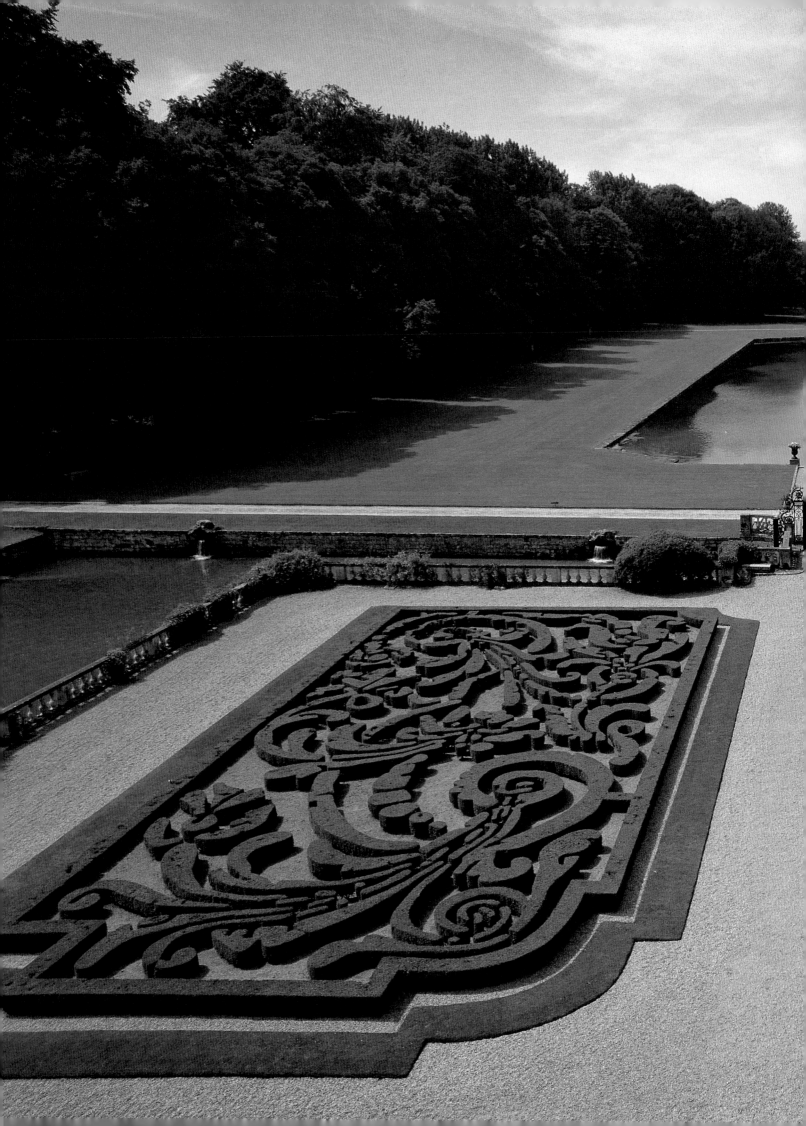

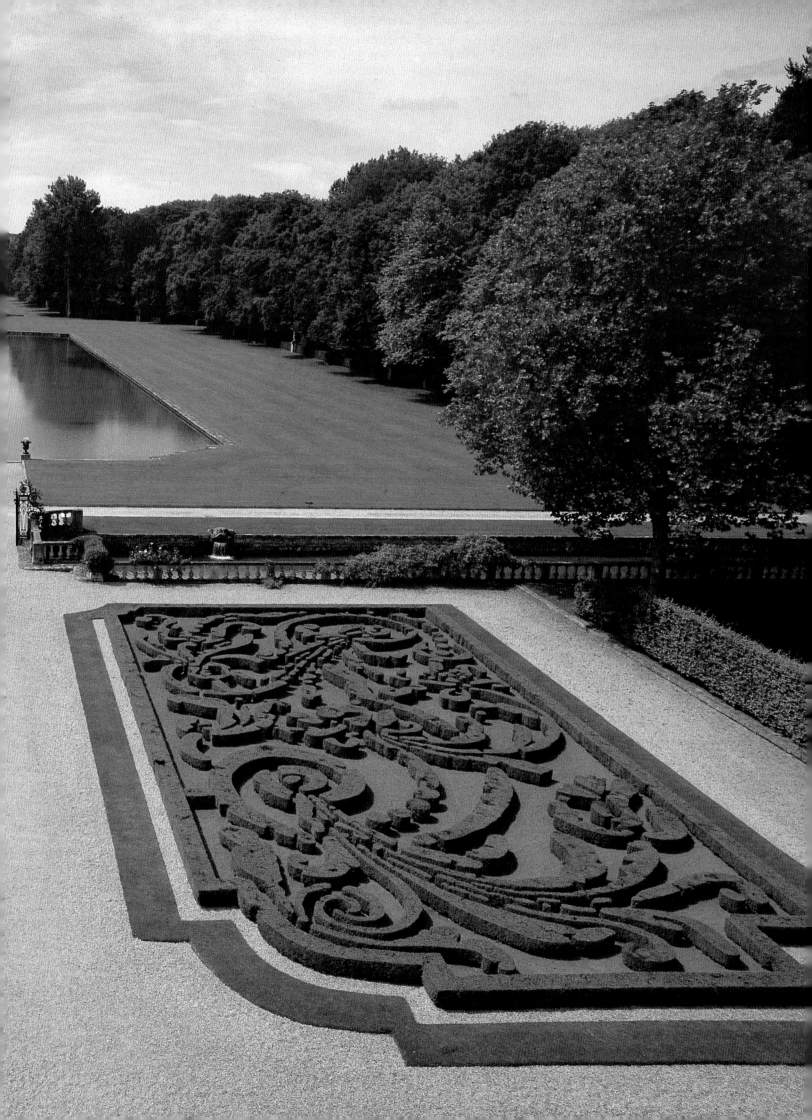

FORMALITY IN the kitchen garden at Felbrigg Hall in Norfolk *(above)*, where box edges and gravel paths create a crisp geometry in classical style. The unique formal garden at the 16th-century Drummond Castle in Perthshire *(opposite)*, is an 1830s' fantasy pastiche of a formal garden of the same period as the castle. Box is one of the chief ingredients. The design is dominated by a giant cross of St Andrew (the patron saint of Scotland) tricked out with a lavish array of topiary, superb garden ornaments and bedding plants. It is seen here from the viewing terrace behind the castle – even the peacock seems part of the decorative scheme.

A VIRTUOSO INTERPRETATION of French formality is the recreation of a garden at Courances *(previous pages)* around the 17th-century château. After the original garden had been swept away in the 19th-century craze for English-style landscape gardens, a 17th-century-style garden was laid out by the designer Achille Duchêne just before World War I. To the west of the house is a pair of embroidered parterres with arabesques of clipped box spread out on a moated island. Beyond, a simple expanse of water points towards an opening in the woods; glimpsed in the distance, a figure of Hercules is the culminating eyecatcher. Apart from the roses on the moat's balustrade, there are no climbing flowers to interrupt the restrained sobriety of the design.

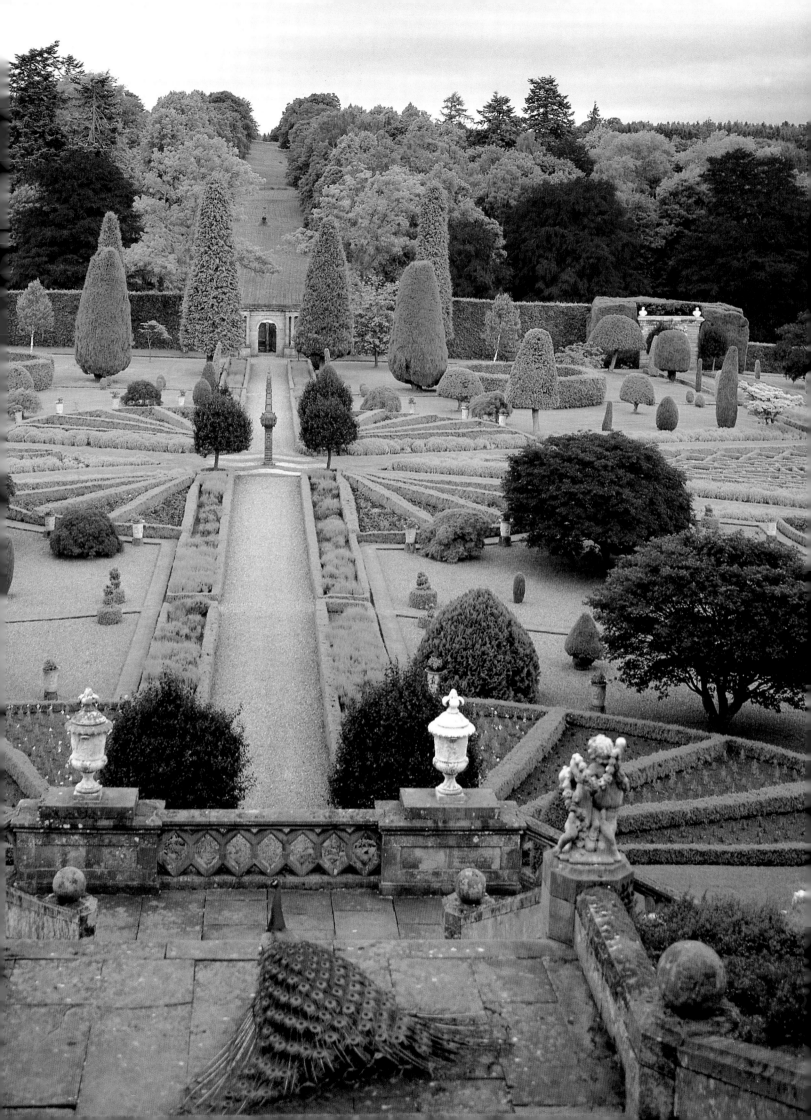

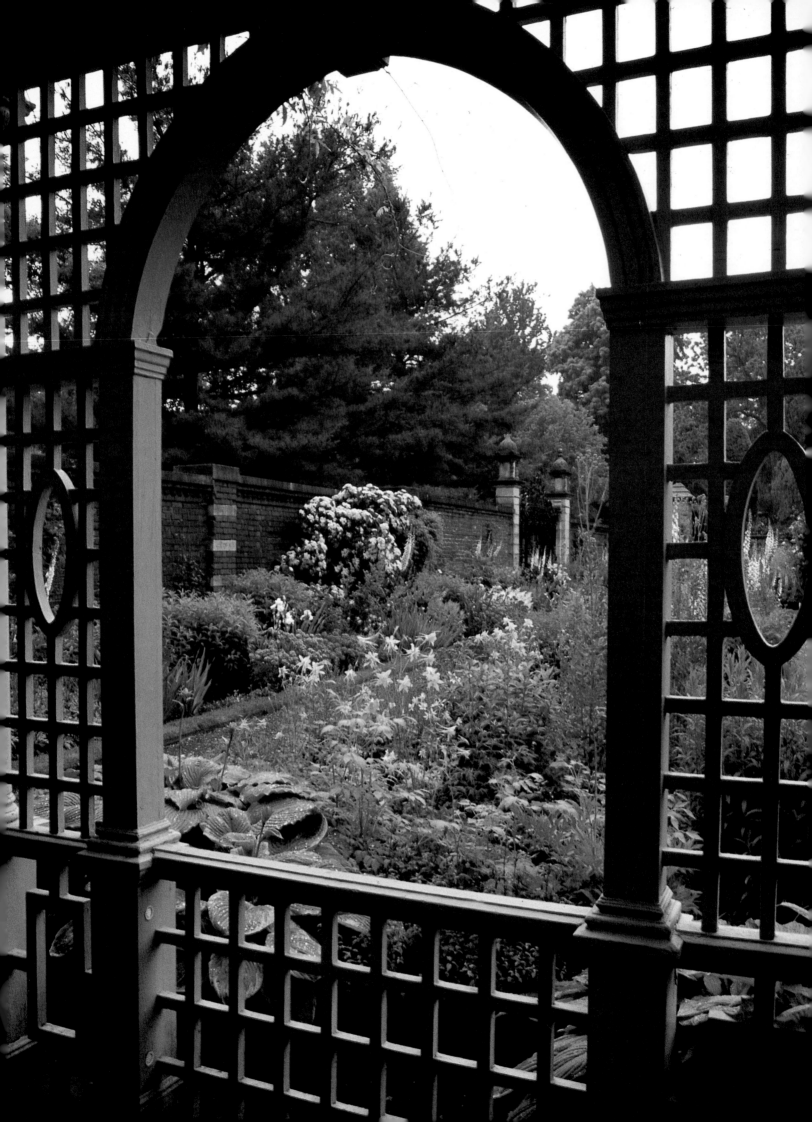

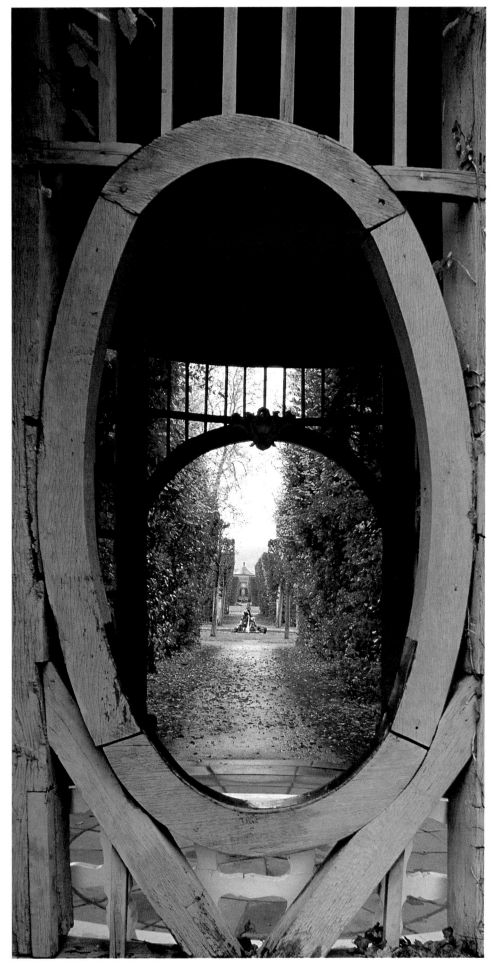

THE FOCUS OF attention in formal gardens is often a particular view or composition. At Old Westbury Gardens *(opposite)*, the 17th-century device of an open arch in trelliswork frames a picture of flower borders. At Felbrigg Hall *(above)* the walls that enclose the orderly, geometric kitchen garden are pierced by arched entrances which draw the eye to the decorative dovecote at its centre. At the heart of the 18th-century rococo garden at Schloss Veitshöchheim near Würzburg in Germany *(right)* is a maze-like arrangement of walks and hedges of hornbeam, *Carpinus betulus*, seen here framed in the window of a summer house.

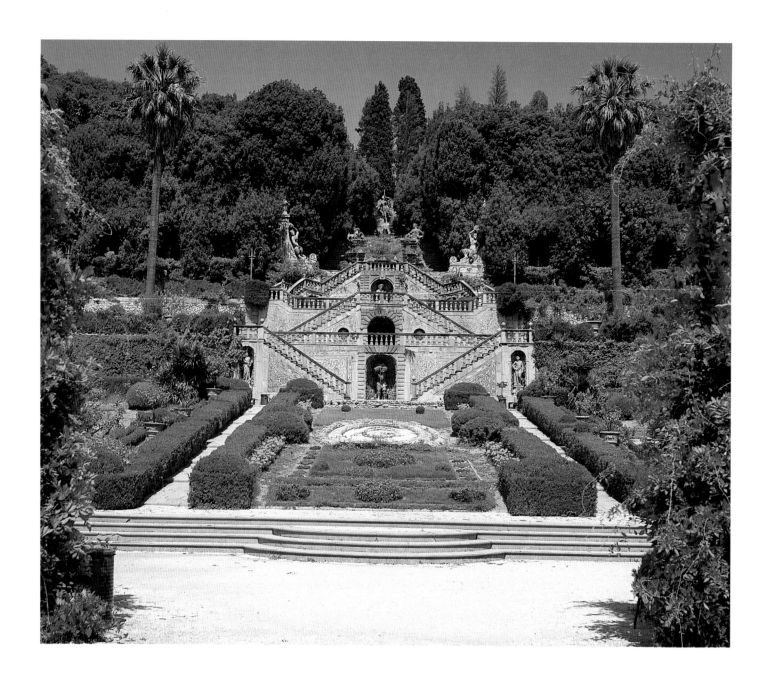

ELABORATE STAIRS with multiple flights were thought of as the most dramatic way of linking terraces in Italian Renaissance gardens. However, at the Villa Garzoni at Collodi in Tuscany *(above)*, the spirit is of almost frenzied baroque exuberance as opposed to the stately classicism of the 16th century. The great garden historian Georgina Masson recognised this 'transformation from the formal to the wild' as the essence of the baroque. The villa and garden date from the 17th century, and here the staircase has become the very heart of the garden. In the 18th century a local architect, Ottavio Diodati, embellished the garden with additional ornaments, and at the peak of the staircase is a figure of Fame trumpeting her renown.

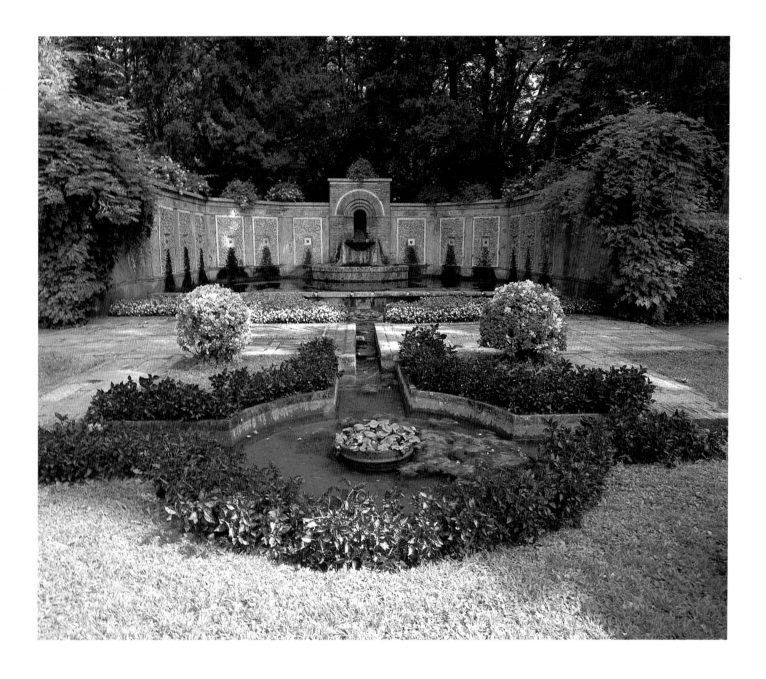

ONE OF THE most famous features at the Villa Reale near Lucca is the 'water theatre' *(above)*, with lions' masks from which water gushes into the pool below. The villa dates from the mid-17th century and parts of the garden are of the same period. In the 19th century it was acquired from the Orsetti family by Napoleon Bonaparte's sister, Elisa Baciocchi, Princess of Lucca. She was a patron of the violin virtuoso, Paganini, and it is related that while reclining in the garden she fainted in ecstasy on hearing his divine music from behind a hedge. The garden here contains a 'green theatre', also 17th-century, enclosed by immense yew hedges, with details of the stage fashioned from clipped yew and box.

A WATER THEATRE with a pebble-encrusted backdrop of niches containing water deities and giant scallop shells *(following pages)* is at the summit of the garden of the Isola Bella, the most spectacular of all those made by the Borromeo family on Lake Maggiore. Multiple terraces rise from the water, making the island resemble some ocean-going liner becalmed in the placid waters of the lake. Among the most enchanting of the baroque gardens of Italy, it was started in the early 17th century. The French traveller Charles de Brosses visited the garden in the early 18th century and wrote that it 'resembles nothing so much as a palace in a fairy tale'. Visitors today are enchanted by exactly the same atmosphere.

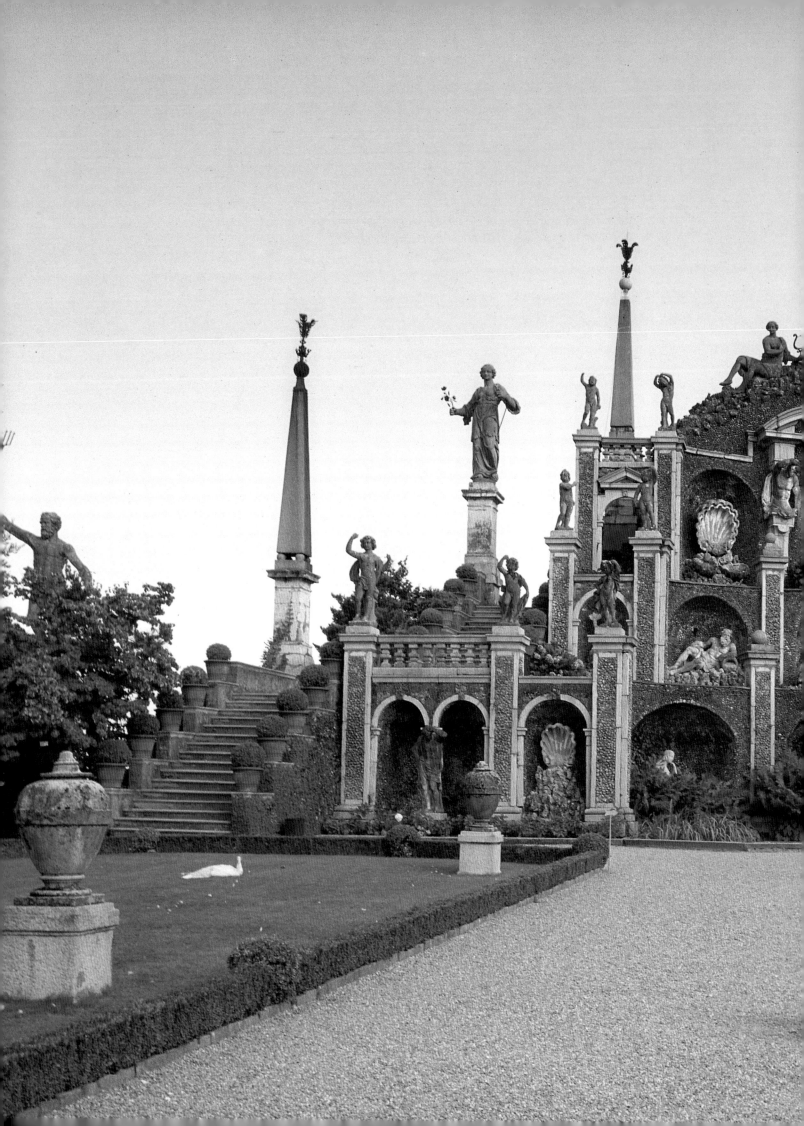

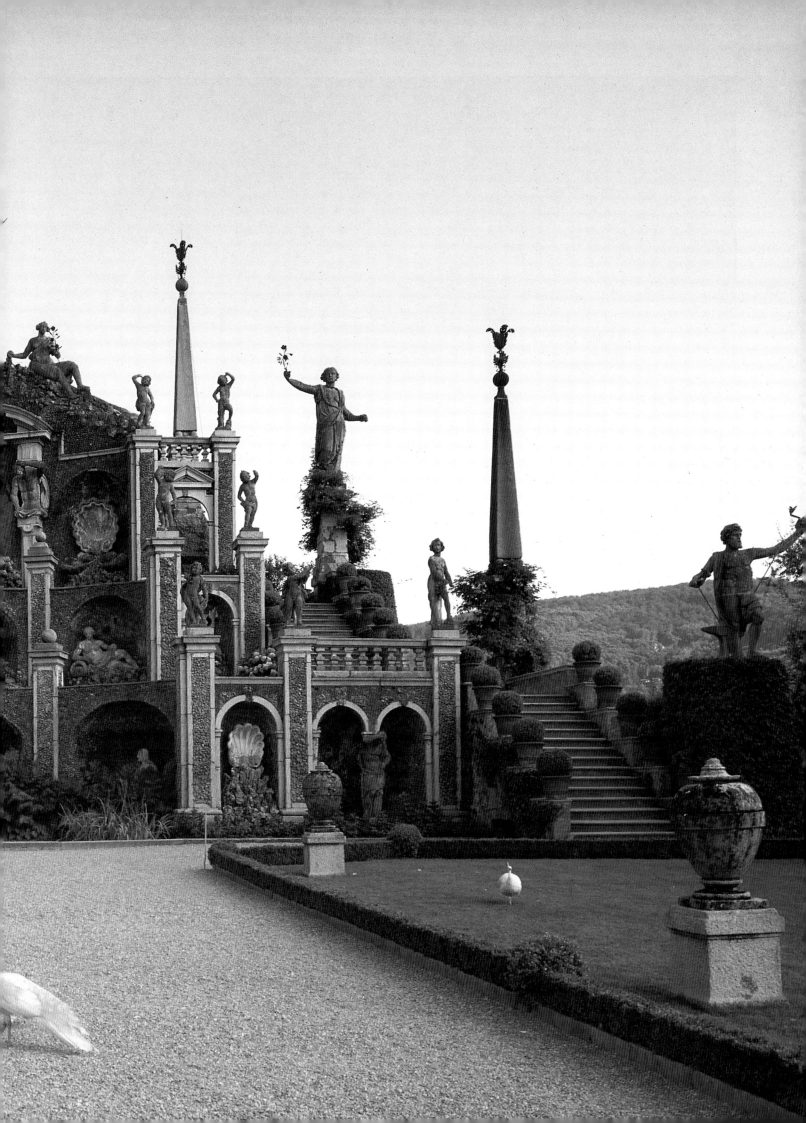

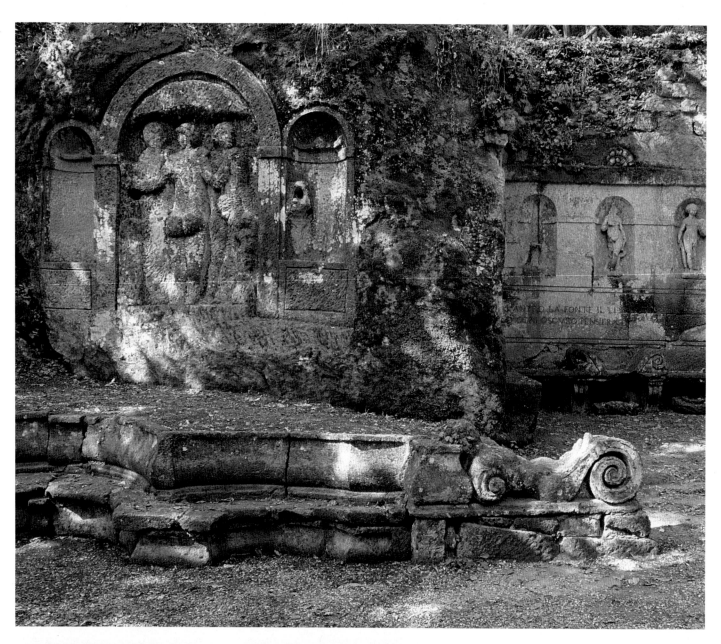

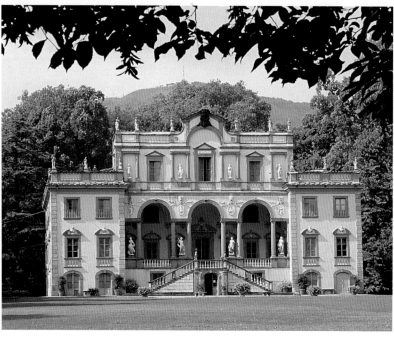

STATUARY AND GARDEN architecture in the Sacro Bosco of the Villa Orsini at Bomarzo (*above*) appear to be organic growths, erupting from the soil. This most extraordinary of gardens was created in the 16th century by the warrior man-of-letters Vicino Orsini. Attempts to unravel the meaning of the garden are challenged by Orsini's own inscription, which reads, 'Only for the heart's amusement'. The formal gardens that surrounded the 17th-century Villa Mansi near Lucca (*left*) were progressively blurred until something more like a landscape garden developed. In the woods behind the villa, however, there are traces of the formal woodland groves – the *bosco* – designed in the 17th century by the Sicilian architect Filippo Juvarra. The Nymphaeum at the Villa d'Este, Lake Como (*opposite*), contains a powerful figure of Hercules hurling Lichas, the fateful messenger, to his death.

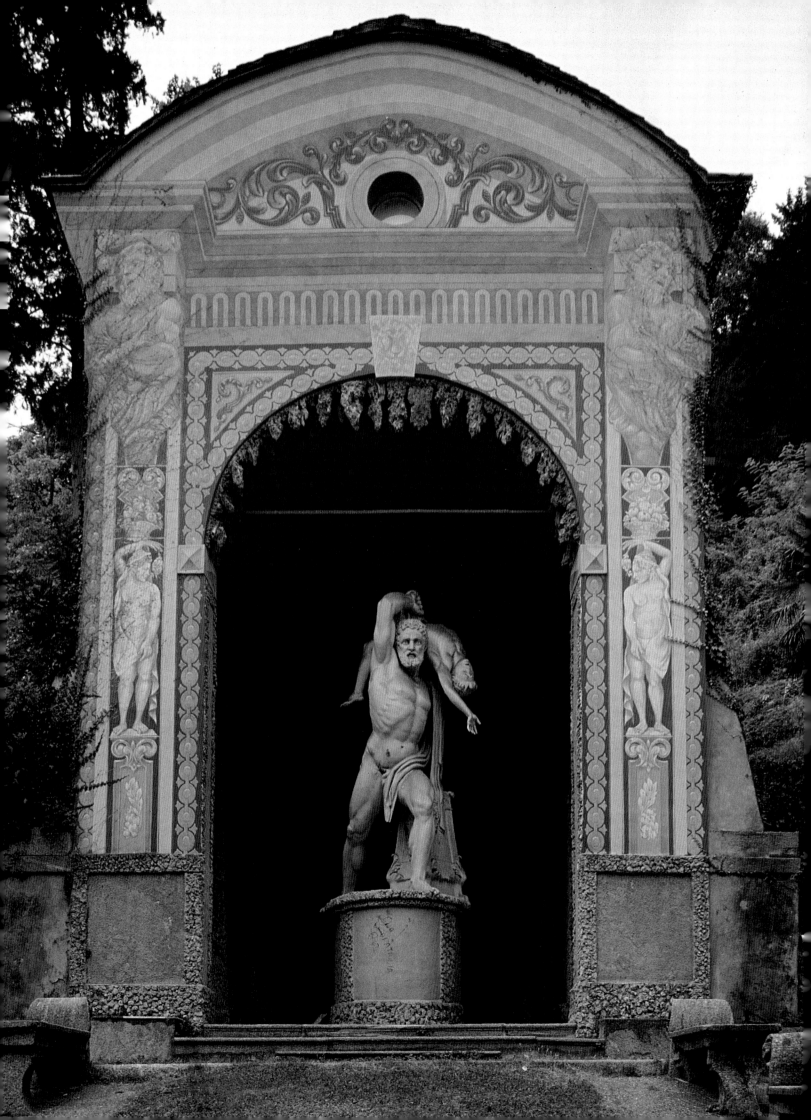

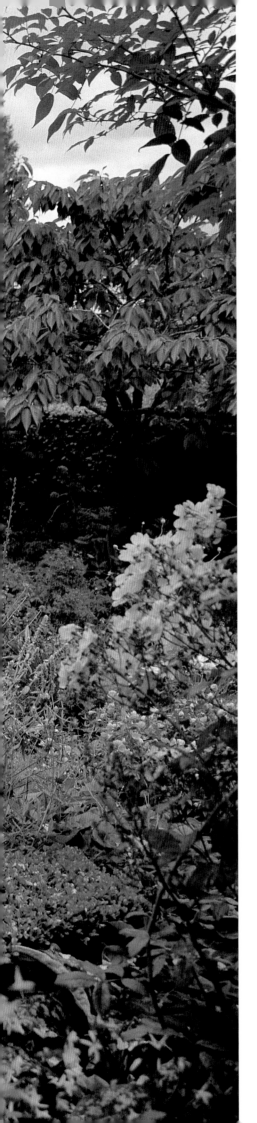

IV
VISIONS
OF
FLOWERS

An APPARENTLY ARTLESS profusion of flowers often conceals high artistry. At Chilcombe House in Dorset *(opposite)* the garden seems to merge into the rural landscape that surrounds it, and a bold clump of blood-red hollyhocks provides exactly the right note of cottage-garden exuberance. The ebullient, rounded shapes of the herbaceous plants echo the distant crowns of trees, linking the garden firmly with the countryside beyond.

THE FLOWER, as a poetic image, as an object of beauty or as a botanical curiosity, has long been treasured. As early as 1400 BC, Egyptian tomb paintings depict ornamental plants as symbols of the magical refreshment of the soul. On the island of Thira, near Crete, lively frescoes of the same date show scarlet lilies and the saffron crocus, *Crocus sativus*. Roman gardening, the most highly developed of the classical age, is vividly described in the writings of Pliny the Elder. From the 8th century in Spain, the Islamic tradition raised the art of flower gardening to new heights and described horticultural techniques in great books that prefigure the discoveries of the Renaissance. But it is only in the period of the High Renaissance in the 16th century that flower gardening came of age. A symbol that is at once vivid and versatile, the flower was one of the most frequently used images of Renaissance writing, as the poetry of William Shakespeare demonstrates.

Botany, because of the value of plants for medicinal purposes, was one of the most flourishing disciplines of the Renaissance. The first European botanical garden was founded in Pisa in 1543 and others followed: in the Low Countries at Leiden in 1587 and in England at Oxford in 1621. The purpose of these gardens was to foster botanical science but, as surplus wealth was created among the middle classes, flowering plants became status symbols, collected in exactly the same way as other rare and precious objects. In the Low Countries there developed a highly sophisticated market, especially for tulip bulbs. Avid collectors were gripped by 'tulipomania', buying a new bulb for vast sums before it had even flowered, perhaps selling it on, making ever-increasing profits. A 'futures' market thus came into existence, which, because of over-speculation, crashed disastrously in 1636.

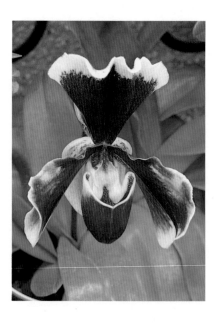

For intricate and curious beauty, there are few plants to excel orchids. From the 18th century, they have been favourite subjects of botanical artists, engaging the attention of many of the greatest names of the day.

The way in which flowering plants were used in the garden in the 17th century clearly reflects their status as desirable possessions. Instead of being grouped profusely as they are in a modern border, they were planted as individual specimens, so that their detail could be scrutinised. The international plant collector came into being to supply this market. John Tradescant and his son, also John, travelled widely in Europe in search of new plants and corresponded with other plant hunters. John Tradescant the Younger made three journeys to Virginia, bringing to Europe some of the new American plants which became keenly sought after.

Although flowering plants were incorporated into the formal designs of the great 17th-century gardens such as Versailles and Hampton Court, they were always subservient to the formal layout, and in the 18th century the landscape movement dispensed with flowers, relegating them to special gardens set aside for the purpose of their cultivation. It is only in the 19th century, as the steady stream of exotic plant introductions to Europe became a flood and garden design capitalised on the vast range of flowers that was becoming available, that flower gardening in the modern sense came fully into being. Bedding schemes using tender introductions such as dahlias developed into a craze. The rose, immensely stimulated by the interest of the Empress Josephine, was rapidly seen in every garden.

The colour theory of artists, especially that of the French Impressionists, spilled over into the world of gardening, influencing the writings of Gertrude Jekyll in England and of Louise Beebe Wilder in the USA. The cross-fertilisation between artists and gardeners took place in the other direction too, with several artists, of whom Claude Monet was the best known, taking an intense interest in the art of gardening. To Impressionists, the greatest inspiration came from the intense colours and profusion of flowering plants. Monet's paintings of his borders at Giverny and his giant and increasingly abstract canvases of water lilies show how deeply flowers inspired him. In the 20th century, living artists such as John Hubbard in Britain and Robert Dash in America (both of whose gardens are shown in this book) show the continuing vitality of that inspiration.

It was only in the 19th century that the flower border, more or less as it is known today, came into existence. Herbaceous borders were planted at Arley Hall in Cheshire as early as the 1840s. The border proved to be an orderly and harmonious way of incorporating a large number of different species into the garden scheme. In the late 19th century, and continuing vigorously into our own time, it has proved one of the most enduring of garden features in Europe and the USA where, in gardens such as Longwood and Old Westbury, they are

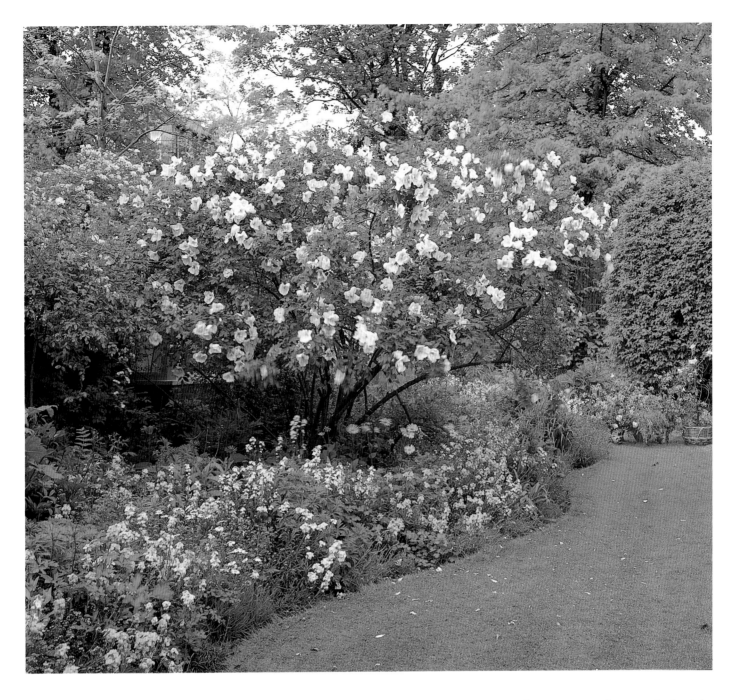

Few roses make any structural contribution to the garden. Here, the rose 'Nevada' has grown into a strikingly handsome shape, showing its wild origins and dominating the border which lies at its feet.

carried out on a grand scale. A more naturalistic approach, popularised by William Robinson in his book *The Wild Garden* (1870), encouraged the use of hardy plants only, arranged in a setting and habitat that resembled those of nature as closely as possible. This was the period of the introduction of many of the greatest flowering shrubs, especially camellias, magnolias and rhododendrons, many of which found their happiest homes in woodland gardens of wild character.

There are more flowering plants in cultivation today than there have ever been before. With the vast array at the gardener's disposal there has also arisen a consciousness of the needs of conservation. Over-collection, especially of bulbs and orchids, has become a world problem. Some plants have become extinct in the wild, surviving only in gardens remote from their native habitats. For the first time, gardeners have become aware of a moral dimension to horticulture. With the precarious survival of some species, the flower has today an even more secure position at the centre of the art of gardening.

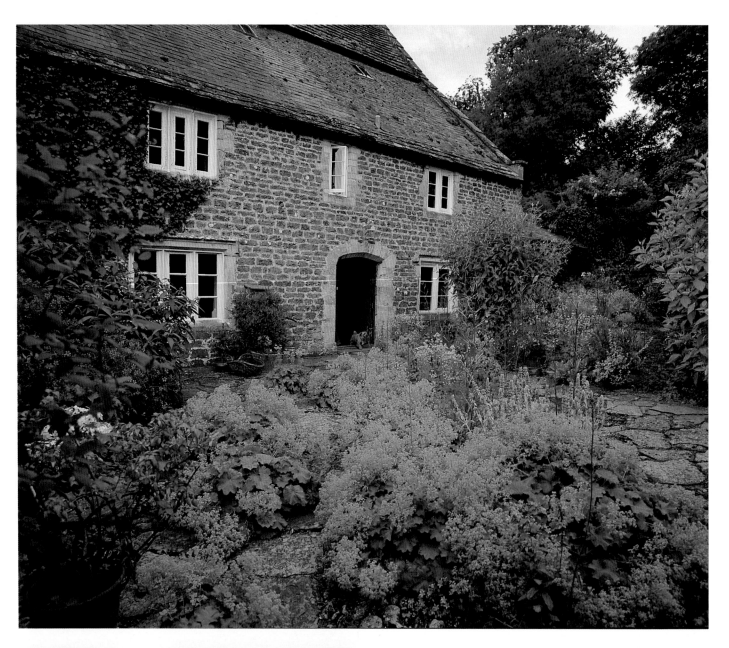

A PROFUSION OF FLOWERS, a relaxed style of planting and an unaffected delight in rich colours are essential to the cottage-garden atmosphere. A mix of lady's mantle, astrantia and lamb's lugs spills over onto a stone-flagged terrace at Chilcombe House (*above*). A brilliant little evocation of a cottage garden at Old Westbury Gardens on Long Island (*left*) shows the continuing potency of crazy paving, foxgloves and pink roses nodding over a white picket fence. An archetypal cottage garden at Tenterden in Kent (*opposite*) has a flowery path running straight as an arrow to the front door and vegetable beds pressing in on either side.

COTTAGE GARDENS MAINTAIN traditional
colour schemes, eschewing the influence of fashion.
Annuals (sharp pink cosmos and white petunias)
are mixed in charming abandon *(above)* with old
cottage-garden perennials like rich yellow golden
rod *(Solidago* species). A more painterly effect is
achieved *(opposite, above)* with salmon pink *Alstroemeria*
Ligtu Hybrid, cerise cosmos and an achillea of
subtly mixed pink and cream. Daring scarlet dahlias
(opposite, below) enliven a border late in the season.

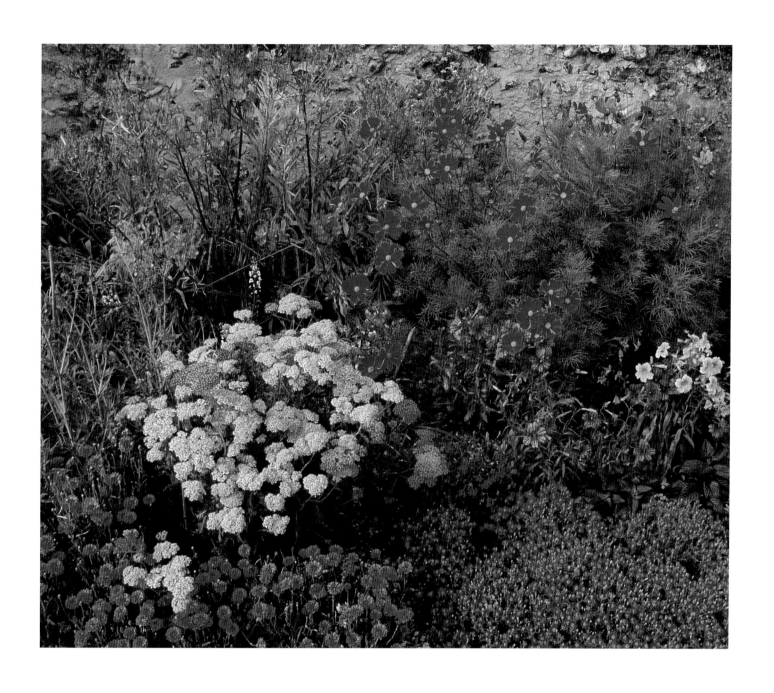

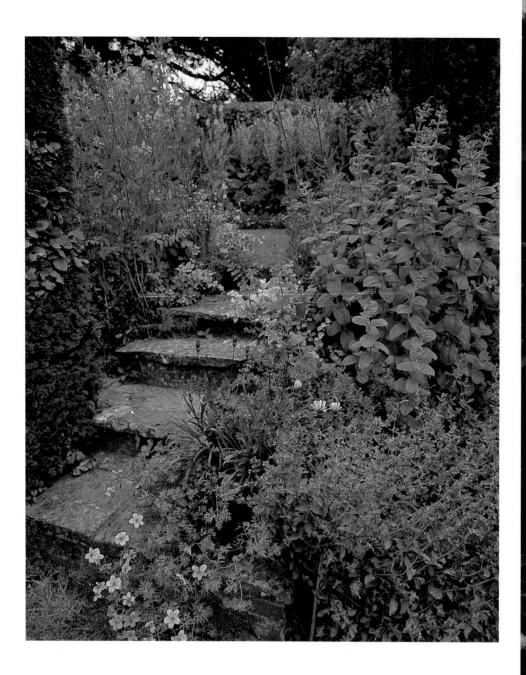

FLOWERS GIVE THE GARDEN its individual
character, even if a certain amount of formality
provides an architectural framework. Chilcombe
(above) has the special atmosphere of an artist's
inspiration. In its isolated rural position in unspoilt
countryside, too much artifice would strike a false
note. Stone steps are fringed with exotics – the
tender yellow *Bidens ferulifolia* and a pale pink arctotis
– but they are brought down to earth by the strands
of common catmint, *Nepeta mussinii*, straggling
through them. In the main flower garden *(opposite)*
blood-red hollyhocks and pink foxgloves rise over
sweetly scented *Lilium regale*, with grey *Stachys
byzantina* and pink opium poppies at their feet.

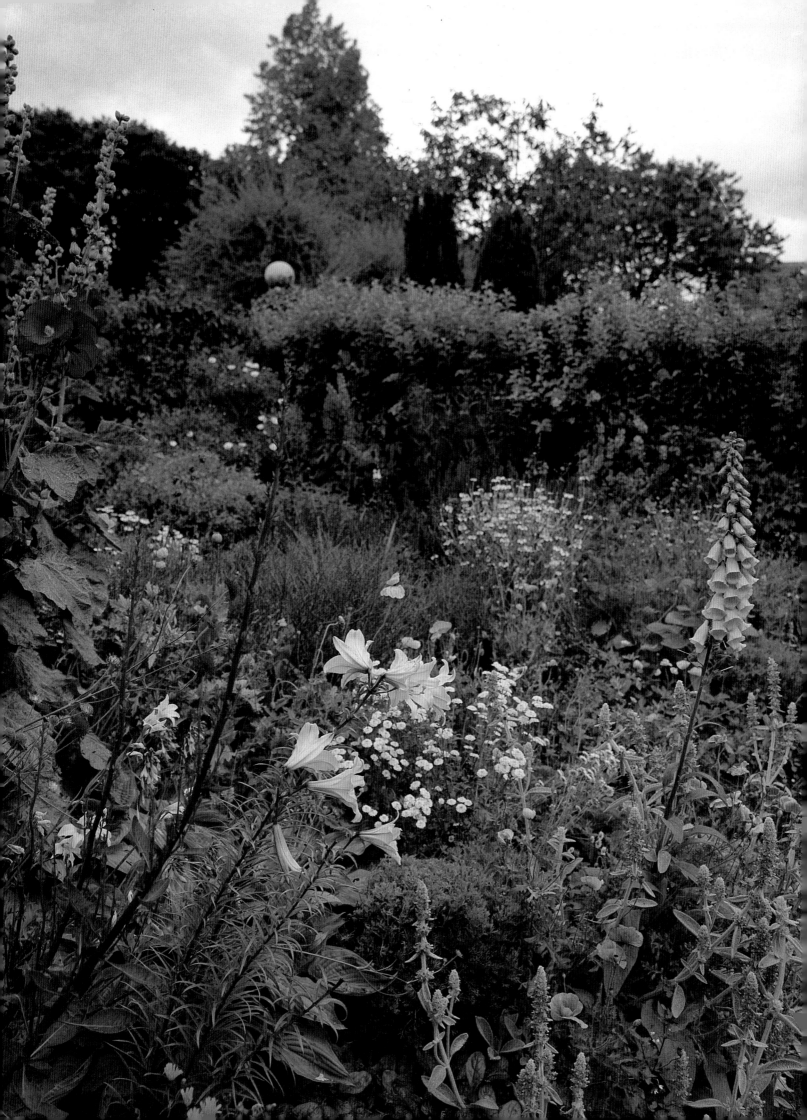

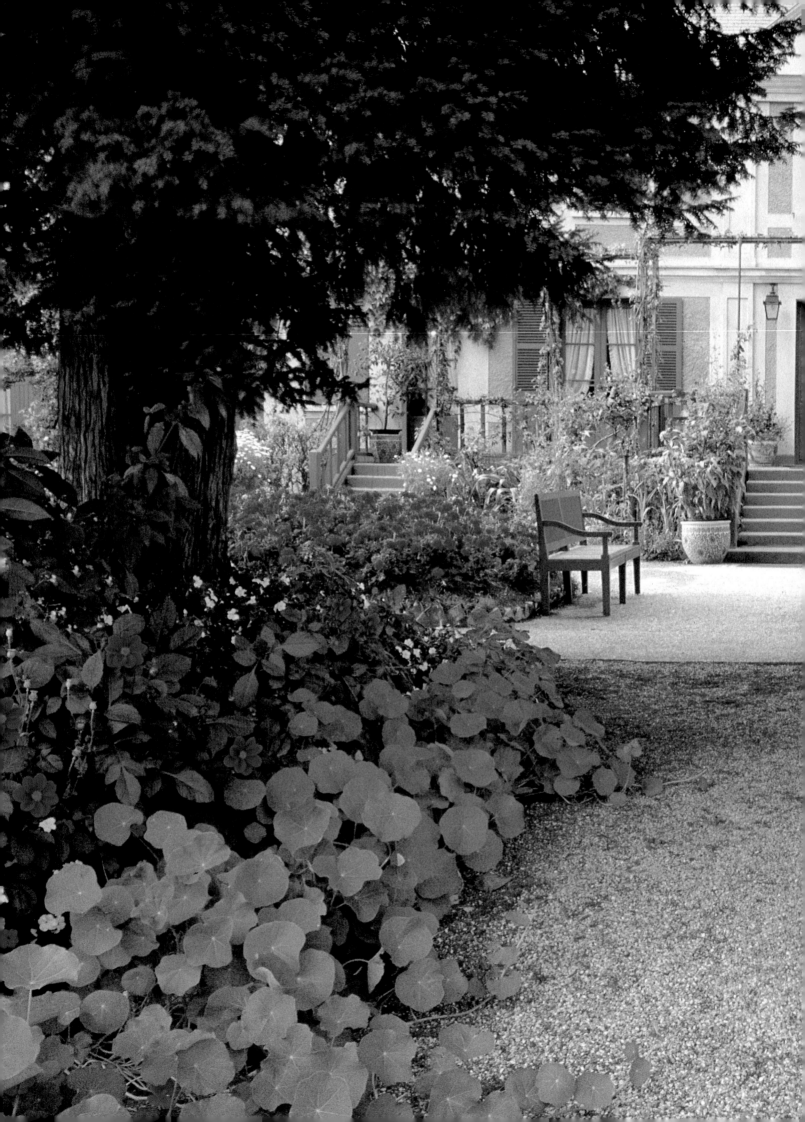

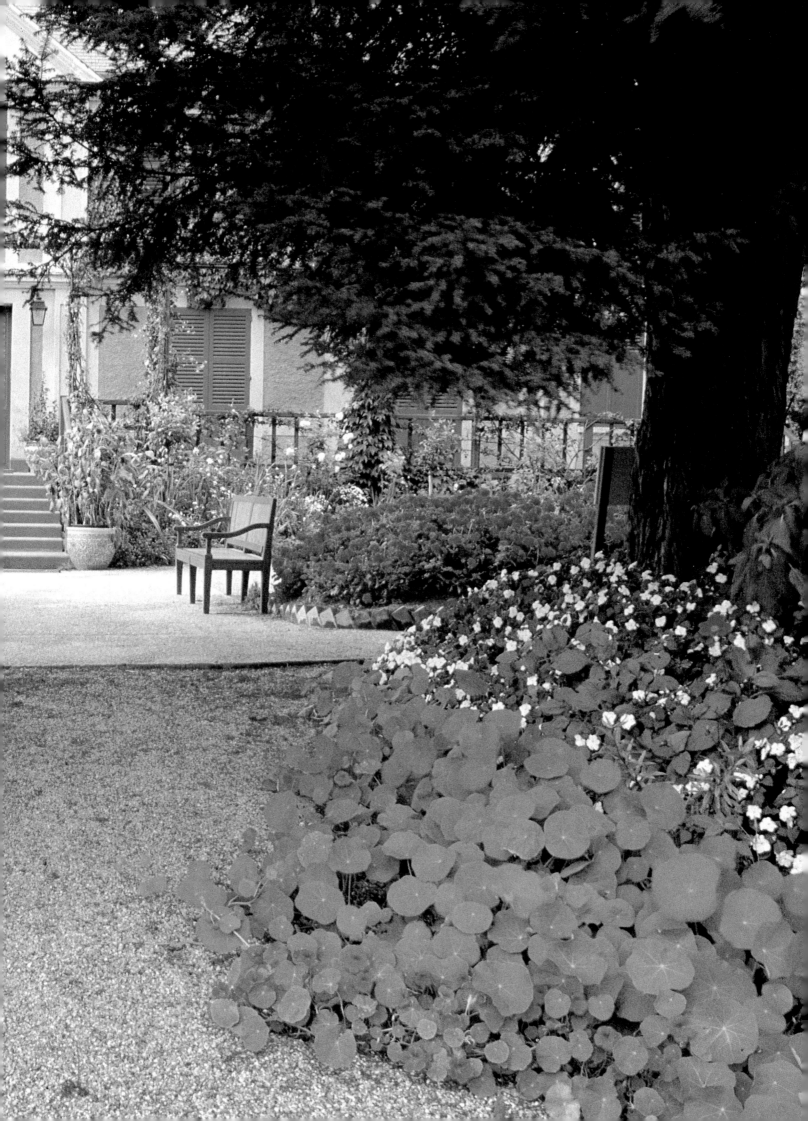

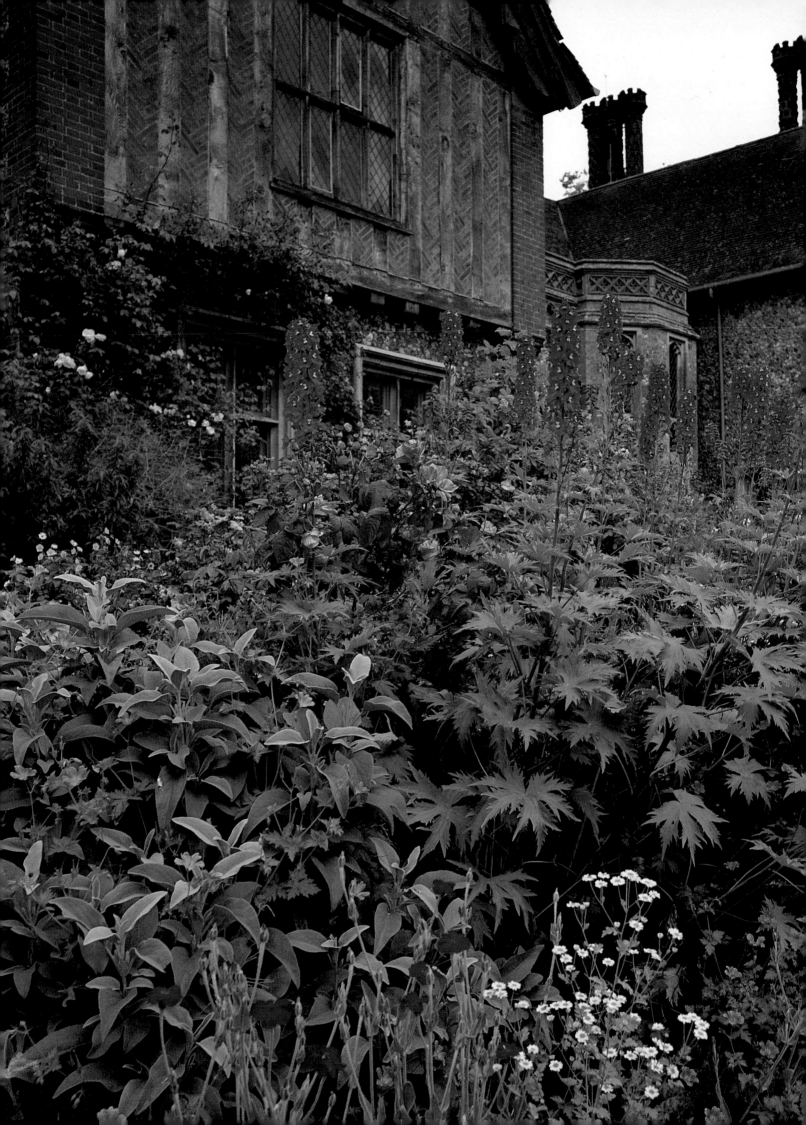

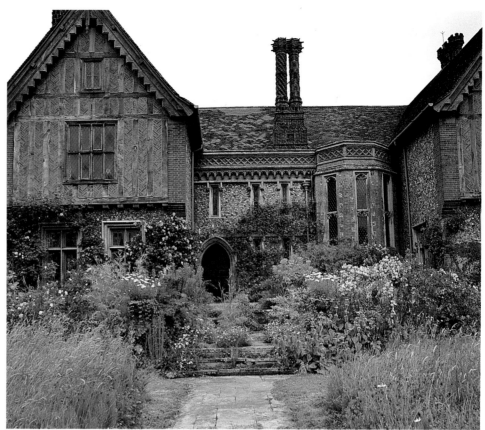

Rising organically from the informal borders in front of it, Elsing Hall in Norfolk is a magnificently romantic moated manor house whose garden is wholly in keeping with its character. Old shrub roses are used in profusion, intermingling easily with other plants and filling the air with their inimitable scent. Startling ultramarine delphiniums (*opposite*) rise above *Rosa gallica* 'Versicolor', one of the most ancient of rose cultivars. The mauve flowers of a cranesbill and the sharp magenta of *Lychnis coronaria* associate with the suede-grey foliage of common sage, *Salvia officinalis*. On either side of a path leading up to the house (*above*), the grass is allowed to grow long, with the purple heads of clover enlivening the pale seed heads of the grass.

'I am filled with delight, Giverny is a splendid spot for me,' wrote Claude Monet shortly after moving there. The garden he made was filled with colour and served as the inspiration for many of his paintings. The part of the garden immediately below the southern façade of the house is known as the Clos Normand (*previous pages*). Here, nasturtiums trail across gravel paths in the shade of yew trees. In high summer the maze of beds on this part of the garden explodes with colour. The house itself was decorated with colours chosen by Monet himself – the woodwork of shutters and steps and the garden benches are painted a special shade of green that he particularly liked.

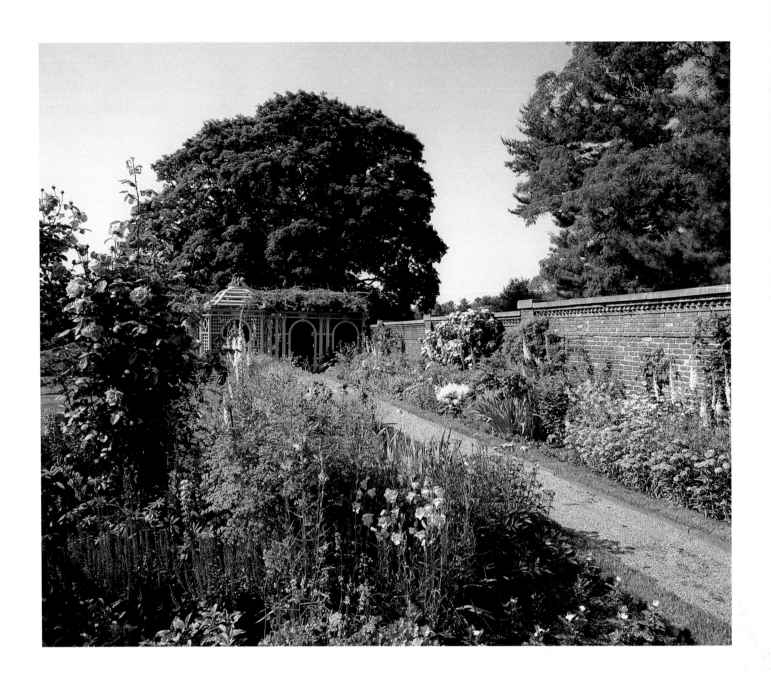

NOTHING COULD BE FURTHER from the spirit
of the cottage garden than the aristocratic borders
in the forecourt garden at the great Tudor house of
Montacute in Somerset *(opposite)*, built for a lawyer
at the court of Queen Elizabeth I. The borders run
up to beautiful late 16th-century gazebos which
look out over the ancient parkland beyond the
garden. At Old Westbury Gardens *(above)*, a skilful
evocation of an English mixed border is given
architectural emphasis by an elegant gazebo.

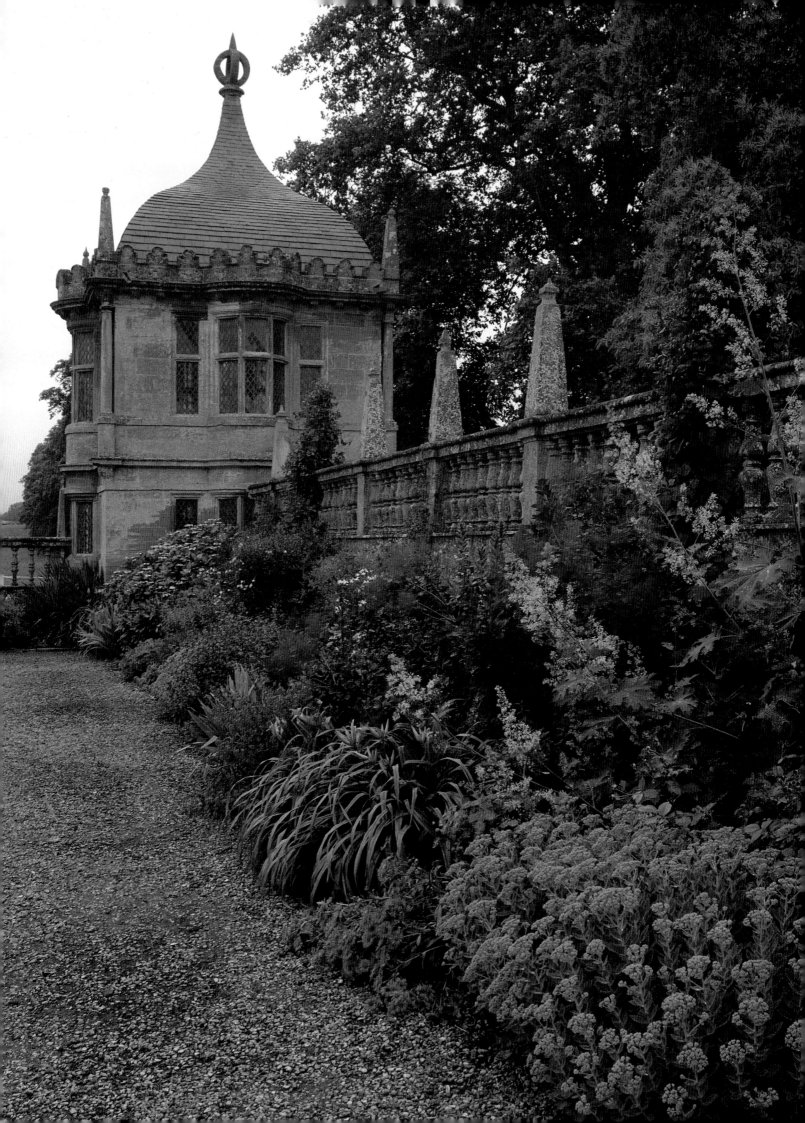

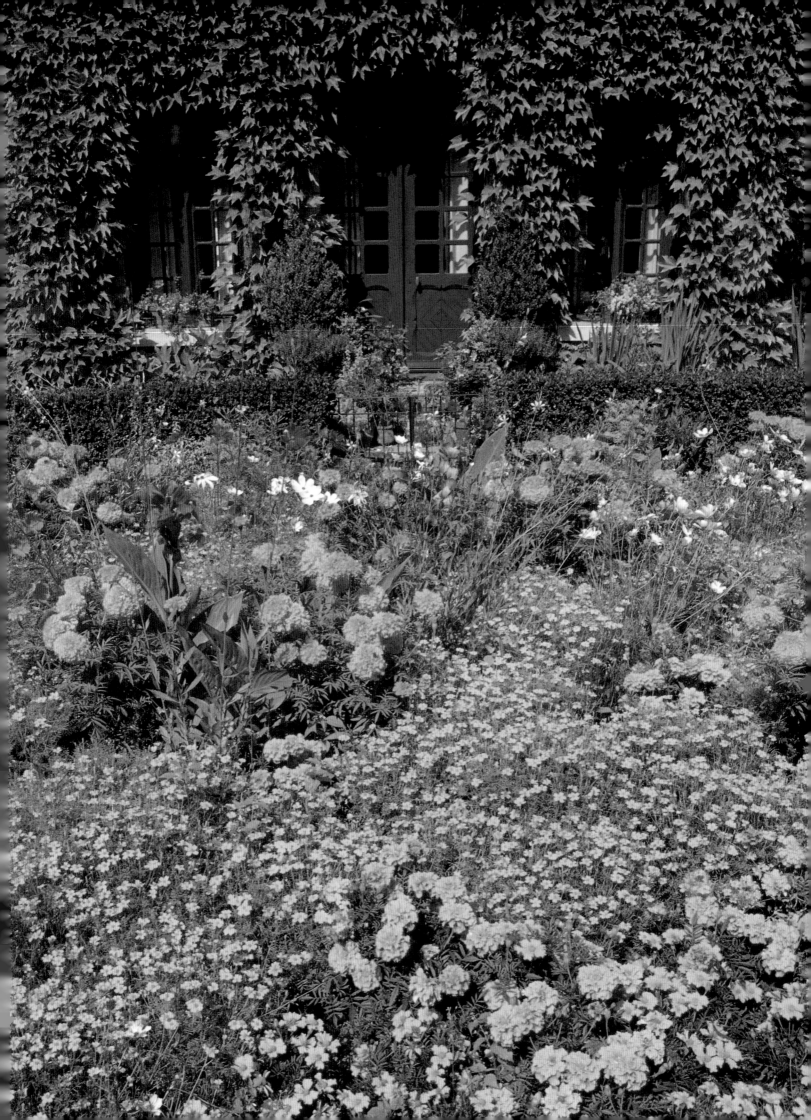

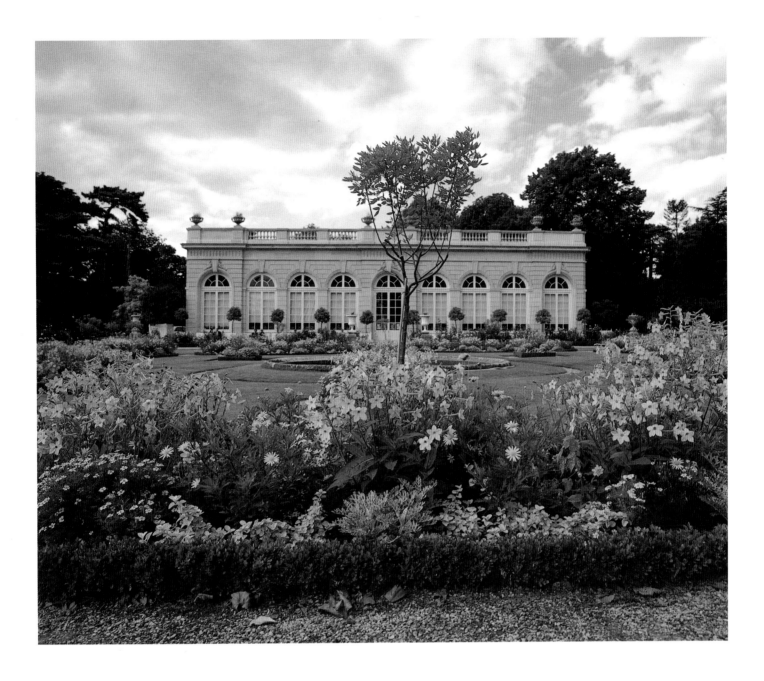

A FORMAL FLOWER GARDEN was laid out in the 19th century in front of the neo-classical conservatory in the garden at Bagatelle *(above)*. The exquisite miniature château, hidden in the Bois de Boulogne on the edge of Paris, was built to the designs of the architect François-Alexandre Bélanger for the Comte d'Artois in 1777. The garden was laid out in the fashionable English landscape style by the Scottish gardener Thomas Blaikie, who wrote an amusing autobiography in which he vividly described his tussles with his patron. Early in the 19th century, the estate passed to an Englishman, the Marquis of Hertford, who left it to his adopted son, Sir Richard Wallace. It was under Sir Richard that the conservatory was built and the flower garden created. Beyond the flower garden is an immense rose garden laid out by Jules Gravereaux, creator of France's greatest rose garden at L'Haÿ-les-Roses, south of Paris. Much use of bedding plants in the 19th-century style is made throughout the garden – the ivy-clad pavilion *(opposite)*, dating from the same period as the orangery, faces a profusion of summer bedding.

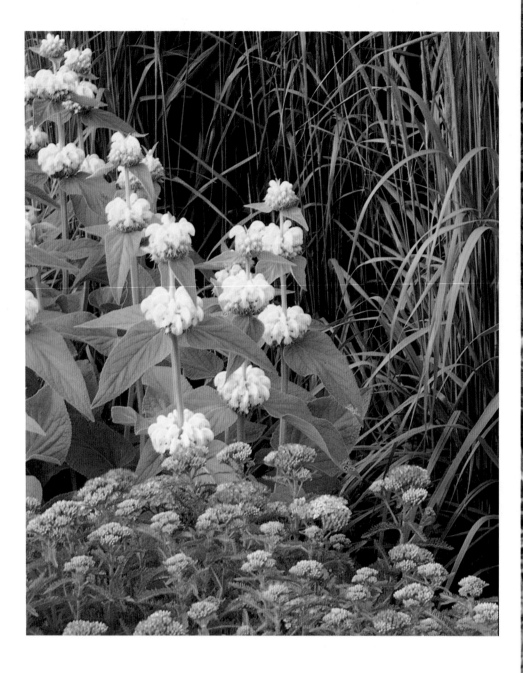

A FAR MORE naturalistic approach to planting, attempting to imitate the artlessness of nature, has been a strong influence in recent garden design. A curtain of grass *(above)* forms a decorative backdrop to the soft lemon-yellow whorls of the herbaceous perennial *Phlomis russeliana* and the strawberry pink of an achillea. A border inconspicuously merging with woodland at Old Westbury *(opposite)* has all the unaffected simplicity of the naturalistic style. White foxgloves, *Digitalis purpurea*, rise among yellow columbines – the native American *Aquilegia longissima*. Tall stems of lilies and flat, pale yellow flower heads of achilleas add structural interest.

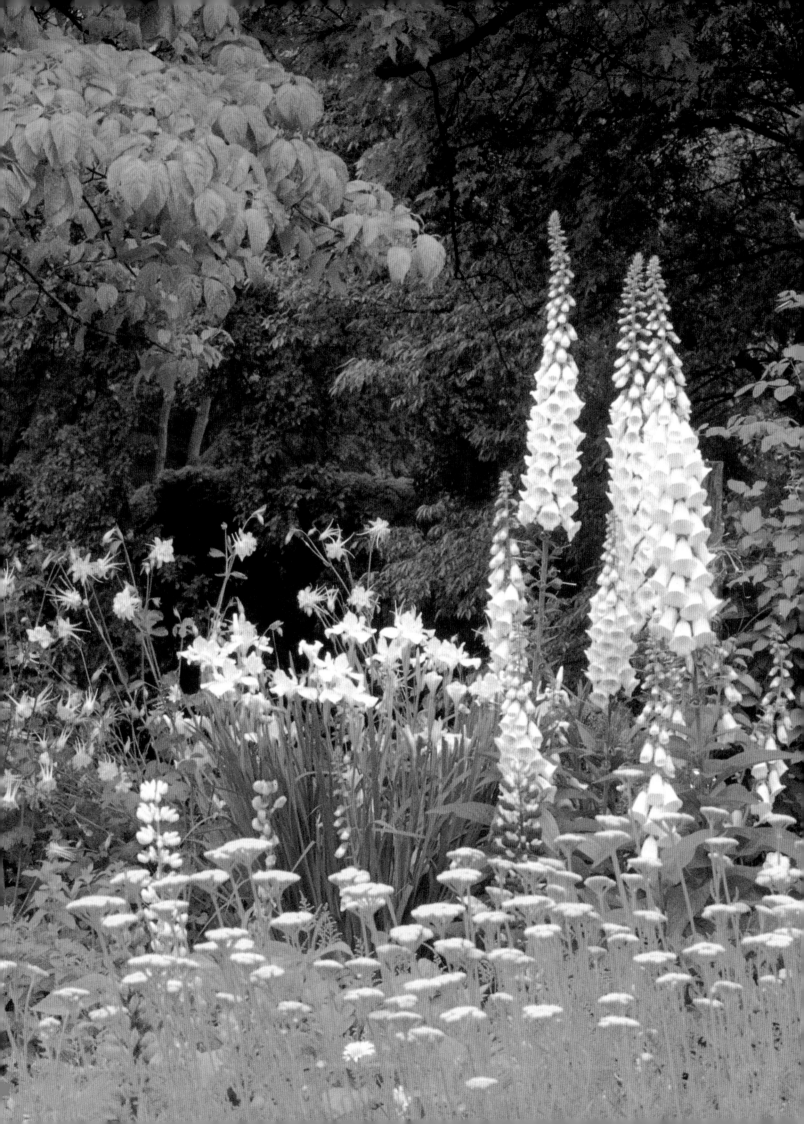

COLOUR MAY BE USED with painterly effect –
here are the subtle contrasts of the sharp purple of
Salvia nemorosa and the much softer lilac of a
cranesbill (*Geranium* species) (*opposite*). The
diminutive flowers of gypsophila (*above*) create an
airy, insubstantial cloud.

The texture of grasses — ornamental throughout the year, requiring little maintenance and with the additional attraction of lively movement — give the flower garden an extra dimension. The value of native American grasses *(above)* at Longwood Gardens, Pennsylvania has had great impact on garden design in the USA in recent years. In Europe, native plants are used naturalistically in generous drifts, giving a wild charm to the garden. The European native masterwort, *Astrantia major,* is planted on the edge of the moat at Elsing Hall *(opposite, above).*
At Knightshayes Court in Devon *(opposite, below),* the arching grass-like stems of the wandflower, *Dierama pulcherrimum,* sway elegantly over a garden path.

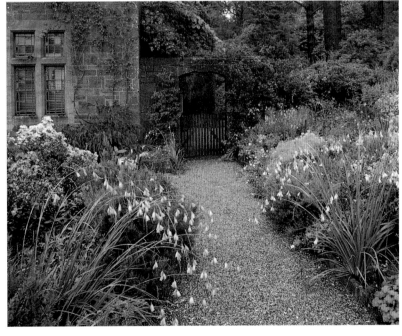

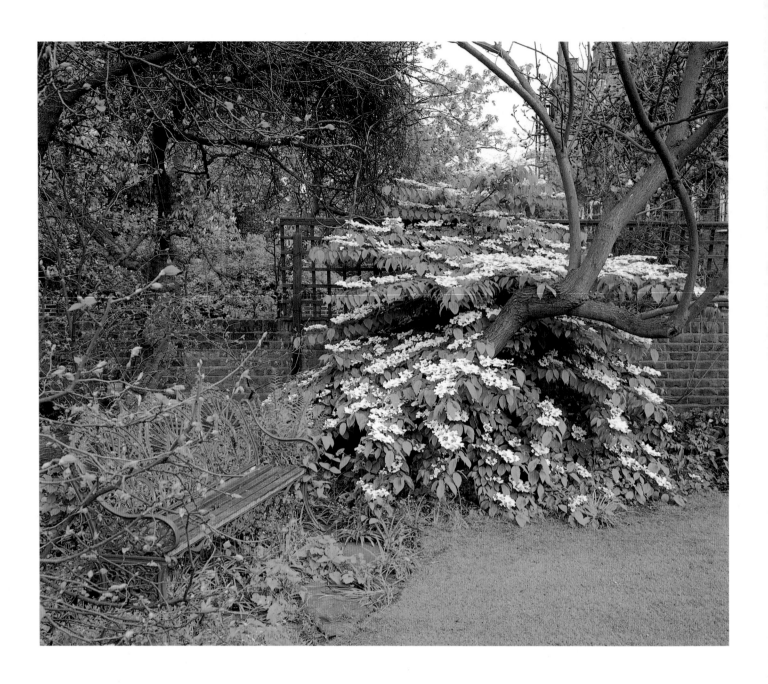

SHAPE OR HABIT is often the most striking
quality of a garden plant. The great flowering shrub
Viburnum plicatum 'Mariesii' (*above*) makes a
handsome ornament in a town garden with its
spreading, tabular growth and flat corymbs of white
flowers. The cast-iron bench is painted a decorative
blue-green, often a much more sympathetic colour
for garden furniture than the over-used brilliant
white. The froth of white flowers of *Crambe cordifolia*
contrasts with the sharply linear leaves of a
dasylirion (*opposite*) at Wave Hill in New York City.

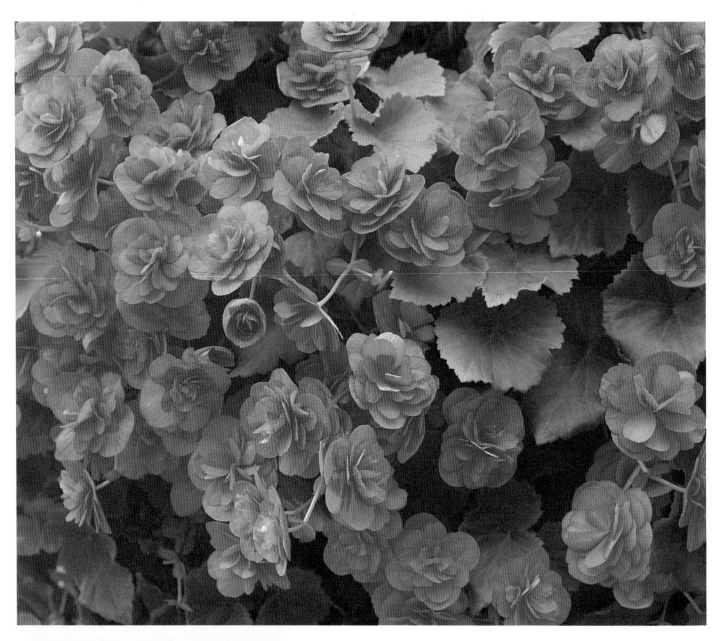

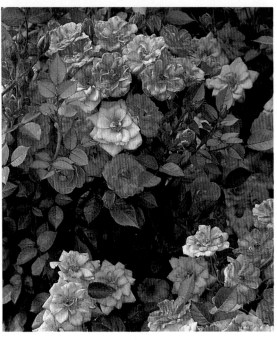

THE COLOUR OF individual flowers is the great ingredient of the flower garden. Since the 19th century, an explosion of hybridised plant forms has provided every shade of every colour that the artist/gardener could desire. Begonias (*above*), all native to the tropics and subtropics, were one of the most popular bedding plants of the 19th century. With over 900 species to draw on, they were the hybridiser's dream, producing a staggering range of leaf-form and flowers. Today, they may still be found in many old-fashioned bedding schemes. Roses (*left*), much more versatile as garden plants, also show an immense range of flower colour.

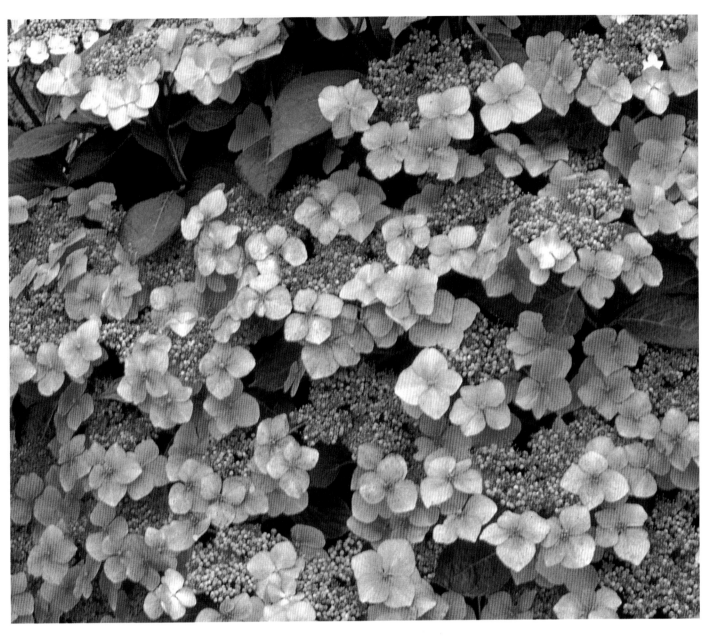

H YDRANGEAS (*above*) are widely distributed through the world. Flowering well in shade, they are valuable shrubs of understated charm. Garden varieties are derived from hybrids of *Hydrangea macrophylla* and *H. serrata*, both from Japan. Most are suitable only for acid soil, in which certain varieties will produce flowers of an intense blue. Pale pink, mauve or white are the commonest colours. Annual bedding lavateras (*right*) are derived from the Mediterranean *Lavatera trimestris*, a racy cousin of the northern European hedge mallow. Their decorative flowers, often with a darker centre, are in sumptuous shades of purple and red.

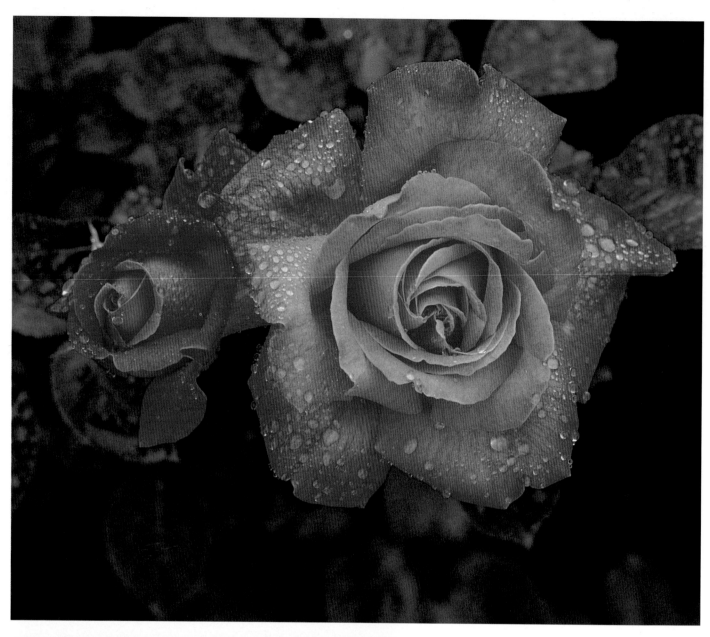

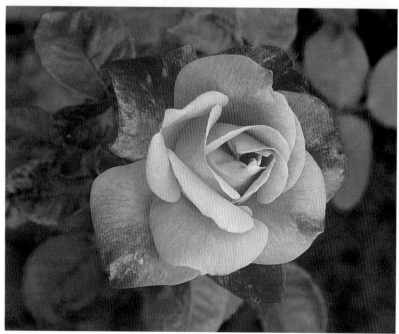

I IS HARD to imagine any 20th-century garden without at least a few roses. The craze was given tremendous impetus by the Empress Josephine in the early days of the 19th century at Malmaison just outside Paris. Here she built up a collection of over 250 varieties, and France became — and remains — a centre of rose breeding. Throughout the 19th century a stream of new introductions transformed the appearance of gardens, often gathered together in a single enclosure or bed. In the 20th century, gardeners have learned to use them in association with other plants, drawing on their great range of colours and magnificent flowers to create marvellous effects.

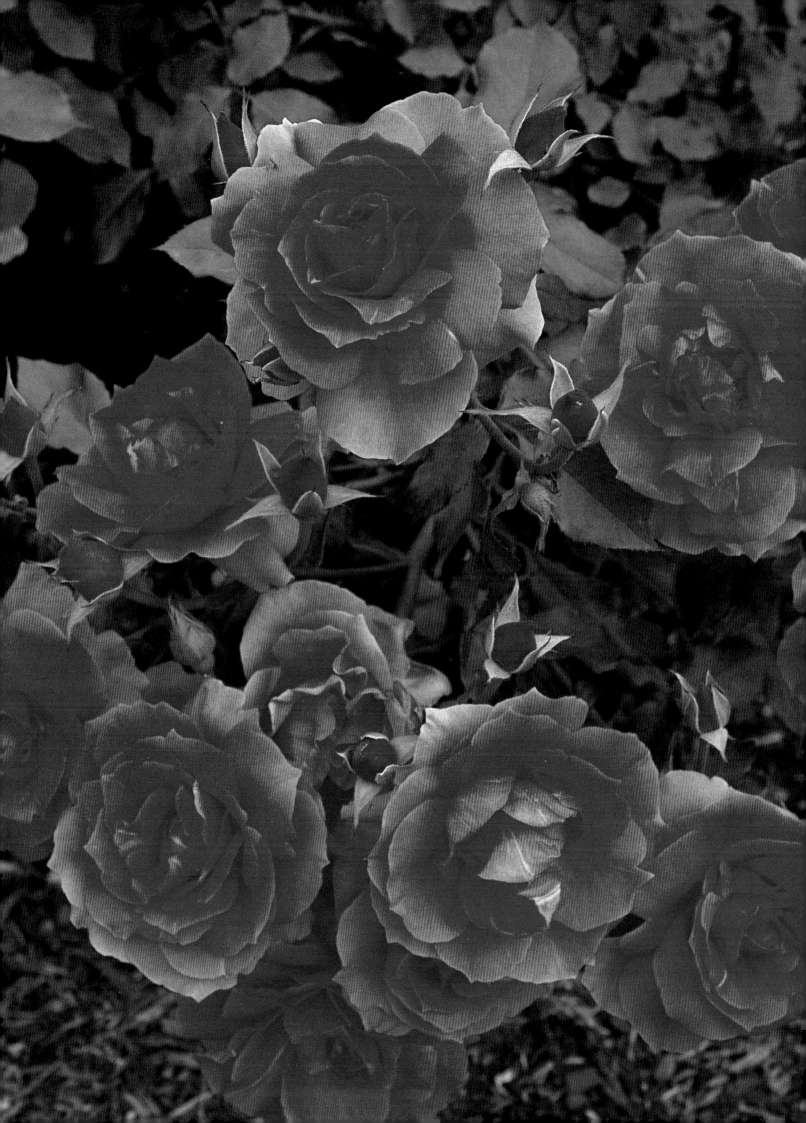

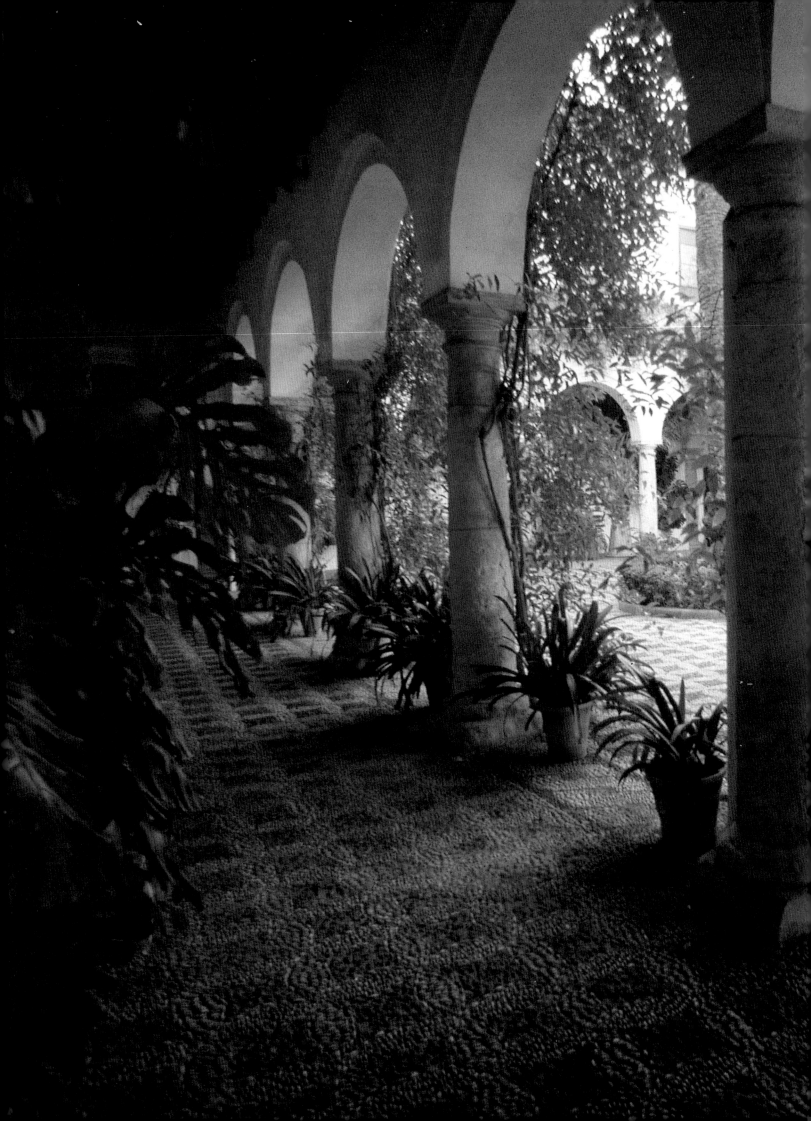

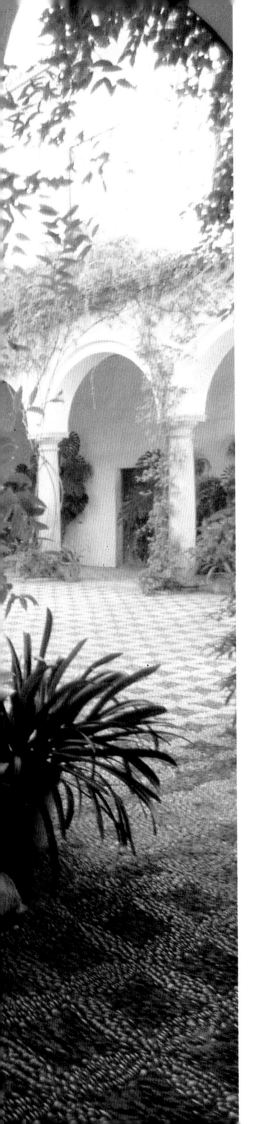

V
SPACES
AND
ENCLOSURES

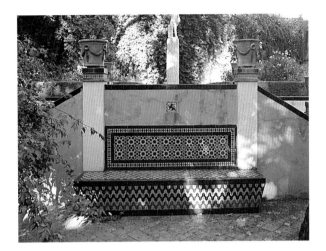

A TRADITION OF courtyard design inspired by the Moorish influence in Andalusia in southern Spain is still a potent force. The 16th-century Palácio de Viana in Córdoba, originating from the end of the Moorish period *(opposite)*, presents a virtuoso set of variations on the classical *patio* theme of elegant arcades, splashing water, tiled surfaces and intricately worked floors. The 15th-century Casa de Pilatos in Seville *(above)*, with its delicately patterned tiles and its serene cloisters, preserves an aristocratic refinement.

THE VERY WORD garden suggests protection, guarding those inside from the perils of life in the world at large. Etymologically it is the same word as 'haven'; indeed *have* is the Danish for a garden. Many other words for garden embody this notion of enclosed protection. The Persian word *pairidaeza* – from which the English 'paradise' is derived – means a fenced wall or walled space. The notion of the garden is, quite simply, that of a place where one may be protected from the dangers of the world outside.

The earliest Western gardens of which detailed pictures survive show an enclosed courtyard. Fifteenth-century Flemish miniatures give enchanting views of the essential type of medieval garden *(hortus conclusus)*. Girdled by walls or trelliswork, they are rich in the symbolism of courtly love or religion. Always nestling against the walls of a castle or great house, they are gardens on a miniature scale. Their ingredients include fountains, lawns spangled with flowers, topiary, plants in pots and, more often than not, a wimpled

lady sitting on a turf bench. Gardens with a specifically religious theme often celebrate the Virgin. These Mary gardens are full of the symbolism of purity (the fountain) and of virginity itself. The enclosure symbolises a remoteness from worldly life, and the rose, one of the commonest flowers in 15th-century garden paintings, is the Mystic Rose, the flower of the spirit of man attainable through sacrifice, with the thorns symbolising the dangers encountered on the journey. Spirituality also suffused the *patios*, or courtyards, of Islamic gardens. But the purpose of these is, in the first instance, entirely practical: to provide shelter from the sun.

Here, water was a vital ingredient because of the special meaning it had to an essentially desert people – it was water itself, in the form of the great river Guadalquivir which irrigated fertile alluvial plains, that brought the Moors to Spain in the first place. Their *patios* acquired a spiritual dimension as places of serenity, conducive to inwardness and meditation. Surviving examples in Andalusia are still imbued with this character, at once austere and sensual.

The cloisters of Christian monastic communities, closely linked architecturally to Islamic *patios*, also served a contemplative purpose. In southern countries they, too, gave protection from the sun, while in colder northern climates such spaces kept out the wind and trapped any glimmer of sunlight. There is no evidence that such spaces were ever gardened, though horticulture as such was certainly an important part of the life of a monastic community, both for culinary and medicinal purposes. The room in which medicinal preparations were stored was called the *officina*. Any plant in the modern system of plant nomenclature bearing the specific name *officinalis* usually had some pharmacological purpose.

Although the cloistered courtyard acquired a specifically religious significance, it also became a model for the formal garden. In the Italian Renaissance entirely secular gardens were inspired by its example. Many villas were built about an internal, usually central, courtyard. In the garden, however, Renaissance courtyards were always interconnected with other parts of the garden and, so far from being entirely inward-looking, would often command some marvellous view over the countryside. The arcaded or pillared *loggia*, an echo of the cloister, provided a shady sitting place from which views of the garden could be admired.

The courtyard garden fell out of favour in response to the passion for naturalistic gardens in the 18th and 19th centuries. However, the architectural garden was given splendid new life by the Arts and Crafts architects. Sir Edwin Lutyens at Le Bois des Moutiers near Dieppe and Hestercombe in Somerset, where he designed a dazzling circular courtyard, found a new seam of inspiration which resulted in some of the most attractive gardens of their type. Some designers of the *avant-garde* – of whose work far too few examples survive – were also inspired by the ancient model of the courtyard. Gabriel Guevrekian, an Armenian architect and garden designer working in France between the wars, created an extraordinary triangular courtyard for the Villa Noailles at Hyères on the French Riviera. Here, brilliantly coloured ceramic panels and geometric squares of planting were the ingredients of a remarkable modern vision. It has recently been restored with only limited fidelity. Other 20th-century architects, such as Le Corbusier and Christopher Tunnard, also took a lively interest in garden design and were inspired by the courtyard form.

A curious version of the courtyard principle is found in the back gardens of terraced houses, built in increasing profusion from the late 18th century

Three quintessential elements of the courtyard garden – enclosure, water and sculpture – are marshalled elegantly at the Palácio de Viana.

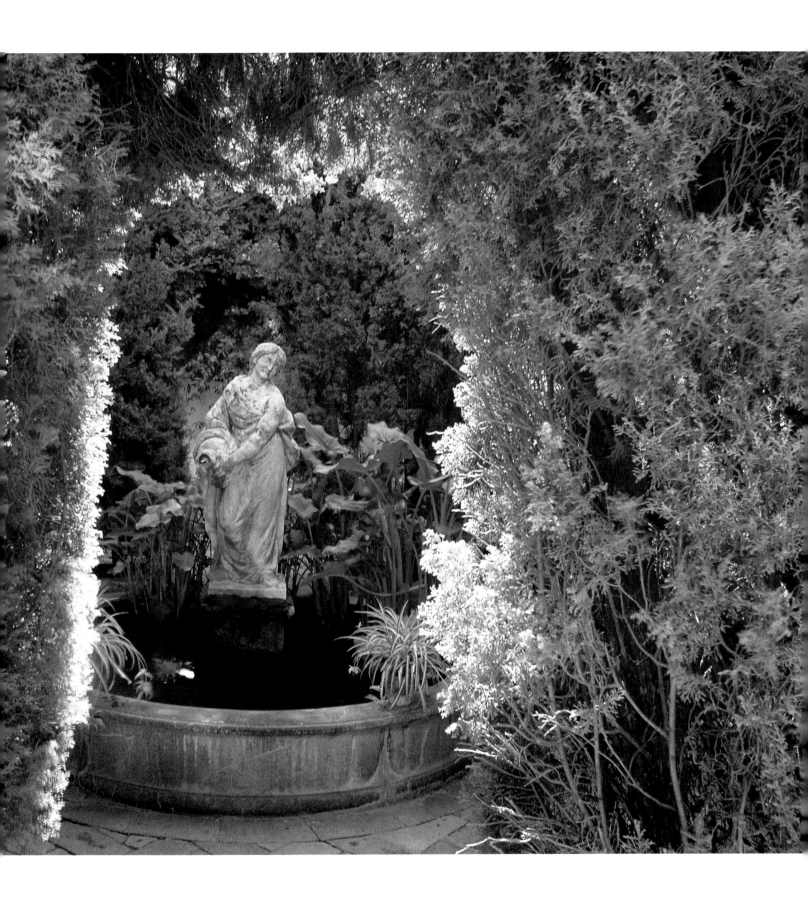

onwards, particularly in Britain. These square or rectangular spaces, usually surrounded by walls or fences, lend themselves to courtyard design. No longer places of meditation or evocations of religious symbolism, these gardens nonetheless may have some of the serenity and peacefulness which was the original character of the courtyard.

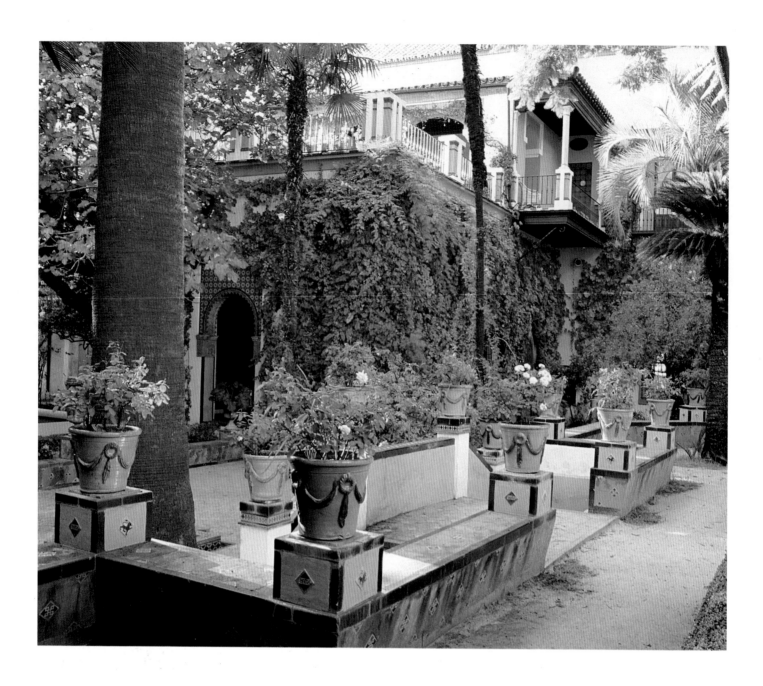

'ONE WOULD HARDLY be suprised to see Cervantes, his host and friends, pacing to
and fro over the glistening tiled pavement that is constantly flooded to cool the air,
discussing Greek philosophy, or withdrawn in a pavilion, absorbed in some fantastical
romance', was Constance Villiers-Stuart's evocation in the 1920s of the richly varied
courtyard gardens at the Casa de Pilatos, Seville (*above*). The main *patio* is severely classical
but others, such as this, are more intimate, preserving just that character. Traditional
glazed terracotta pots decorated with swags are filled with white pelargoniums, and
substantial trees – date palms, and fig trees – give welcome shade. The floor is paved and
the walls studded with ancient tiles, *azulejos*. The most exquisite of the *patios* in the
Alhambra in Granada is the Patio de los Leones (*opposite*). It lies at the heart of a palace
dating from the reign of Sultan Mohammed V in the 14th century. A central fountain and
basin is supported by carved lions and the water is taken by four runnels into the
surrounding loggias. This quadripartite division of Islamic courtyards is a symbolic
reference to the Garden of Eden described in the book of Genesis and in the Qur'an –
'And a river went out of Eden to water the garden; and from thence it was parted and
became four heads.' The arcades are ornamented with refined carving. The planting is
modern; originally the garden had multicoloured sunken beds resembling oriental rugs.

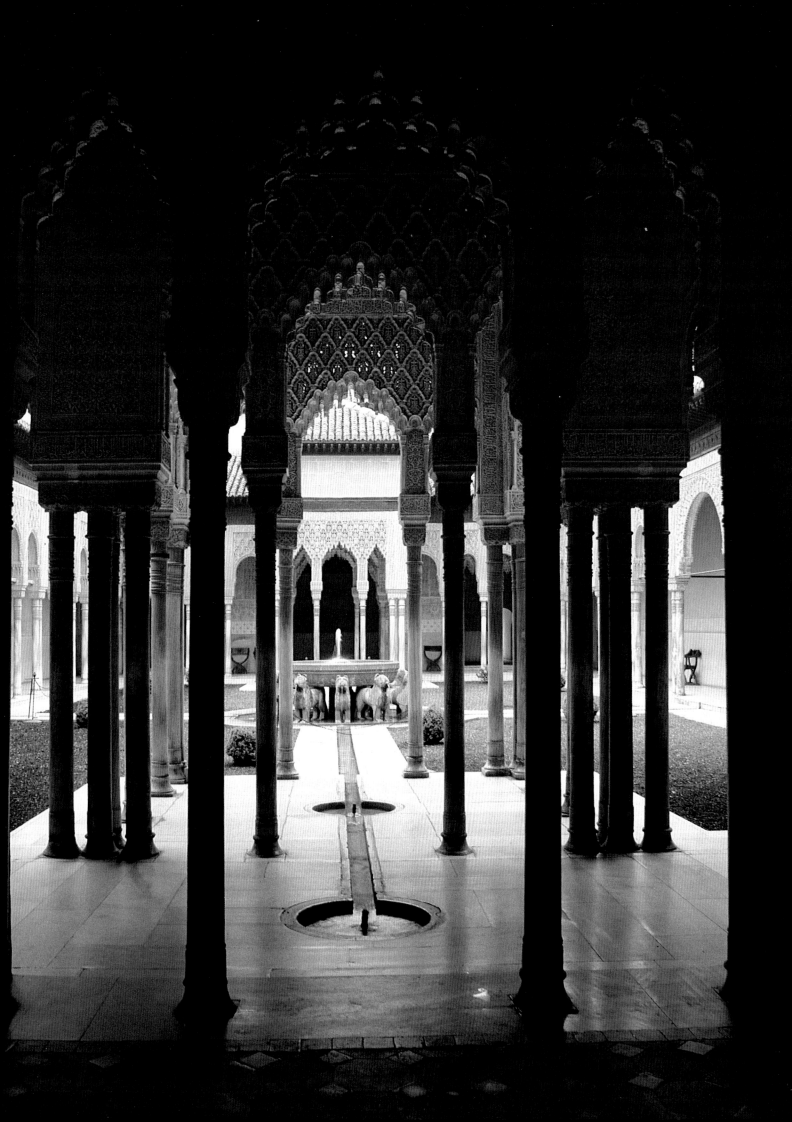

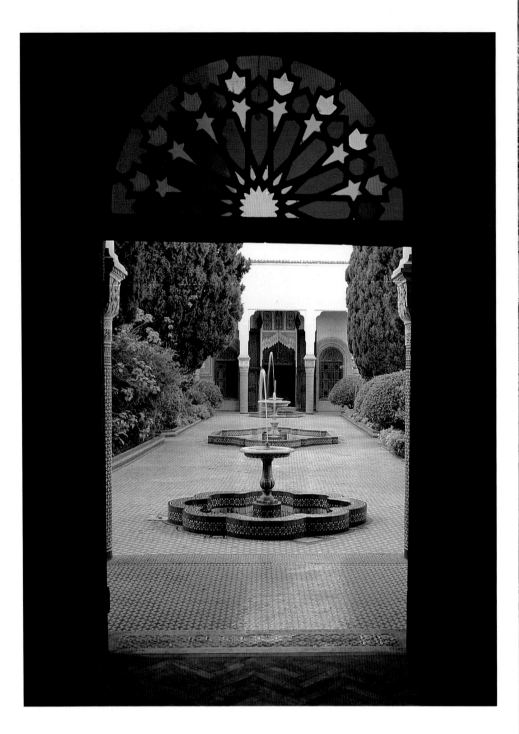

THE ISLAMIC STYLE of enclosed, inward-looking gardens orginated in Morocco, where it is still found today. In the 7th century, the country was invaded by Arabs, who converted the country to Islam; the Moors who subsequently came to southern Spain in the 8th century were their descendants. The floor and pools in the restrained *patio* design of a garden in Fez (*above*) are covered in characteristic tiles of subtle geometric patterns. The more eclectic garden at the Casa Blanca (*opposite*), also in Fez, has Moorish details (such as the finely carved panel behind the pool) but the exuberant planting, with bananas and water lilies, is entirely modern in spirit.

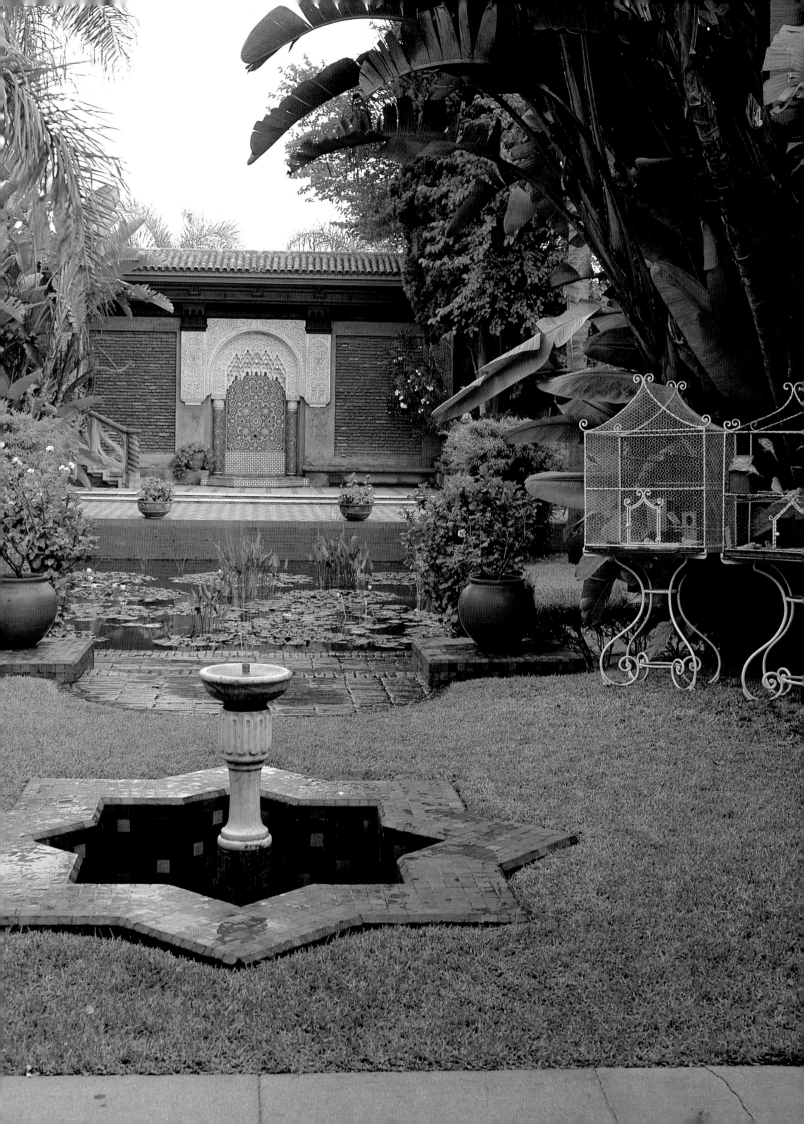

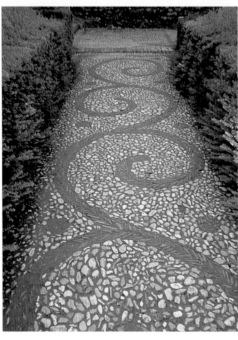

PATHS AND *PATIOS* are exquisitely ornamented with patterns of pebbles in southern Spanish gardens. The Palácio de Viana has rich variations on the theme: natural pebbles of slightly contrasting colour (*above*) are woven into a geometric pattern; pebbles of the same kinds (*opposite, above*) are given a more sophisticated, formally decorative appearance. At the Alhambra in Granada (*left*) a swirling design of roughly shaped stones lures the visitor on. In an old stable-yard at the Château de Villandry on the Loire (*opposite, below*) a fine stone urn stands in an expanse of intricately laid brick and pavers of subtle pattern.

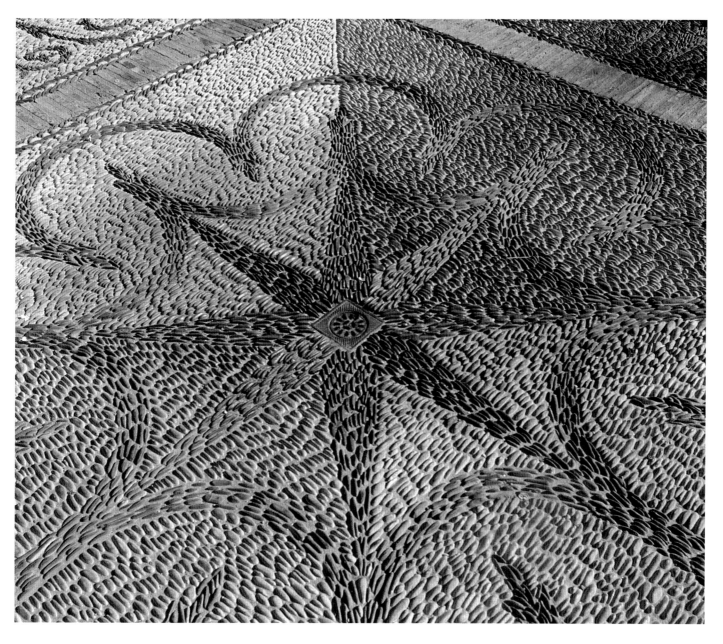

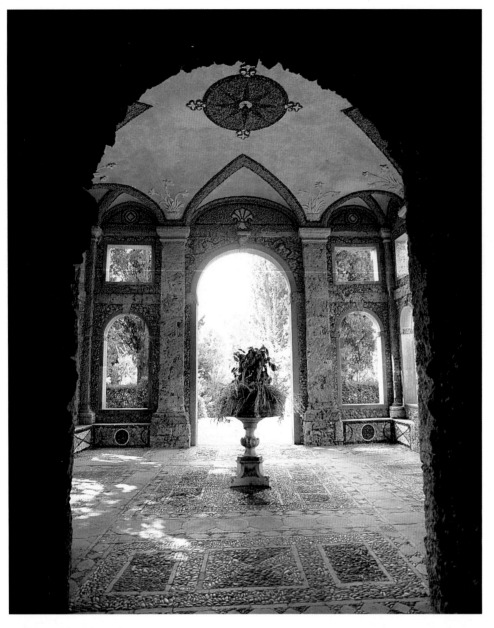

THE QUINTA DE MONSERRATE (*left, below*) at Sintra in Portugal was built in 1789 in suitably romantic style – the earliest example of Gothic revival architecture in Portugal. Monserrate preserves much of this extravagant architectural atmosphere today, but it is also one of the finest collections of tender plants – especially of trees – in Europe. The romantic woodland and plantsman's garden was strongly influenced by several generations of English owners. The disgraced writer William Beckford lived here in the 1790s and was inspired by its exotic atmosphere to write his Orientalist fantasy, *Vathek*. Lord Byron visited, and was impressed by the 'horrid crags by toppling convents crowned'. Between the wars, the then owner, Sir Herbert Cook, employed 74 gardeners here.

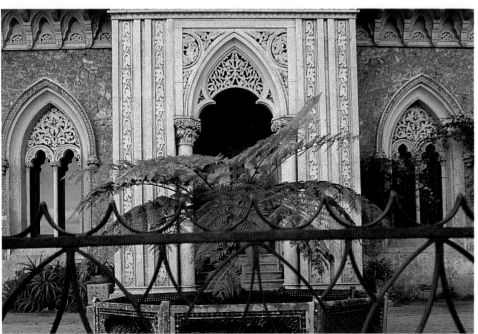

THE VILLA REALE near Lucca contains romantic 17th-century gardens laid out for the Orsetti family. However, incorporated in the garden are much earlier features, such as the 16th-century Bishop's Villa, Villa del Vescovo (*opposite*), an elegant pavilion built around a central courtyard. This pavilion, and various other of the garden features, were well-known to contemporary travellers, for example, the Grotto of Pan (*left, above*), swathed in vines and concealed in the woods, was visited in the late 16th century by the French writer Montaigne. The interior ceiling is domed and classical while the exterior is elaborately decorated with tufa and mosaic.

GREEN RETREATS in great cities defy the
limitations of space. Gardeners have shown great
ingenuity in creating gardens at the foot of shady
basements or perched at the very top of residential
buildings. Successful gardens in such demanding
sites always use plants that are well adapted to their
setting. New York City offers many remarkable
examples of this challenge to urbanisation. A paved
courtyard *(above)* uses plants such as rhododendrons
and hydrangeas which will flourish in a shady place.
A sky-high garden *(opposite)* capitalises on
spectacular views to create an out-of-doors room
of great character. In this exposed position, plants
grown in low containers give plenty of colour but
are shielded from the brunt of the wind.

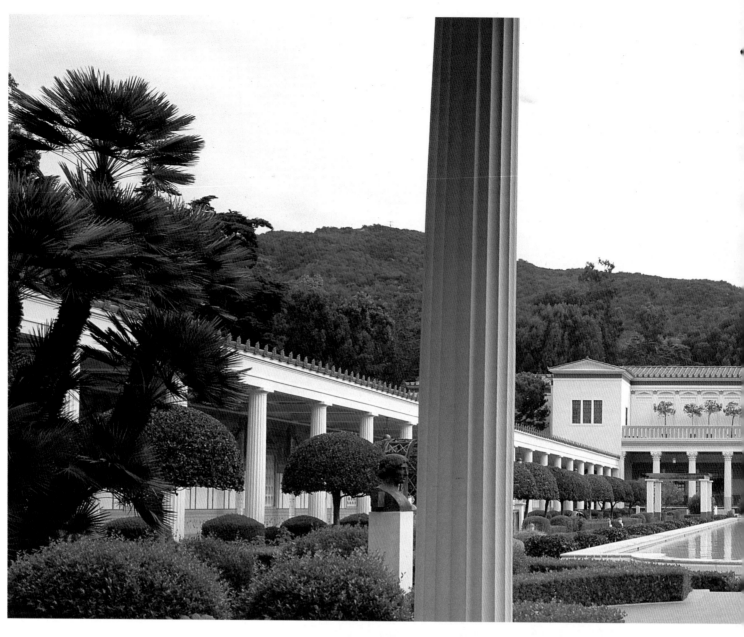

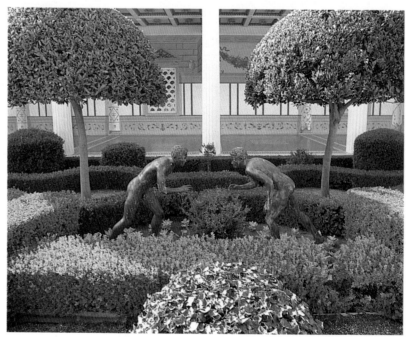

Creating a green space in the urban jungle is one of the most attractive adventures in gardening. In New York City (*previous pages*) the challenge has been triumphantly met in this flower-filled border, where a lavish mixed planting of herbaceous perennials and shrubs show the rich possibilities of such a setting. Even trees are a possibility – a soaring silver birch throws down the gauntlet to the distant skyscrapers.

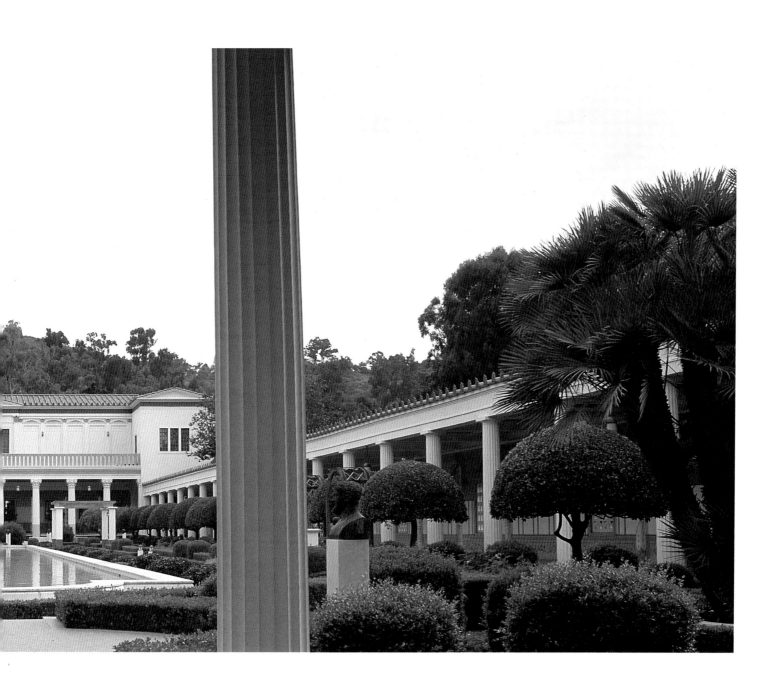

COLONNADES FLANK a long central pool leading up to the main range of the J. Paul Getty Museum *(above)* at Malibu on the coast of California. It is housed in a meticulously reconstructed Roman villa based on a 1st-century AD original, the Villa dei Papiri on the slopes of Mount Vesuvius, destroyed in the great volcanic eruption of 79 AD. The museum has a major collection of classical antiquities for which the villa provides a magnificent and appropriate setting. The plants used in the gardens are those that might have been found at an aristocratic Roman villa of the period, and the planting is strongly formal, in keeping with the disciplined classicism of the layout. Bay, *Laurus nobilis*, that essential Roman plant, is clipped into topiary mushrooms. It was Pliny the Elder who first described the use of topiary *(topiaria opera)* in Roman gardens of exactly this date. Two bronze figures of the Discus-thrower *(left)* – one of the perennial subjects of classical statuary, subsequently copied in countless garden ornaments – are enclosed in low hedges of box, *Buxus sempervirens*, with a clipped mound of European ivy, *Hedera helix*, in the foreground. The bold sculpturesque shapes of the planting provide a fitting background for the statues.

Minimalist architecture and the simplest of planting are juxtaposed on a shady deck (*left*) where a topiary juniper makes a sculpturesque pot plant. This garden, like many in California, seems especially suited to the spirit of the place. A Mediterranean flavour pervades the leafy sitting place in a courtyard (*above*), but the ingredients are characteristically eclectic. A terracotta oil jar is fringed with Japanese anemones, and waves of the pretty but invasive Mexican daisy, *Erigeron karvinskianus*, lap about the paving. The relaxed atmosphere of this out-of-doors room, with appropriately laid-back planting, is found only in places with a climate as benign as that of coastal California.

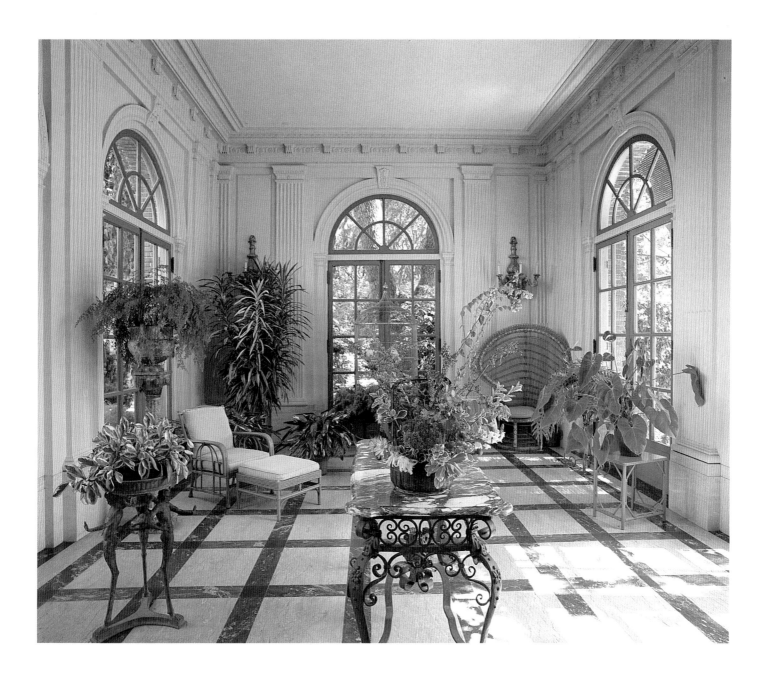

A BEAUTIFULLY DETAILED garden house in
Filoli Gardens in San Francisco (*above*) reveals the
strong influence of the English Georgian style,
evident too in the architecture of the great mansion
built by William Bourn II in 1915. The gardens
were laid out by the designer Bruce Porter, with
Bourn's active participation. They contrived sixteen
acres of richly eclectic design that are the epitome
of the Californian estate garden on the grandest
scale. Bourn's father was a Gold Rush Californian
who came to the state in the 1850s to make an
immense fortune. The name is an acronym derived
from Bourn's credo – 'Fight for a just cause, love
your fellow man, live a good life.'

VI
COLLECTORS' GARDENS

A MAGNIFICENT dream-like landscape at Lotusland,
Santa Barbara, is fashioned from both native American
and exotic planting in a naturalistic setting.
Sculpturesque agaves (*opposite*) flank the entrance to a
jungle of Chilean wine palms, *Jubaea chilensis.*
The stalkless flowers of cacti (above) appear to cling
to their bulbous, water-storing stems.

T HE URGE TO COLLECT plants has been known ever since
their systematic study first began. One of the earliest
documented plant collectors was Father Henry Daniel, a
Dominican friar living in Stepney, London, in the 14th
century. In his garden he grew 252 different kinds of herbs, many
of which he seems to have gathered in the wild. This may not seem
a very large number by the standards of modern gardens, but in its
day it was an extraordinary collection. By the end of the 14th
century in England, the number of plants generally cultivated in
gardens was not much more than 100 and, by the end of the
medieval period, at the beginning of the 16th century, it was only
about 200. So Daniel was a pioneer, both as a knowledgeable
botanist and a skilful collector. He also wrote learnedly about
plants and his surviving manuscripts provide precious sources of
information about taste in plants at the time.

It is only in the Renaissance that the systematic study of plants
was widely practised. Botany, like other branches of science,

engaged the attention of some of the cleverest intellects of the day. The Flemish botanist Charles de l'Ecluse (1526-1609) – or Carolus Clusius as he was known in Latin – was a central figure in the new learning. He studied plants in the field, especially in southern Europe, and was a great influence in the developing fashion for tulips which he propagated from bulbs sent from Constantinople. He became the first director of the Hortus Academicus at Leiden University, where the garden he created has been reconstructed most charmingly. Clusius was plainly interested in the beauty of plants as well as their scientific aspects. It is fitting that one of the prettiest tulips, *Tulipa clusiana*, is named after him.

In Europe the first flurries of collecting were devoted to plants indigenous to the continent but, hand in hand with the great voyages of discovery, the study of the flora of other parts of the world began. This revealed immense new riches which started to flow back to European collections. North America, particularly through the Virginia Company, was an early focus of interest. In the 17th century John Tradescant, father and son, brought back many American plants to England. They were part of an American/European network of plant collectors whose exchanges of knowledge and plants tremendously enriched both botany and gardening. A new breed of plant collector, the knowledgeable gentleman-amateur, appears for the first time in the 17th century. Henry Compton, Bishop of London from 1675 to 1713, built up a formidable collection in his garden at Fulham Palace where, in the words of a contemporary, he 'had about 1000 species of exotick plants in his stoves [i.e. glasshouses] and gardens'. The 17th century also saw the start of Florists' Societies. These had nothing to do with flower shops – they were groups of individuals who collected and studied individual groups of herbaceous plants, with a particular interest in garden varieties. Among the flowers in which they took a special interest were tulips, auriculas, hyacinths, anemones and pinks. The members of the societies were from the middle classes, usually based in cities. They were the first plant societies and had considerable influence on the development of garden plants.

The heyday of plant collecting was in the late 18th and early 19th centuries. When the first catalogue of plants at Kew was published in 1768 there were 3,400 plants in the collection. By 1789 it had grown in size to 5,600 plants. This was the result of the remarkable activities of Sir Joseph Banks who had sailed to Australia with Captain Cook and organised a dazzling series of plant-hunting expeditions. Bringing back seed was simple enough but the problems of keeping living specimens alive during very long voyages exercised plant hunters until the invention in the 1830s of the Wardian case, a sealed glass case in which the plant would not lose moisture, enabling it to survive a long journey in perfect condition.

The Himalayas in the 19th century were one of the great hunting-grounds for plant collectors. Sir Joseph Hooker, who became Director of Kew in 1865, had embarked in the 1840s on a study of rhododendrons in the Himalayas, which had a decisive effect on the taste for the great flowering shrubs, as can be seen today in such gardens as Trebah in Cornwall. Another collector to specialise in the east was E. H. 'Chinese' Wilson, who organised plant-hunting expeditions to China on behalf of the Arnold Arboretum at Cambridge, Massachusetts, of which he became director. He sent back fabulous new specimens, generally of shrubs and trees, but with the occasional perennial such as the superlative *Lilium regale* – today deservedly one of the most popular of garden bulbs.

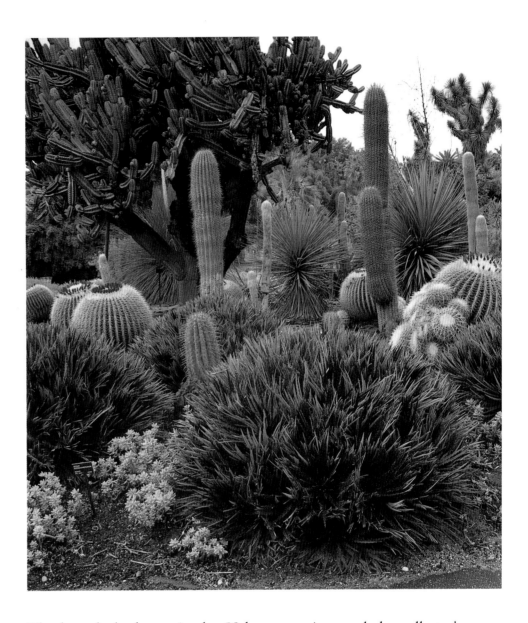

The collection of cacti in the Desert Garden at the Huntington Botanical Gardens in California is a remarkable representation of the desert flowers of southern USA and central Mexico. Over the years it has been rearranged to form an astonishing landscape deploying a vast repertory of plants.

The heated glasshouse in the 19th century increased the collector's scope immensely, allowing the cultivation of tender plants. Orchids – the largest group of all flowering plants, and largely from the tropics – became the focus for passionate collection. The royal orchid nursery, Sanders of St Albans, sold immense numbers of tender exotics and was at the centre of the orchidomania that gripped wealthy collectors in the 1880s.

In Europe, with its relatively small indigenous flora, the focus of collection has long been on new exotics from more richly endowed habitats. North America, with a vast native flora, is a different matter – from quite early in its history knowledgeable collectors assiduously studied native plants. John Bertram, a Pennsylvania farmer, visited many other parts of his country collecting plants, and through contacts with English plantsmen, became a vital source in Europe of North American plants. With the opening up of the West in the late 19th century even greater treasures were revealed, of very different kinds. In the Pacific north-west marvellous trees and shrubs flourished in the mild climate with its very high rainfall. In southern California, where the climate was entirely different, the astonishing riches of drylands plants proved a fascinating subject for collectors in places like Lotusland. In modern times the collector's plant has become the gardener's, too, as cacti and other succulents are used as garden plants to brilliant effect.

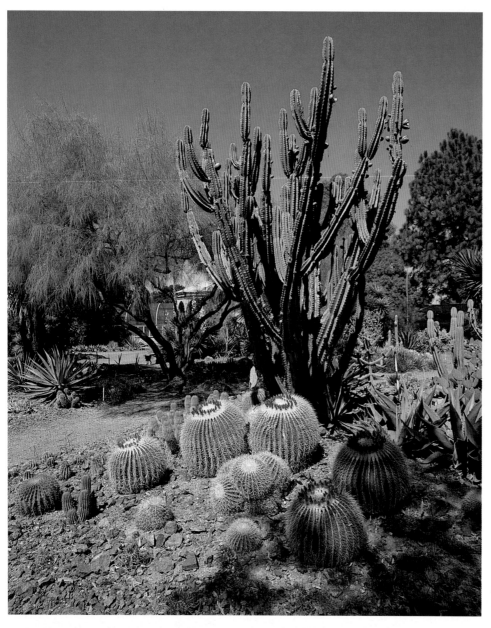

THE RUTH BANCROFT garden at Walnut Creek near San Francisco is the result of an obsession that started over forty years ago. Although many other plants are grown in the garden – including 1,000 cultivars of irises – it is the succulents that form the heart of this extraordinary collection. Low-growing aeoniums and sedums (*opposite*) hug the ground, throwing out delicate spires of flowers. Cacti (*left, above*) range widely in size and shape. The great Mexican *Agave americana* (*left, below*) has a marvellous sculpturesque quality which reaches its zenith with the unfurling of its immense flower stems, capable of reaching 30ft/9m in height. It takes many years to reach this stage and flowers only once.

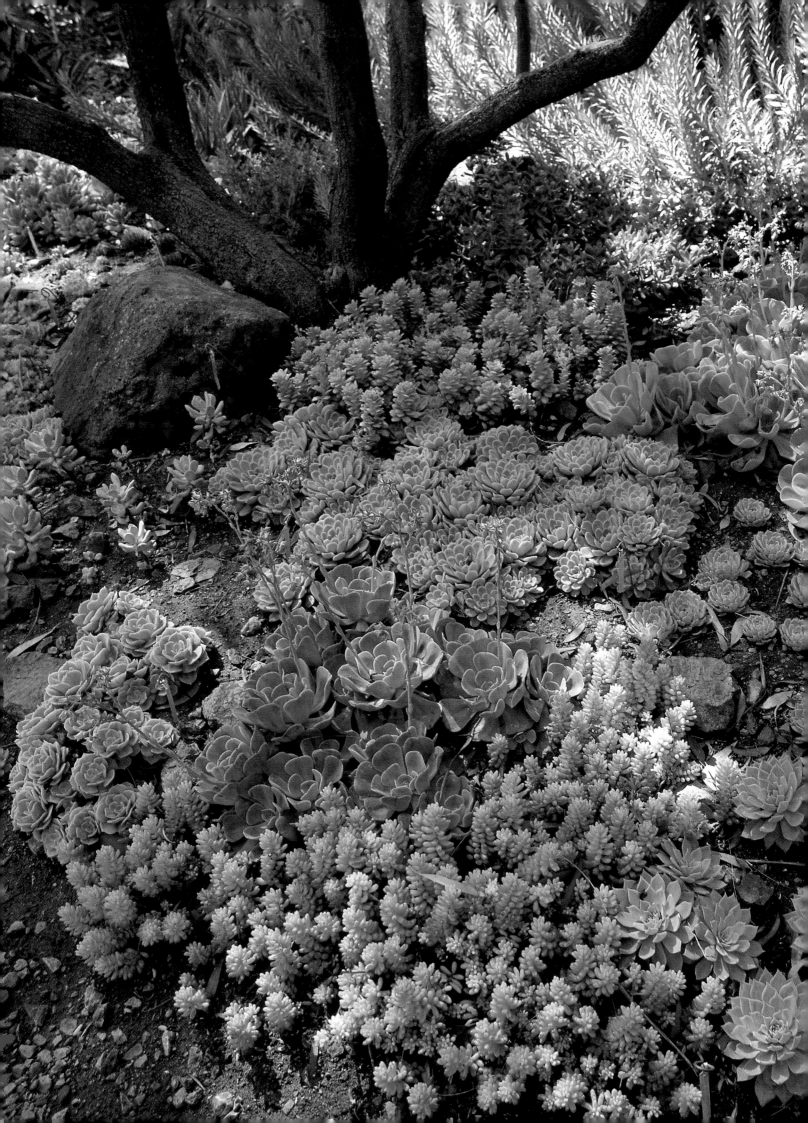

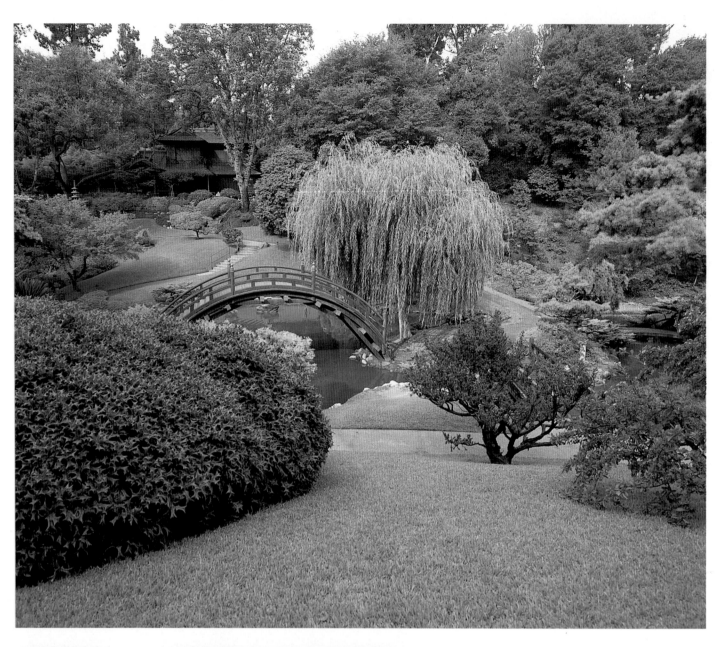

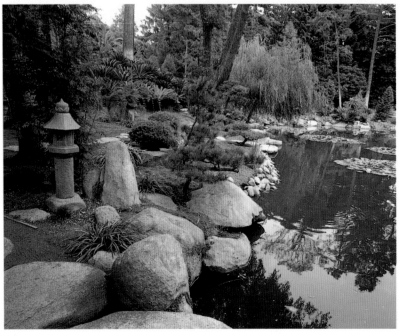

The Huntington Botanical Gardens at San Marino near Los Angeles form one of the most distinguished plant collections in the USA. It was assembled by a pioneer railroad builder, art collector and benefactor whose ranch became, in 1903, the nucleus of a collection that now covers more than 150 acres and contains over 20,000 different plants in finely designed pleasure gardens. The Japanese garden (*above*) was created in 1911 at the height of the fashion for the Japanese style in the USA; the traditional moon bridge is overhung with weeping willow, *Salix babylonica*. Two stone lion dogs guard the way into the garden (*opposite*). In a Santa Barbara garden (*left*), a naturalistic pool is embellished with plants of striking foliage, rockwork and a Japanese snow-lantern.

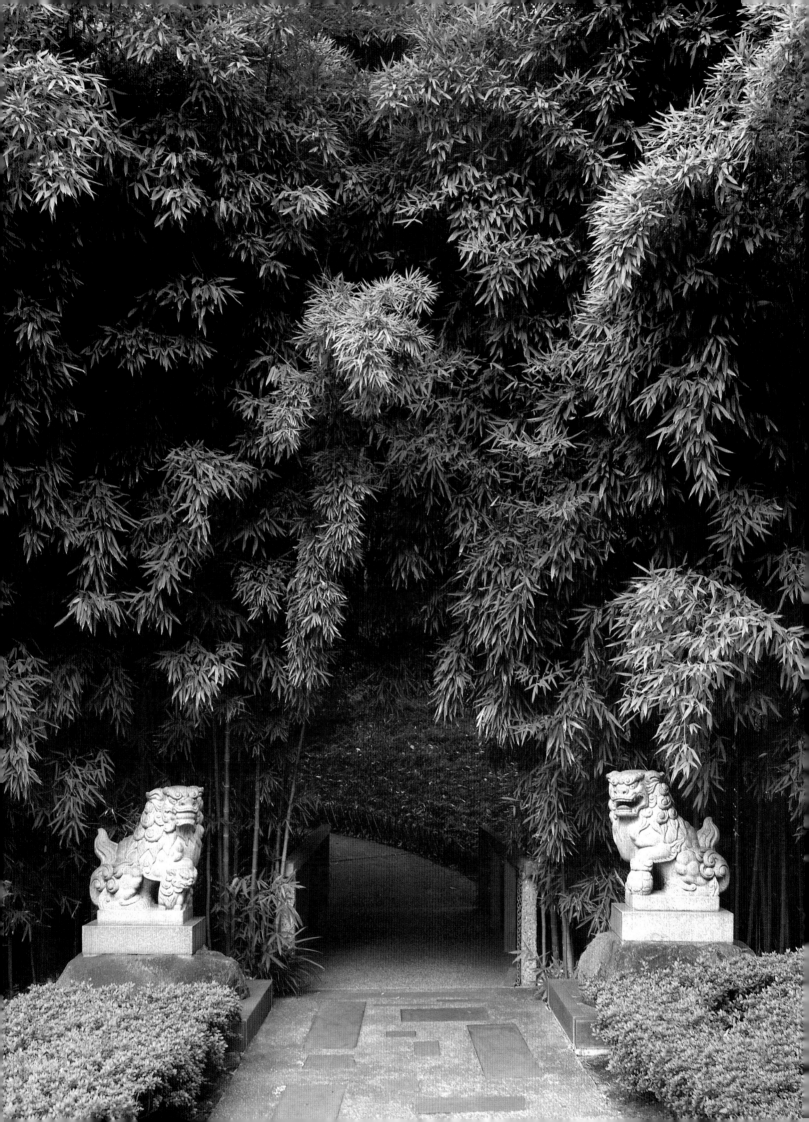

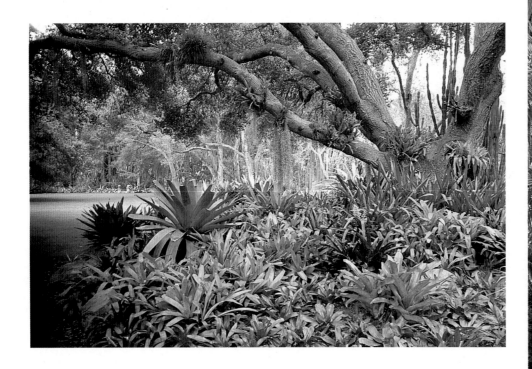

LOTUSLAND, AN ARCHETYPAL southern
Californian estate *(above)*, was the creation of a
remarkable individual, Ganna Walska, a Polish
opera singer with a succession of husbands – six in
all, and all of them wealthy. She bought the estate at
Montecito on the eastern edge of Santa Barbara in
1941 and renamed it Lotusland. When she arrived,
there were already plants of distinction here but
over the years – and she died at the age of 100 in
1984 – she refined and elaborated the estate to
form a most individual vision. The Blue Garden
(opposite) is planted with blue grass, *Festuca glauca*, and
the paths are edged with blue glass, the slag left over
from the manufacture of Coca Cola bottles.

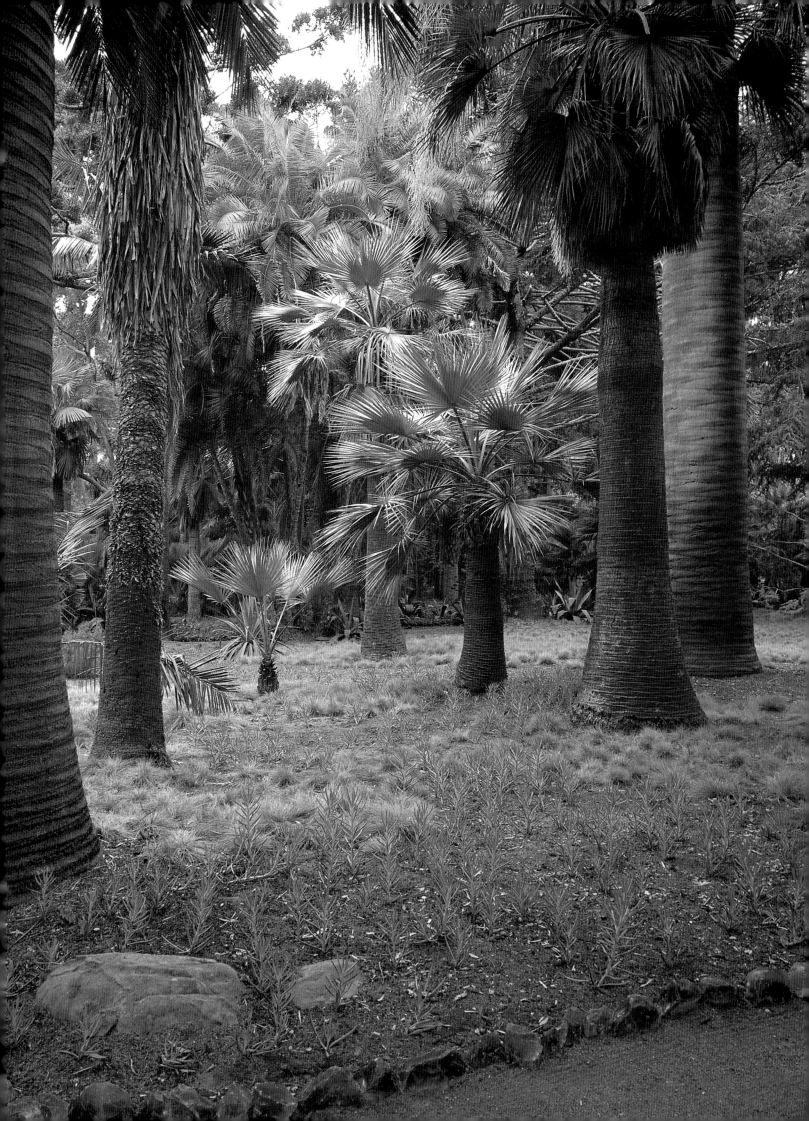

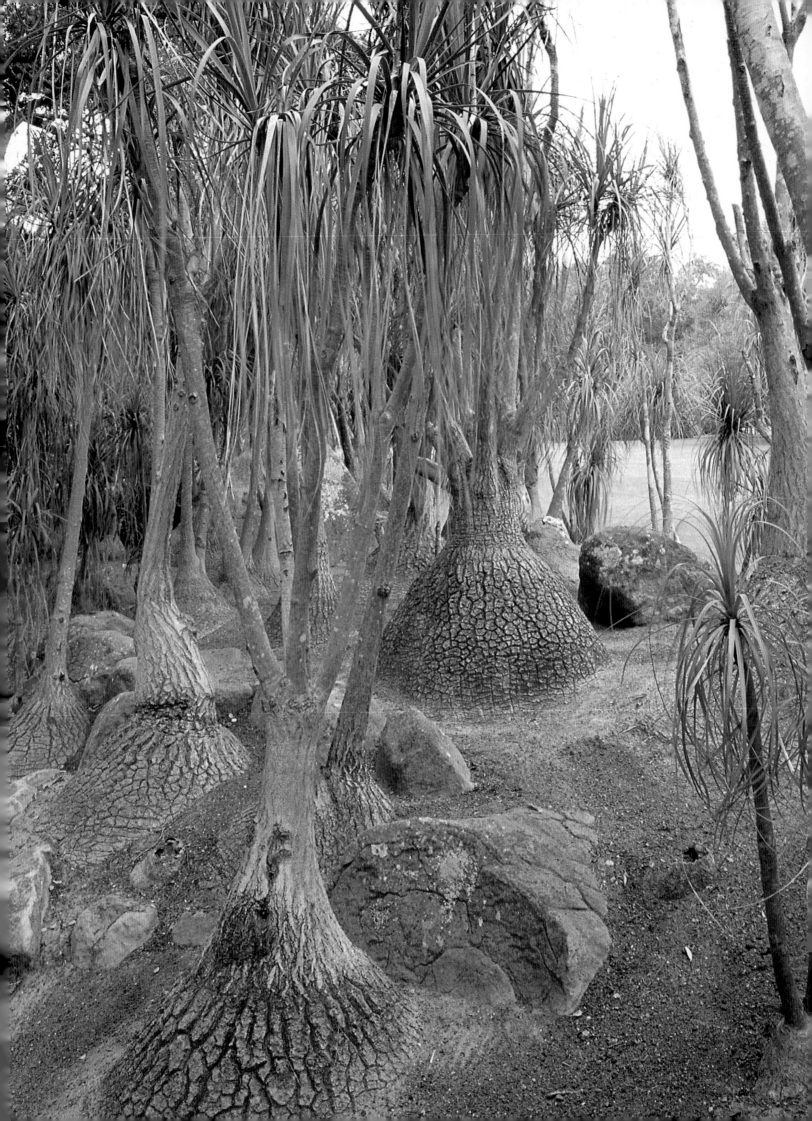

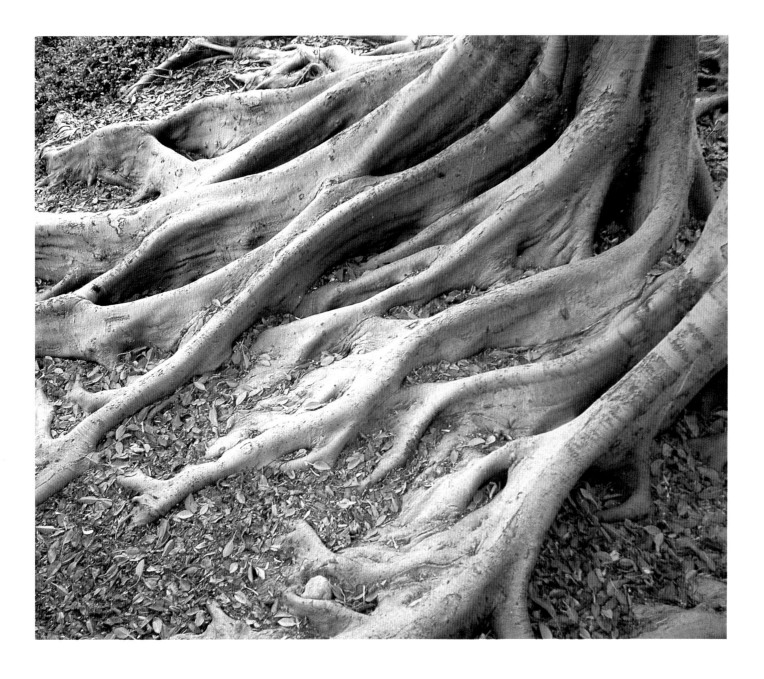

CALIFORNIAN GARDENS pioneered the use of native American plants in convincingly naturalistic settings. In recent years, this has become a fashionable influence on garden design. Balboa Park in San Diego (*opposite*), named after Vasco Nunez de Balboa, the Portuguese explorer who discovered the Pacific Ocean in 1513, was founded in 1868 and has a fine display of gardens of different types. Among the most striking of drylands plants are the magnificent specimens of the Mexican elephant foot tree, *Nolina recurvata* — the swollen base of the stem is used to store moisture. The half-exposed roots of the dragon tree, *Dracaena draco* (*above*), make extraordinary patterns, resembling the sprawling limbs of a prehistoric monster. Amongst the longest-lived of all trees, a specimen in Tenerife in 1868 was estimated to be 6,000 years old.

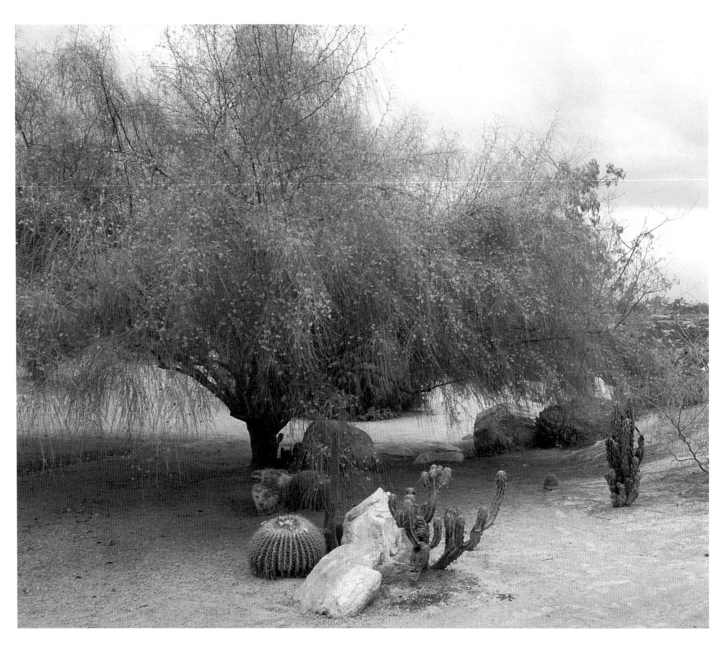

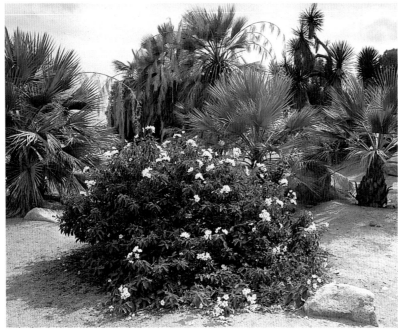

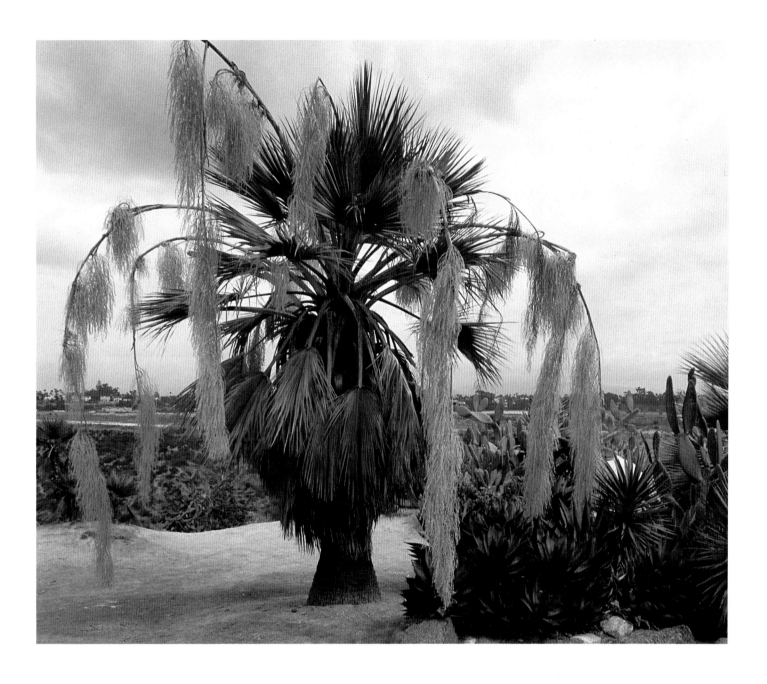

THE FINE DISPLAY of pleasure gardens at Balboa Park includes representations of Spanish and English gardens, but the most memorable area is the Desert Garden, with a remarkable collection of exotics and drylands plants, especially from Central America, shown in authentic habitats of sand and scattered rocks (*opposite, below*). The rounded shapes of the golden barrel cactus from Mexico, *Echinocactus grusonii* (*opposite, above*), contrast with the sprawling forms of substantial shrubs. Another striking Mexican plant is the blue hesper palm, *Brahea armata* (*above*), whose magnificent blue-grey fronds, moving gracefully in any breeze, are vividly ornamental. It throws out dramatic spires of yellow flowers, up to 14ft (4m) long.

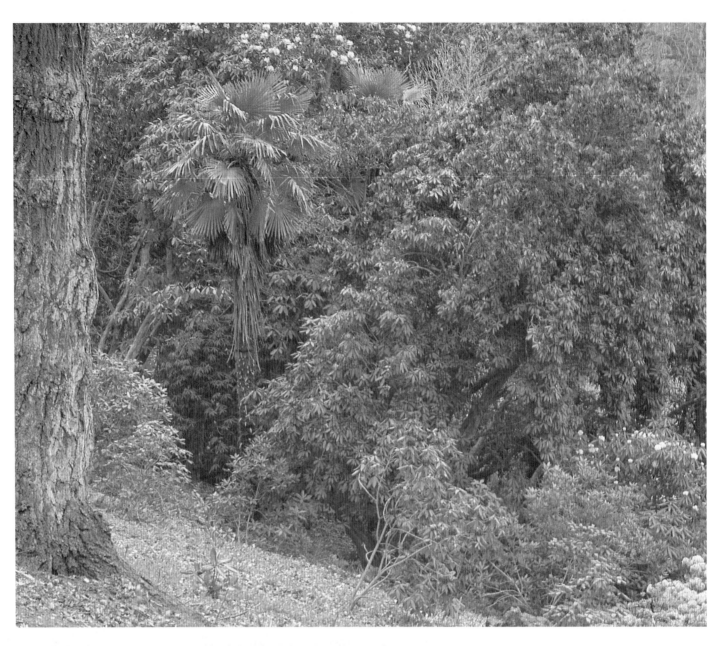

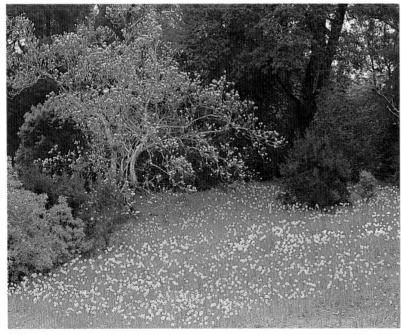

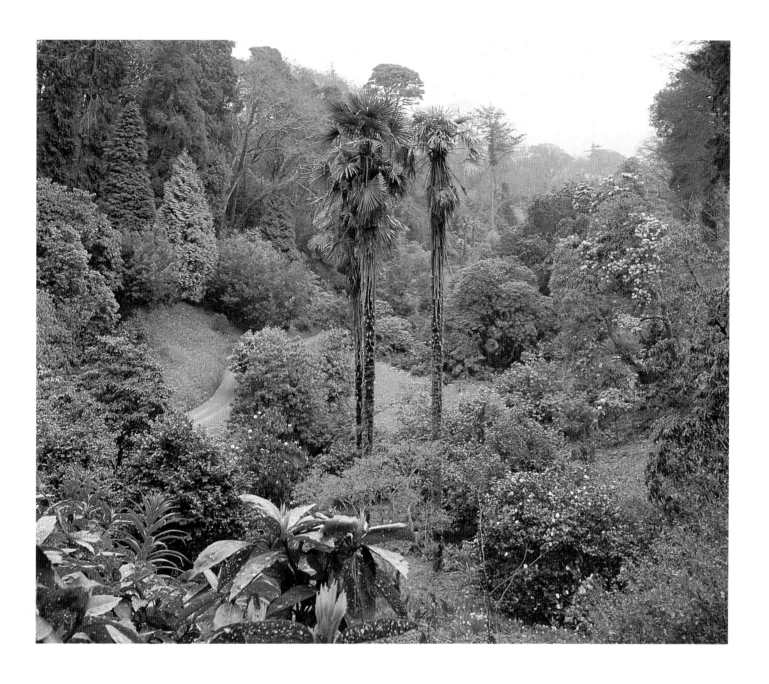

THE INTRODUCTION of magnificent Himalayan shrubs, especially rhododendrons, electrified British gardening in the 19th century. Two areas proved to have the perfect microclimate, wet and warm, for growing these great aristocrats: Cornwall in the south-west of England *(opposite, below)*, and the west coast of Scotland. Trebah in Cornwall also has the priceless advantage of a magnificent natural setting, a precipitous ravine tumbling down to the sea. Here the Fox family assembled a marvellous collection of plants. *Rhododendron arboreus* (*opposite, above*), with its brilliant scarlet flowers, has grown to a great size, as has the group of soaring Chusan palms, *Trachycarpus fortunei*, at the centre of the ravine (*above*). After forty years of neglect, a new owner has spent a decade restoring this great treasure house of plants.

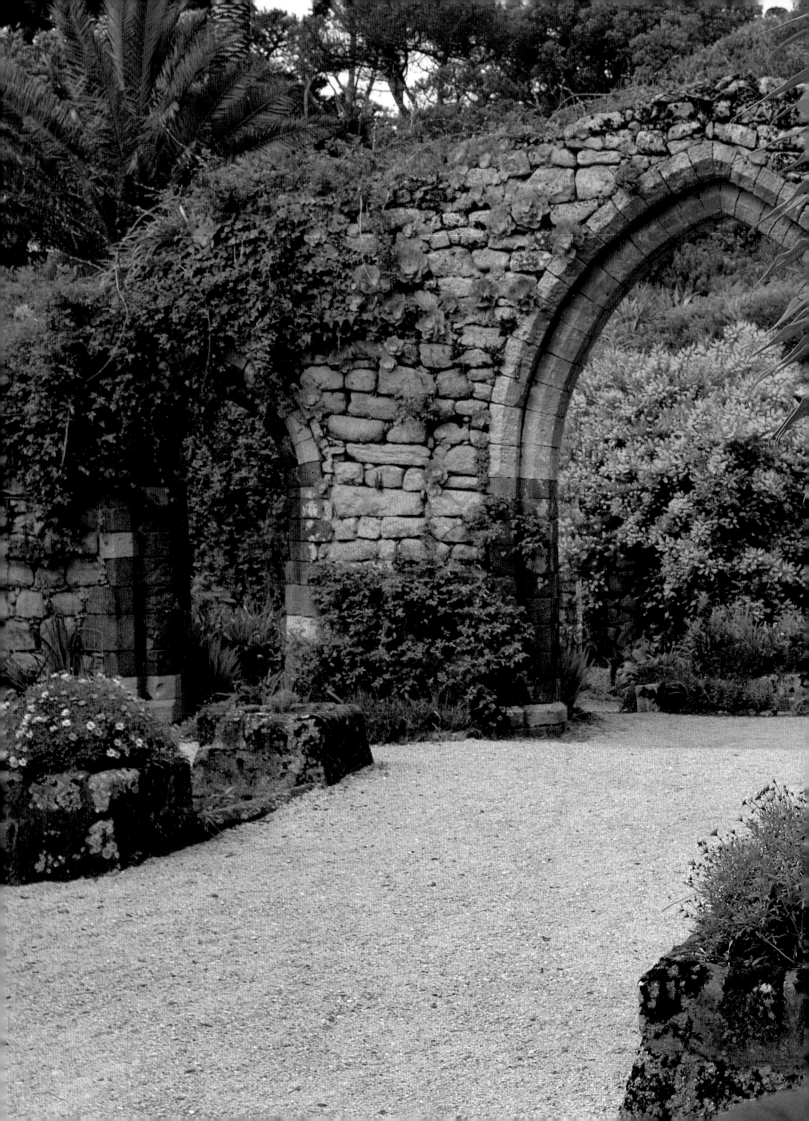

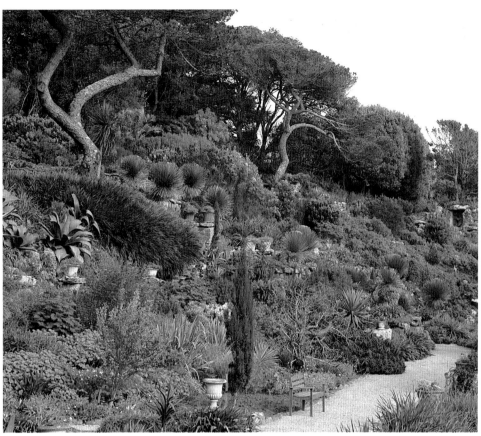

ONE OF THE FINEST collections of sub-tropical plants in the world, in particular those of the southern hemisphere, is to be found on Tresco, one of the Scilly Isles, a group of exquisite islands enjoying a remarkably benign maritime climate in the Atlantic Ocean off the south-west tip of England. The garden of Tresco Abbey has been developed by the Dorrien-Smith family since the 1830s. At its heart, the ruins of the 12th-century Benedictine abbey (*opposite*) make handsome features. Old specimens of Monterey cypress, *Cupressus macrocarpa*, and Monterey pine, *Pinus radiata*, (*above*), originally planted as windbreaks against Atlantic storms, have assumed bold contorted shapes.

VII
DREAMS
AND
FANTASIES

THE SHAPES of hand-thrown pots are given their full value set against the giant foliage of *Gunnera manicata* at Roche Court in Wiltshire *(above)*. The lively use of colour on a painted wheelbarrow and a garden gate stirs the senses in the artist Robert Dash's Long Island garden *(opposite)*. A sheaf of garden bamboos in a stoneware vase hints at Oriental austerity, enigmatic yet full of meaning.

THE GARDEN IN *Alice Through The Looking Glass*, with its talking flowers, barking tree and giant chess board, grips the imagination in a most insidious way. Lewis Carroll's thoroughly mysterious voyage is a fantastical version of the exotic travels that so absorbed the Victorians. The passion for the exotic in garden style often leads gardeners to seek inspiration in the half-understood garden traditions of other cultures. The problem is that, of all human artefacts, gardens are profoundly rooted in the cultures that produced them. The recreation of some imported style which more or less faithfully copies the original is a perilous enterprise yet, like Biddulph Grange in Staffordshire, it can exert its own independent fascination. After Japan was opened to the West in the late 19th century, a craze for *japonaiserie* gripped the world's imagination. It inspired Puccini to compose *Madam Butterfly* and Gilbert and Sullivan to create *The Mikado*, and Japanese gardens became the rage in Europe and America. The story is told of the making of an ambitious Japanese-style garden in Surrey which, on

its completion, the Japanese ambassador was invited to open. He walked about it in astonishment and eventually pronounced: 'This is a most remarkable garden – we have absolutely nothing like it in Japan.'

The uprooting of garden styles to an alien context often produces bizarre effects. At Versailles, that great symbol of French national pride, the *Jardin Anglais* contains examples of summer bedding schemes which represent the pinnacle of French accomplishment in that most distinctive of French horticultural styles. Nowhere in England is there a *jardin anglais* like that. It is curious that countries with such rich cultural traditions as France should seek inspiration from elsewhere.

The powerful and highly original imagination so typical of France has produced some remarkable gardens in which fantasy is given free, and wonderful, rein. At the Palais Idéal du Facteur Cheval in Hauterives south of Lyon, the village postman, Monsieur Cheval, inspired by the curious rock formations of his native country, created in the late 19th century one of the strangest of all garden buildings. Working with the newly discovered material of cement, he fashioned an immensely elaborate building encrusted with a frenzy of ornament – writhing snakes, grimacing masks, frolicking animals, fearsome monsters and occasional mottos attempting to explain the source of this staggering creation. One of them reads '*L'extase d'un beau songe et le prix de l'effort/ Dans la réalité tu graves la magie*' ('The ecstasy of a beautiful dream and the reward of effort/ You inscribe magic on reality').

There is something almost psychopathological about the postman Cheval's ideal palace, a not always reassuring glimpse into another person's psyche. Another fantastic French garden, La Maison Picassiette in the suburbs of Chartres, exudes a very different character – a delightfully innocent charm. It is the creation of Raymond Isidore, a roadmender and cemetery sweeper, who embarked on it as the war broke out in 1938. In his garden he created a series of courtyards and little rooms in which the surface is dazzlingly encrusted in mosaics of broken china. These are full of religious references (the Virgin, the Magi and angels galore) and many images of his favourite buildings – mostly the great cathedrals of France, with Notre Dame de Chartres in a position of justifiable prominence. There is a tender, lighthearted gaiety in all this, allied to a marvellously gifted decorative sense.

The gardens of artists may or may not include an element of fantasy but they certainly tend to be independent-minded. Monet's garden at Giverny was intended by him to be a deliberate evocation of the Norman farmhouse gardens of his childhood, with poultry pecking among the flowers, as well as a source of inspiration in his painterly life. Anyone who has seen his later giant, almost abstract paintings of water lilies, and who looks into the waters of the lily pool at Giverny, will enjoy an experience of almost hallucinatory power.

Artists continue to make gardens which they may use, as Monet did, as a subject or inspiration for their work. Places like Roche Court in Wiltshire and Octave Landuyt's garden near Ghent also provide marvellous settings for works of sculpture, which animate their surroundings, and which in turn cause us to see the sculptures in a new way. Sometimes, though, the garden itself is used as a kind of visual laboratory of artistic creativity. James de Rothschild at Waddesdon Manor in Buckinghamshire had borders enclosed in wire mesh in which, fluttering hither and yon, were butterflies whose colours were chosen to harmonise with those of the border. Lord Berners at Faringdon House, weary of the inevitable white of his fantailed pigeons, painted them in different

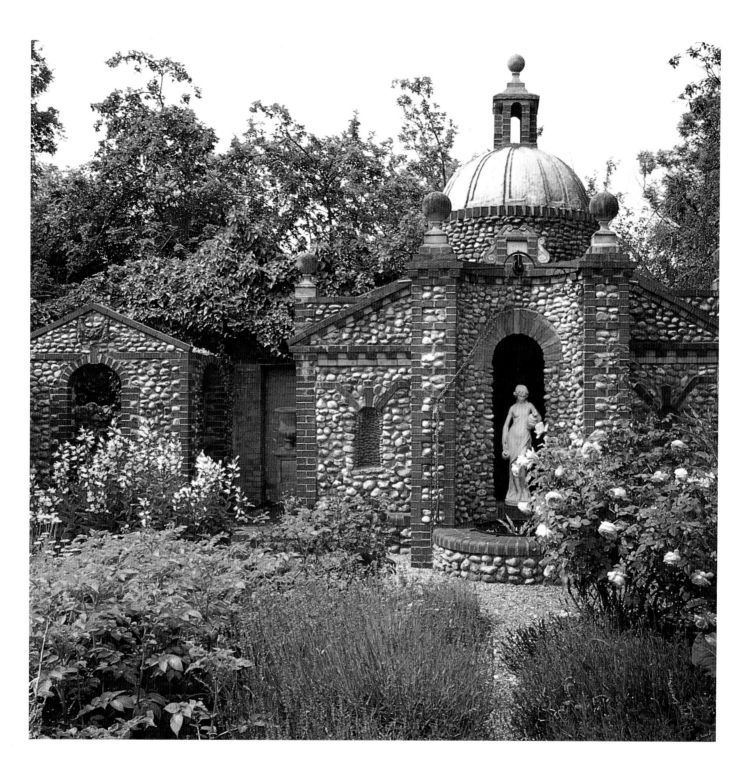

The gardens at Corpusty Mill in Norfolk
are enlivened with a sequence of dazzling
garden buildings of Gothic inspiration. Some
of them are half-ruined, seeming to survive
from some ancient and slightly eccentric
monastic community – but in fact they
were all created by the present owners in
recent years.

colours to ornament the sky. These are *jeux d'esprit*, but the richly imaginative spirit sometimes extracts true poetry from unexpected sources. In Ian Hamilton Finlay's exquisite garden at Little Sparta in Scotland a beautifully fashioned birdtable is in the form of an aircraft carrier on whose deck small birds charmingly descend.

One of the most remarkable dream gardens is Sir George Sitwell's Renishaw, a beautiful fantasy evocation of Renaissance Tuscany amid the coalfields of Derbyshire. Here he planted a little naturalistic group of yews whose purpose was to emphasise the extreme formality of the rest of the garden. He found it extraordinarily difficult to dispose these trees in a natural way. If art is difficult, nature is harder still.

THE RHYTHMIC repetition of
colour on a gate, an archway and a
door sharpens the effect of a vista
through the dense vegetation in
Robert Dash's garden *(left)*.
However, most gardeners, who feel
quite free to use brilliant colours in
their planting, usually limit
themselves to the predictable in their
paintwork. Great trees and open
expanses of space create a dramatic
context for large-scale works of art.
The Belgian artist and gardener,
Octave Landuyt, makes use of this
to give emphatic value to his
enigmatic sculpture *(opposite)*.

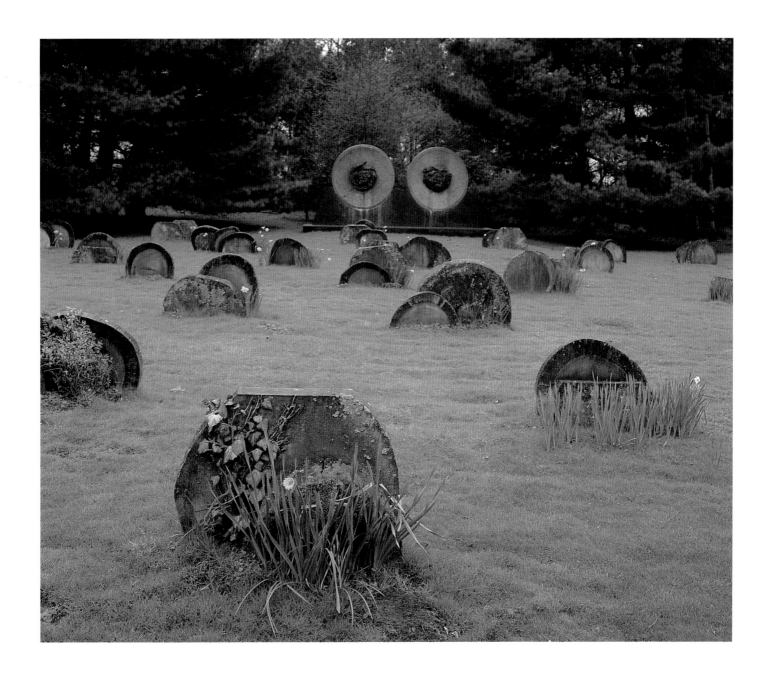

Modern sculpture can look magnificent set in a garden. At Roche Court *(opposite)*, a handsome Edwardian garden is used by a dealer in 20th-century art and crafts to display her wares. Here, Tim Harrisson's hallucinating tooth-like carvings erupt from the turf. Octave Landuyt's garden near Ghent is a magician's laboratory of sculpture and *objets trouvés* used to animate the landscape. To create this extraordinary effect *(above)*, he cut slices from a tree trunk with a chainsaw and set them on edge in the ground. In Gil Friesen's Californian garden *(right)*, distinguished works of art embellish the garden to great effect. This minimalist sculpture by one of the most celebrated of 20th-century American artists, Richard Serra, is an inspired essay in perspective.

THE SPARE, PARED-DOWN 20th-century architecture of California lends itself to planting of bold simplicity. In this private garden in Los Angeles, the tall trunks of Chilean palms, *Jubaea chilensis*, erupt from fine gravel *(opposite)* echoing the window slits in the façade of the house. A grove of giant bamboos *(above)* effortlessly conveys an atmosphere of melancholy enigma, a *haiku* capable of any interpretation.

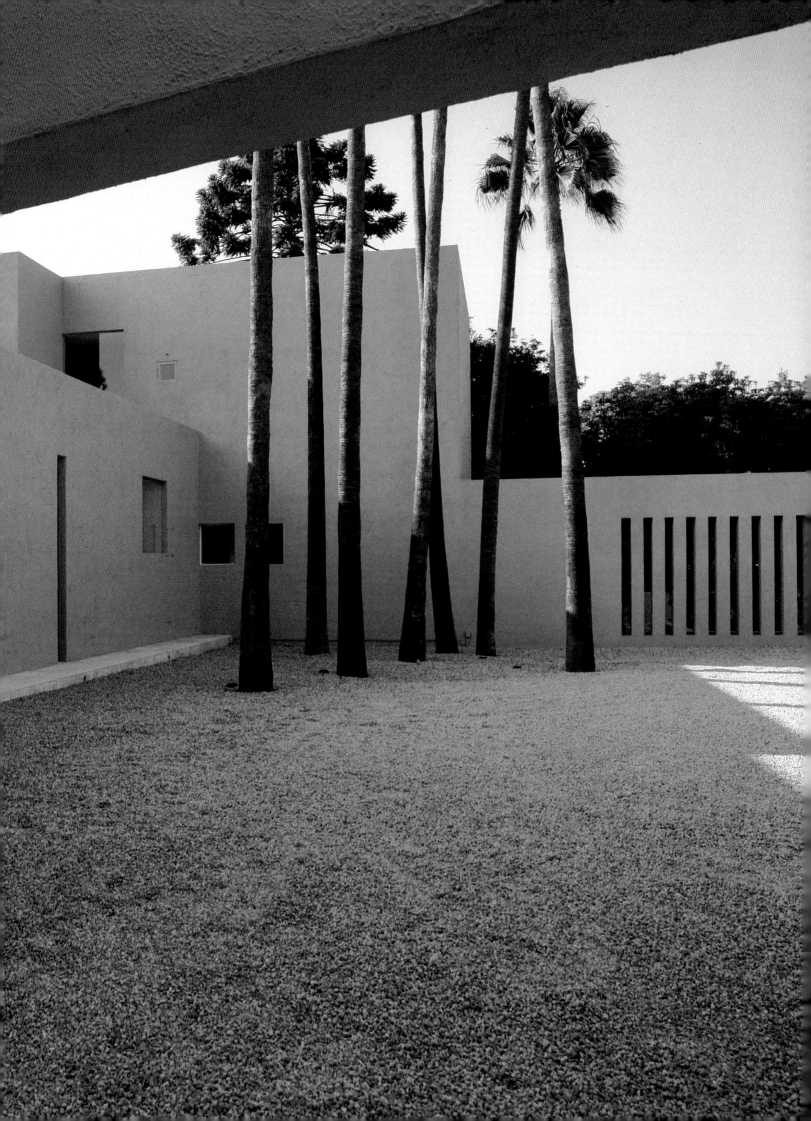

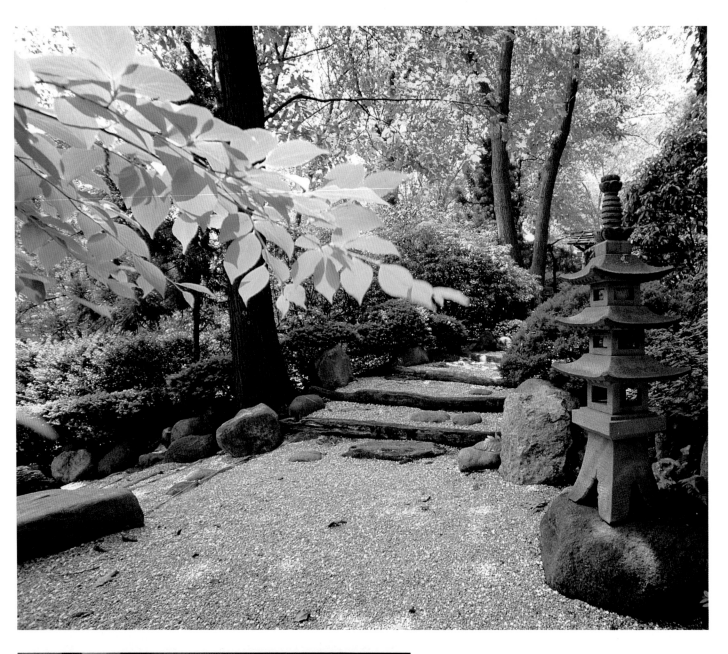

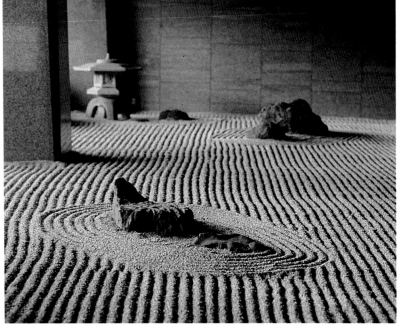

Visions of Japanese gardens take many
different guises. The enclosed monochromatic
garden in Tokyo (*left*) deploys ingredients stripped
down to a bare minimum – gravel finely raked into
eddying ripples swirling about shapely rocks and a
little snow-lantern, all in subtle shades of grey. The
Japanese garden at the Bailey Arboretum in Locust
Valley, Long Island (*above and opposite*) displays the
rich vocabulary of Japanese design. A path surfaced
with gravel winds uphill, with steps formed by
weathered baulks of timber; stepping stones
scattered between the treads lead the eye and foot
onwards. The essentially unchanging appearance of
evergreens gives that air of permanence so
fundamental to Japanese garden philosophy.

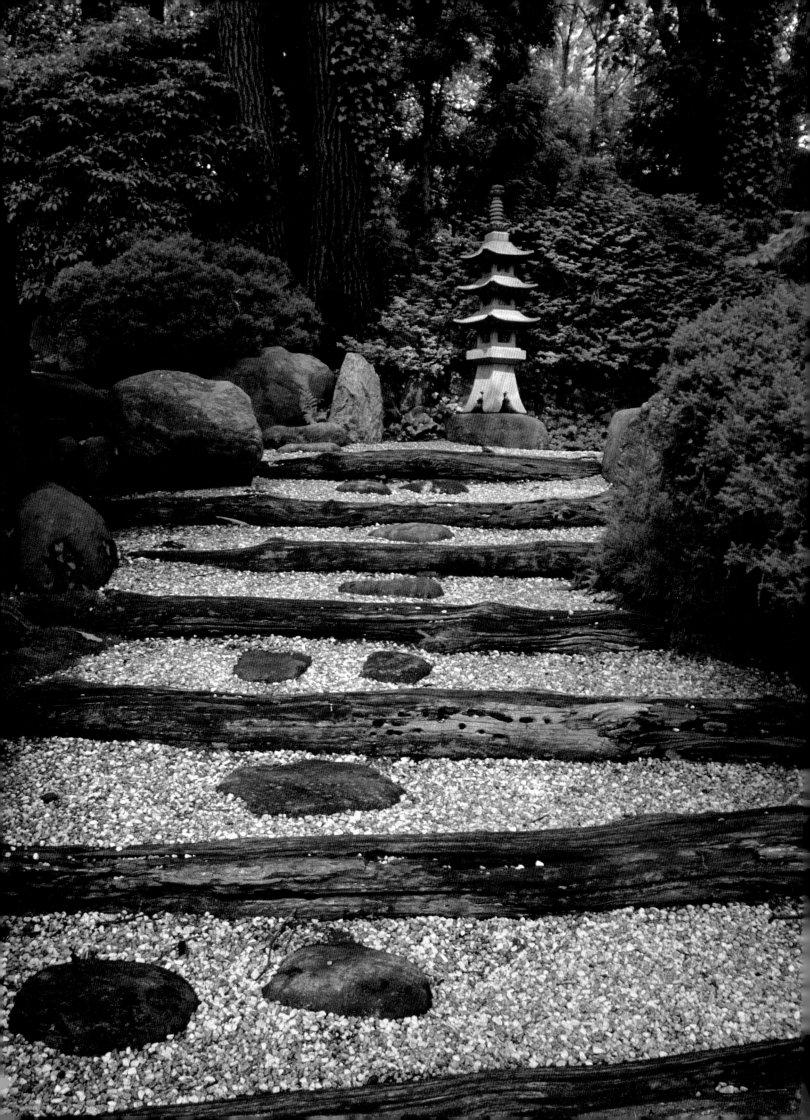

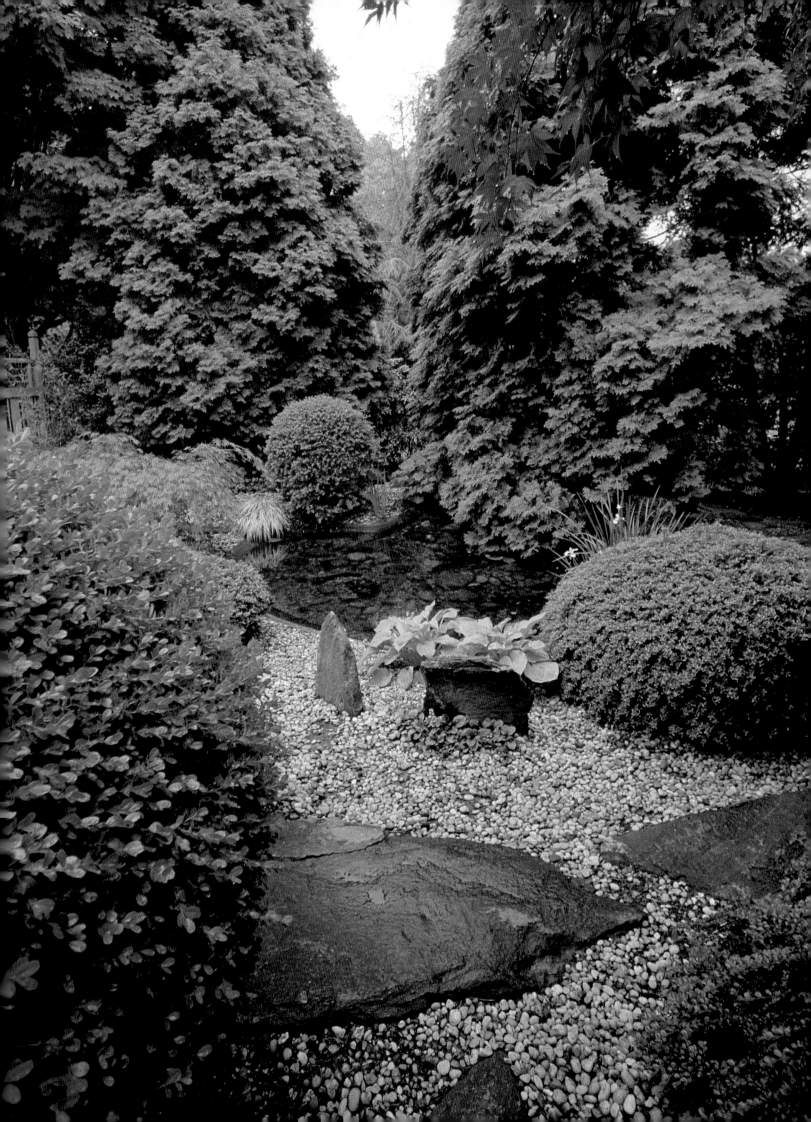

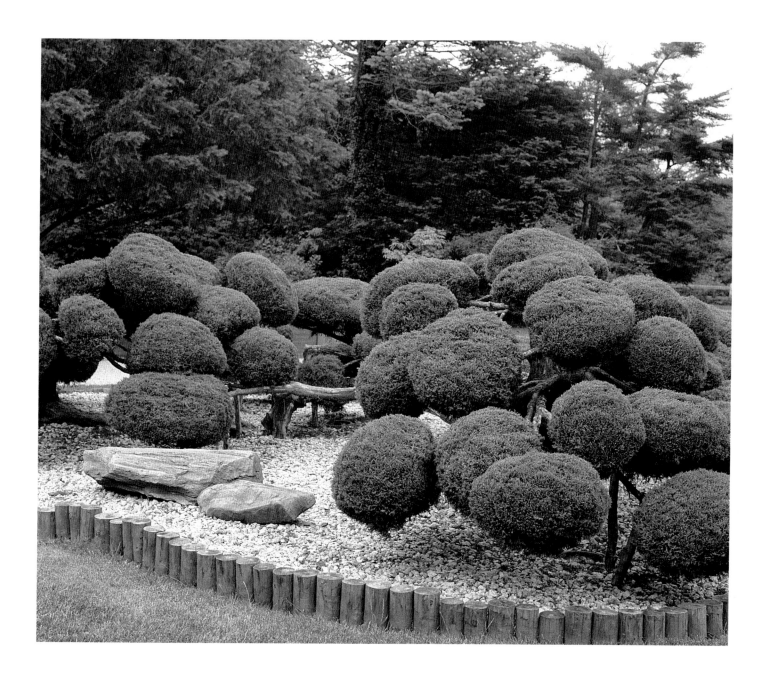

The INFLUENCE OF Japanese garden design on the West has been a potent force since the late 19th century. At Old Westbury Gardens *(opposite)*, the Japanese garden is a freestyle evocation, with rock forms emerging from gravel, a pool of limpid water, unchanging evergreens and the finely cut foliage of a Japanese maple. In Carol Mercer's Long Island garden *(above)*, a sinuous edging of sawn-off tree trunks contains a sea of gravel. Sprawling junipers, poodled into billowing shapes, have a venerable air of permanence and their horizontal emphasis is echoed in scattered rocks deposited as though by some seismic upheaval.

'THE GREAT VISION of the guarded mount', was the poet John Milton's description of St Michael's Mount, an island off the coast of Cornwall *(above, left and opposite)*. It was named after the apparition here of St Michael in 495 AD, in honour of which King Edward the Confessor founded a Benedictine Abbey on the island in the 11th century. In later years it became a fortress and in 1660 passed into the ownership of the St Aubyn family, who live there to this day. Gardens spread out on rocky terraces, commanding vertiginous views. The climate is mild, and tender exotics thrive here, clinging to the rocks in the teeth of Atlantic gales. The author Nigel Nicolson called it 'the largest and loveliest rock garden in England'.

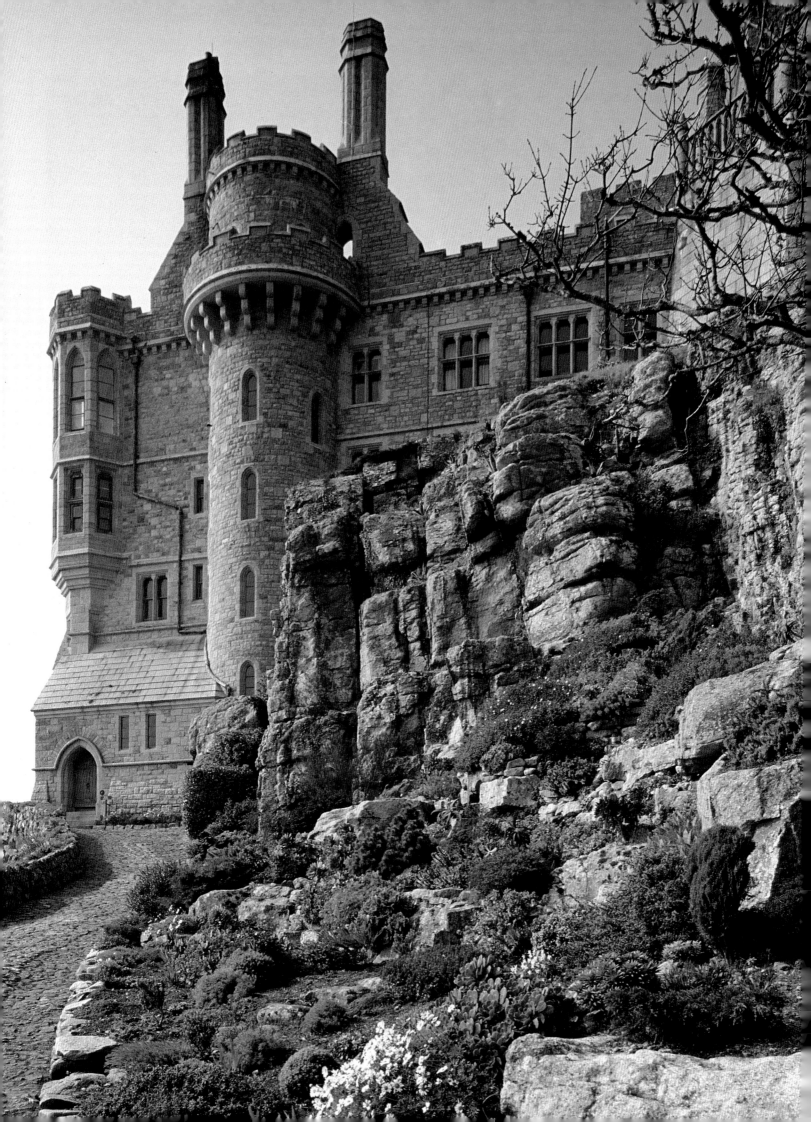

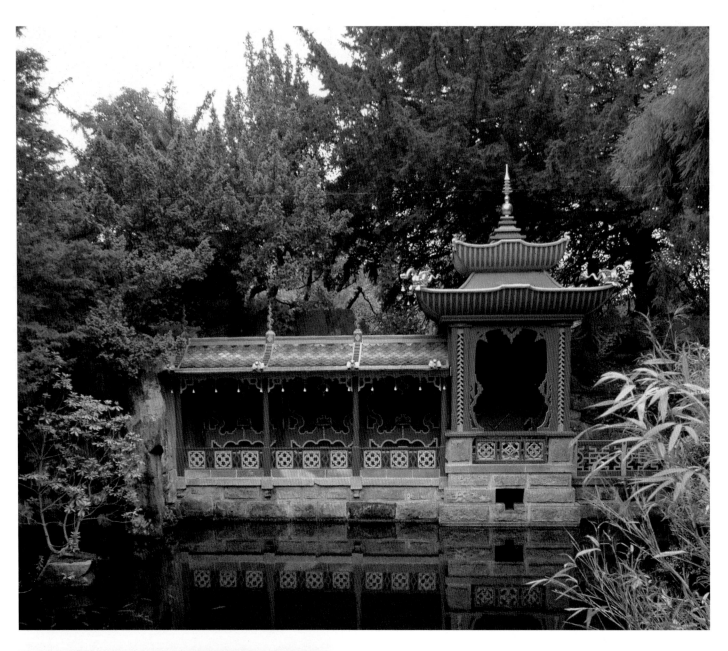

A<small>N INTENSE INTEREST</small> in exotic forms
of foreign gardening traditions gripped English
gardeners in the 19th century. The dream-like
Biddulph Grange in Staffordshire is one of the
most complete and remarkable of the gardens
made at the height of this fashion. The part called
China *(above, left and opposite)* is approached in
an extraordinarily dramatic way. A cleft in an
apparently natural rock marks the opening of a
narrow tunnel which leads into total darkness.
After a while, light is glimpsed at the end of the
tunnel, which opens out into a dazzling, richly
worked Chinese house painted in scarlet, green
and gold. It overlooks a pool, shaded by Japanese
maples and ornamented with a splendid bridge.

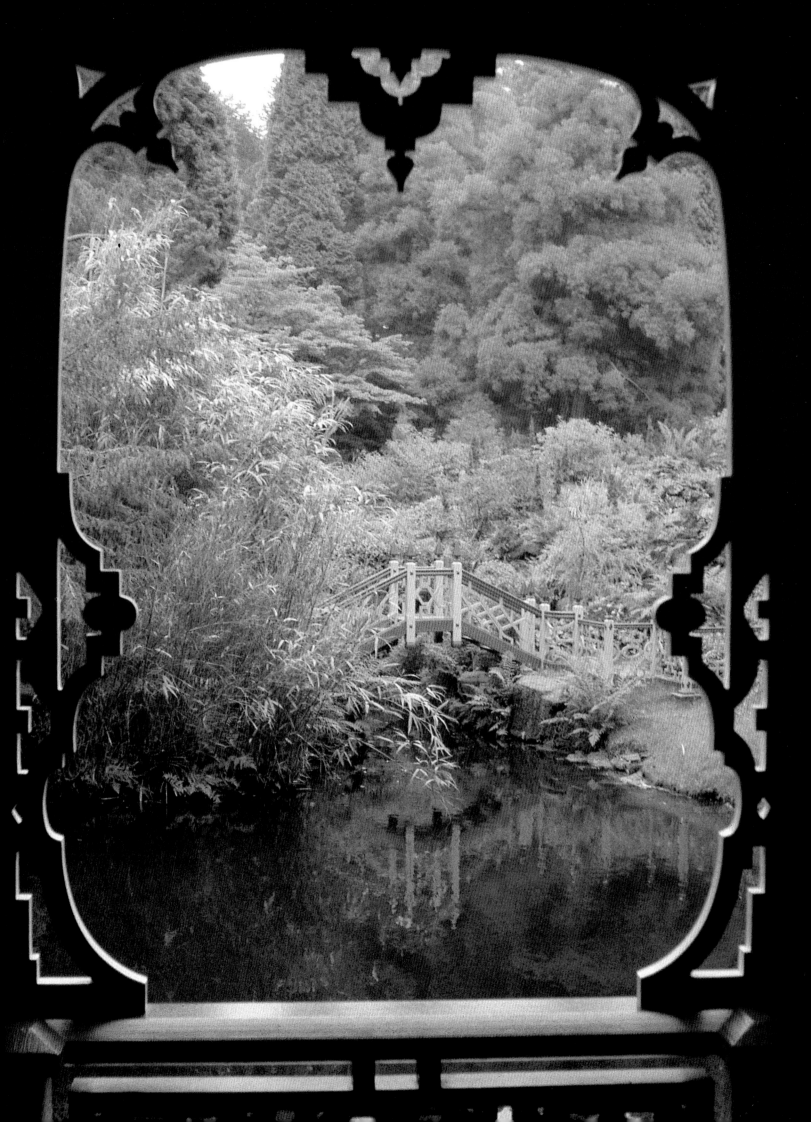

GARDENS OPEN TO THE PUBLIC

BRITAIN

Biddulph Grange
Biddulph
Stoke-on-Trent, Staffordshire
ST8 7SD
National Trust

Chilcombe House
Chilcombe
Near Bridport, Dorset
DT6 4PN
Mr & Mrs John Hubbard

Drummond Castle
Muthill
Crieff, Tayside
PH5 2AA
Grimsthorpe & Drummond Castle Trust

Elsing Hall
Elsing
Near East Dereham, Norfolk
NR20 3DX
Mrs D Cargill

Felbrigg Hall
Roughton
Near Norwich, Norfolk
NR11 8PR
National Trust

The Gibberd Garden
Marsh Lane, Gilden Way
Harlow, Essex
CM17 0MA
The Gibberd Garden Trust

Haseley Court
Little Haseley
Oxfordshire
OX40 7LL
Mr & Mrs D Heyward

Knightshayes Court Gardens
Bolham
Tiverton, Devon
EX17 7RQ
National Trust

Montacute House
Yeovil,
Somerset
TA15 6XP
National Trust

Roche Court
Sculpture Garden
East Winterslow,
 Near Salisbury
Wiltshire
SP5 1BG
Earl & Countess of Bessborough

St Michael's Mount
Marazion
Near Penzance,
Cornwall
TR17 0EF
National Trust

Stourhead
Stourton
Warminster, Wiltshire
BA12 6QD
National Trust

Trebah
Mawnan Smith
Near Falmouth, Cornwall
TR11 5JZ
Major & Mrs J A Hibbert

Tresco Abbey
Tresco
Isle of Scilly
TR24 0QQ
Mr R A Dorrien-Smith

FRANCE

Parc de Bagatelle
Bois de Boulogne
75016 Paris

Château et Parc de Courances
par Milly-la-Fôret
91490 Essonne

Jardins du Château de Fontainebleau
Palais National
77300 Fontainebleau
Seine-et-Marne

Jardins Claude Monet
Musée Claude Monet
27620 Giverny
Eure

Parc Jean-Jacques Rousseau
1 rue René de Girardin
60950 Ermenonville
Oise

Le Vasterival
76119 Sainte-Marguerite-Sur-Mer
Seine Maritime

Jardins de Versailles
78000 Versailles
Yvelines

Les Jardins de Villandry
37510 Villandry
Indre-et-Loire

GERMANY

Aschaffenburg
Schloss und Gärtenverwaltung
Schlossplatz 4
63739 Aschaffenburg
neben Frankfurt am Main

Charlottenhof/Park Sanssouci
Staatliche Preussicher Schlösser und
Garten
P O Box 601462
14414 Potsdam

Schloss Schwetzingen
Schlossverwaltung Schwetzingen
Mittelbau, 68723 Schwetzingen
Baden-Württenburg

Schloss Veitshöchheim
Schloss und Gärtenverwaltung
Residenzplatz 2
97070 Würzburg, Bayern

Park Luisium
Staatliche Schlösserverwaltung
06786 Wörlitz neben Halle

ITALY

Albergo Villa D'Este
Cernobbio
Lago di Como

Villa Garzoni
Via della Cartiere 1
Collodi, Pistoia
Toscana

Villa Mansi
Segromigno in Monte
Lucca
Toscana
Famiglia Mansi-Salom

Villa Orsini
Parco dei Mostri
Bomarzo,
Viterbo
Latium
Sig Giovanni Bettini

Villa Reale
Via Fraga Alta 2
Marlia, Lucca
Toscana
Conti Pecci-Blunt

Villa San Remigio
Via San Remigio
Pallanza,
Lago Maggiore
Novara
Regione Piemonte

*Isola Bella
Stresa,
Lago Maggiore
Novara
Principi Borromeo-Arese

*Isola Madre Stresa
Lago Maggiore
Novara
Principi Borromeo-Arese

*Visits by boat only:
Compagnia di Navagazione,
Lago Maggiore,
Arona, Novara

NETHERLANDS

Paleis Het Loo
National Museum
Koninklijk Park 1
7315 JA
Apeldoorn

Kasteel Twickel
Twickelerlaan 1A
7495 VH
Ambt-Delden

Kasteel de Wiersse
Wiersseallee 9
7251 LH
Vorden
E V Gatacre

PORTUGAL

Palácio da Fronteira
Largo de São Domingos de Benfica
1500 Lisboa
Fondacão das Casas de Fronteira Alorna

Quinta de Monserrate
Palácio da Ajuda
Largo da Ajuda
1300 Lisboa
Sintra
Instituto Portugues do Patrimonio Arqueologico

SPAIN

La Alhambra
Parque de Alhambra
Granada

Jardines de La Granja
La Granja de San Ildefenso
Segovia

Casa de Pilatos
Plaza de Pilatos
Sevilla

Palácio de Viana
Plaza de Don Gome No 2
Córdoba

USA

Bailey Arboretum
Bayville Road and Feeks Lane
Lattingtown, Long Island
NY 11560

Balboa Park Management Center
San Diego
CA 92101

Ruth Bancroft Garden
Walnut Creek
CA 94598

Filoli Gardens
Canada Road
Woodside
CA 94062

J. Paul Getty Museum
(Garden of the Villa of the Papiri at
Herculaneum)
17985 Pacific Coast Highway
Malibu
CA 90265-5799

Huntington Botanical Gardens
1151 Oxford Road
San Marino
CA 91108

Longwood Gardens
PO Box 501
Route 1, Kennett Square
PA 19348-0501

Lotusland
695 Ashley Road
Montecito, Santa Barbara
CA 93108

Old Westbury Gardens
PO Box 430
71 Old Westbury Road
Old Westbury
NY 11568

Wave Hill Center for Environmental
Studies
675 W 252 St
Bronx, New York
NY 10471

INDEX

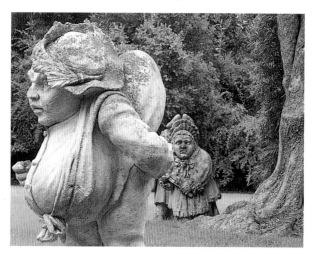

Grotesque figures of dwarfs strut in the green theatre at Lotusland in California.

Note: page numbers in italic refer to *captions* to illustrations.

Acknowledgements

I would like to thank all the gardeners who have helped in so many ways, particularly the owners of the gardens featured. I hope they feel that my work has done justice to their great skills and achievements.

I would also like to thank Patrick Taylor for his knowledgeable and fascinating text on both the gardens and the plants. His books are a great inspiration to all garden lovers and I feel privileged that he has contributed so much to this book.

I should also like to thank all those people who helped with organising the various gardens, particularly Jenny Mackintosh, Caroline Taylor, Elaine Winkworth, Sebastian Hedgecoe, Pamela Burton, Richard Hertz, Ray Woolcock, Doreen Mitchell, Richard Skelton and Don Walsh, and the Trustees and Custodians of many of the great gardens. Thanks also to the tourist boards of Belgium, France, Germany, Holland, Italy, Spain and the USA and the many friends whose advice and suggestions were invaluable.

I would like to thank the editorial director, Cindy Richards, the editor, Katherine Lambert and the designer, David Fordham for the great work they have done. Lastly, Mark Collins and Cameron Brown who were enthusiastic enough to publish this book.

The Publishers would like to thank Dr Brent Elliott, Librarian, and his very helpful staff at the Lindley Library.